DREAM ANATOMY

Michael Sappol

In memoriam, Gretchen Worden (1947–2004),
who made us look and made us laugh.

This catalogue is produced in conjunction with *Dream Anatomy,* an
exhibition about anatomy and the artistic imagination, featuring material
from the collections of the National Library of Medicine.

www.nlm.nih.gov/dreamanatomy

U.S. DEPARTMENT OF HEALTH AND HUMAN SERVICES
National Institutes of Health, National Library of Medicine

U.S. DEPARTMENT OF HEALTH
& HUMAN SERVICES

D1293967

U.S. GOVERNMENT OFFICIAL EDITION NOTICE

Use of ISBN
This is the Official U.S. Government edition of this publication and is herein identified to
certify its authenticity. Use of the 0-16 ISBN prefix is for U.S. Government Printing Office
Official Editions only. The Superintendent of Documents of the U.S. Government Printing Office
requests that any reprinted edition clearly be labeled as a copy of the authentic work with a
new ISBN.

U.S. DEPARTMENT OF HEALTH
& HUMAN SERVICES

Legal Status and Use of Seals and Logos
The logo of the Department of Health and Human Services (DHHS) authenticates *Dream
Anatomy*, by Michael Sappol, as an official publication of the Department. It is prohibited to
use the DHHS logo on any republication of this book without the express, written permission
of the Department.

© All portions of this publication are protected against copying or other reproduction outside
 of the United States in accordance with provisions of Article II of the Universal Copyright
 Convention.

Catalogue Design: Riggs Ward Design, L.C., Richmond, VA

Cover Image:
Govard Bidloo (1649–1713) [anatomist]
Gérard de Lairesse (1640–1711) [artist]
Ontleding des menschelyken lichaams Amsterdam, 1690. T. 71. Copperplate engraving
with etching. National Library of Medicine.

Back Cover Image:
Katherine Du Tiel (b. 1961) [artist]
Inside/Outside: Muscle/hand. San Francisco, 1994. Photograph: © Katherine Du Tiel.
National Library of Medicine.

NATIONAL LIBRARY OF MEDICINE CATALOGING IN PUBLICATION
Sappol, Michael.
 Dream anatomy / Michael Sappol. – Bethesda, Md.: U.S. Dept. of Health and Human
 Services, National Institutes of Health, National Library of Medicine; Washington, D.C.:
 For sale by the Supt. of Docs., U.S. G.P.O., 2006.
 (NIH publication; 05-5615)

 Published in conjunction with the exhibition Dream Anatomy (Oct. 9, 2002 to
 July 21, 2003), organized by the Exhibition Program of the History of Medicine
 Division of the National Library of Medicine

 1. Anatomy, Artistic – history. 2. Exhibits – catalogs. 3. History of Medicine. 4
 Imagination. 5. Medical Illustration – history. I. National Library of Medicine (U.S.).
 History of Medicine Division. Exhibition Program. II. National Library of Medicine (U.S.)
 www.nlm.nih.gov/dreamanatomy
 WZ 28 N277s 2006
 978-0-16-072473-2
 0-16-072473-2

For sale by the Superintendent of Documents, U.S. Government Printing Office
Internet: bookstore.gpo.gov; Phone: toll free (866) 512-1800, DC area (202) 512-1800; Fax: (202) 512-2250
Mail: Stop IDCC, Washington, DC 20402-0001

TABLE OF CONTENTS

Fig: 3.

Fig: 7.

Fig: 6.

Fig: 4.

Fig: 5.

M. Vander Gucht sculp:

FOREWORD

The National Library of Medicine has been described as the jewel in the crown of the U. S. Public Health Service. If that is so, then the Library's historical collections are the setting for that jewel.

The National Library of Medicine traces its founding to 1836, but it was not until 1865, when Army surgeon John Shaw Billings took over the collection, that the Library began its rise in the estimation of the world medical community. When Billings retired, in 1896, the "national medical library," as it was frequently called, was the largest such institution in the world. Because Billings was also an avid collector of historical books, journals, and manuscripts, the National Library of Medicine today has a fine collection of original materials chronicling the healing professions as far back as the eleventh century.

From October 9, 2002 to July 31, 2003, the Library's "Dream Anatomy" exhibition was a popular destination for visiting historians, librarians, health professionals, students, and the public. It piqued the interest of writers and journalists around the country, and was the subject of many articles and illustrated features.

The present volume captures the flavor of the exhibition. It handsomely reproduces many of the images, most from the Library's historical collections, others borrowed for the occasion. The reader will also find an informative and insightful essay, and the original exhibition text, by Michael Sappol, the exhibition curator and author of this book.

Dream Anatomy is the first collaboration of the National Library of Medicine and the U.S. Government Printing Office in the publication of a catalog based on an exhibition. I hope the peruser of this volume will agree with me that the partnership has been successful.

Donald A.B. Lindberg, M.D., *Director*
National Library of Medicine

1. William Cowper (1666–1709) [anatomist]. Gérard de Lairesse (1640–1711) [artist]. Michiel van der Gucht (1660–1725) [engraver]. *The anatomy of humane bodies* (after Govard Bidloo, *Anatomia*, 1685). London, 1698. Copperplate engraving. National Library of Medicine.

Os Basillare,

Os Laude, sine Capitale.

Os Coronale,

Os parietale ab vtraq; pte.

Ossa paris quattuor,

Os petrosum ab vtraq; pte.

Ossa nasi duo,

Os Occipitale,

Os colatorij vnum,

Spondiles vere et mendose. xxx,

Ossa mandibule superioris xj,

Ossa mandibule inferioris duo.

Os furcule ab vtraq; pte,

Os spatule ab vtraq; pte,

Os Adiutorij,

Os Adiutorij,

Cossa vere et mendose. xxiiij,

Arundo maior,

Arundo minor,

Spondile,

Focile minus

Focile maior

Os Sae sine Anche,

Ossa Rascete viij, vno eis addito,

Ossa pectinis 4,

Os femoris, Os Ilij, et Pixis sub Anchis, Ite tria ossa caudę,

Ossa rascete. 8,

Ossa pectinis 4,

Ossa digitorū xv,

Ossa digitorū xv,

Os coxę,

Os Coxę,

Rotula genu,

Rotula genu,

Minor tanna

Maior tanna,

Maior tanna,

Os nauiculare ab vtraq; pte,

Os Calcanei,

Os Cahab,

Ossa Rascetę 4,

Ossa pectinis xv,

Ossa digitoꝝ. 14,

Os Calcanei,

PREFACE

Dream Anatomy is derived from an exhibition of the same name, held at the National Library of Medicine from October 2002 to July 2003. The curator, Michael Sappol, had long wanted to use the Library's extraordinary collection of historical anatomical works as the basis of an exhibition. A hiatus in the Library's regular exhibition schedule allowed him and exhibition coordinator Elizabeth Mullen, along with other members of the exhibition program team, to develop—in considerable haste—an exhibition on the history of anatomical representation, using materials from the Library's rich collections. As soon as *Dream Anatomy* opened, it was evident that it had struck a chord with the public. Visitors, the press, and professional journals were warmly appreciative. After the close of the physical exhibition, the *Dream Anatomy* web site www.nlm.nih.gov/dreamanatomy has continued to attract visitors, more than 2,000,000 at last count.

Because of the short lead time for the exhibition, it was impossible to prepare an exhibition catalog at the time. When visitors asked how they could obtain a book version of *Dream Anatomy*, we had to tell them there wasn't one, but that we hoped to have something in the future. Now, that future has arrived.

This history explains some unusual aspects of this *Dream Anatomy* book. Unlike most exhibition catalogs, it comes well after the close of the exhibition. For curator Michael Sappol, a cultural historian of anatomy, the time lag provided a chance for reflection. The making of an exhibition is always a learning process. At the end of *Dream Anatomy*'s run, after many fruitful discussions with visitors and colleagues, Sappol had developed a deeper understanding of the history of anatomical representation.

2. Hans von Gersdorff. *Feldtbüch der Wundartzney: newlich getruckt und gebessert.* Strasbourg: 1528. Wood engraving. National Library of Medicine.

We decided therefore to create a book that fulfills two functions. First, it presents a revised and enriched version of the exhibition gallery, adding some images not included in the original exhibition but which serve to highlight its major themes. Second, the accompanying text contains an original scholarly interpretation of the history of anatomical representation, enhanced by Sappol's latest thoughts on the subject.

The usual format for an exhibition catalog is to pair an interpretive essay with a "gallery" section. This book retains that dual structure, but we have elected to profusely illustrate the essay, so that it functions as a guide to and reflection of the themes of the exhibition. We know that some readers will opt to read the text of the book, but that others will treat it essentially as a picture collection. We hope that the numerous illustrations accompanying the essay will entice this second group to attend to the text and to reflect on the changing history of anatomical representation.

Dream Anatomy the book, like the exhibition, is for everyone: middle and high school students, medical profession-als, artists, art lovers, bibliophiles, students in the humanities, and casual readers. Our goal is to reach scholars and non-scholars. The essay deals with serious issues, but is intended to be pleasurable and accessible.

Such an approach, in fact, mirrors what 16th- and 17th-century anatomical texts themselves did. As Andreas Vesalius, the first great modern anatomist, argued, you can't just say it, you have to show it. At the same time, in printed works and public dis-sections, Vesalius and his successors infused the study of anatomy with pleasure: first and foremost, the pleasure of looking.

The dual structure of the book reinforces the idea of doubling that runs throughout the exhibition. The anatomical body is a body double—the essay calls it a "mirror" that first anatomists, and later a larger public, peered into. Anatomical illustration and display required collaboration between art and science, and eventually became the terrain on which art and science were defined in opposition to each other. *Dream Anatomy* invites you to look and think twice about the anatomical body and its relation to self. The appeal of the topic—anatomy, anatomical representation, the anatomical conception of self, whether treated historically, aesthetically, or scientifically—is evidenced by the wave of anatomical exhibitions that currently attract record-setting crowds, the popularity of anatomically-themed art, and the numerous scenes of anatomical dissection which now appear in movies and on TV. The history of anatomy, *Dream Anatomy* argues, is everybody's history: we all think of ourselves as anatomical beings.

Elizabeth Fee, Ph.D., *Chief, History of Medicine Division*
National Library of Medicine

ix

ABOUT THE NATIONAL LIBRARY OF MEDICINE

The National Library of Medicine is the world's largest medical library. Located in Bethesda, Maryland, on the campus of the National Institutes of Health, the Library plays a major role in medical research, scholarship and the provision of medical information to the public and the health professions. Its collection includes more than seven million items—books, journals, technical reports, manuscripts, photographs, prints, films and ephemera. Housed within the Library is one of the world's finest collections of historical materials on health and disease, and the health sciences. The Library's History of Medicine Division has early manuscripts from the eleventh century on, more than 500 books printed before 1501, and more than 70,000 printed before 1801. It has a rich collection of prints, photographs, medical and health

films (from the silent era to the present), and modern manuscripts (1601 to the present), including the papers of many important scientists and leaders in the fields of biomedicine and public health. The Library also features exhibitions on medical and health topics, and hosts a variety of websites.

The *Dream Anatomy* exhibition opened at the Library on October 9, 2002 and ran until July 31, 2003. Many of the images featured in the exhibition, and in this catalogue, can be found on the World Wide Web at the following sites:

Dream Anatomy
http://www.nlm.nih.gov/dreamanatomy

Historical Anatomies on the Web
http://www.nlm.nih.gov/exhibition/historicalanatomies

Turning the Pages
http://archive.nlm.nih.gov/proj/ttp/intro.htm

Images In the History of Medicine
http://wwwihm.nlm.nih.gov

Anatquest (Visible Human Project images)
http://anatquest.nlm.nih.gov

Other Library websites can be found by going to:
http://www.nlm.nih.gov

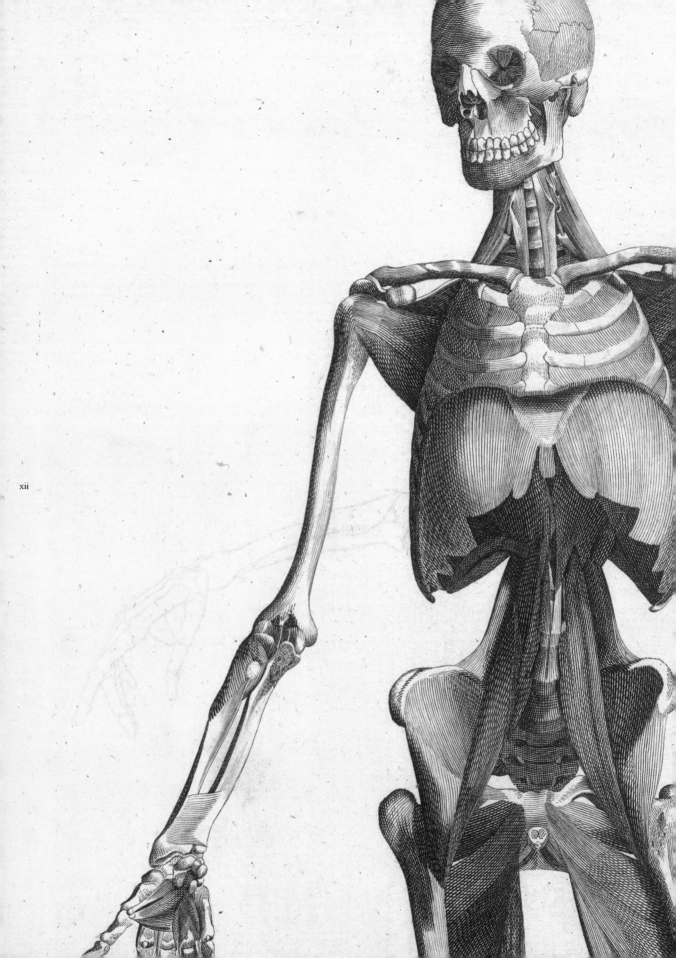

xii

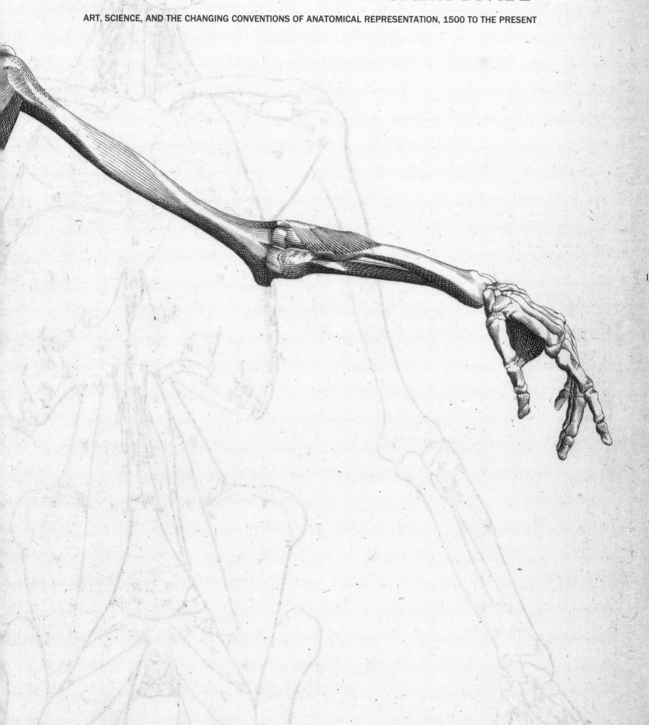

DREAM ANATOMIES AND THE GREAT DIVIDE

ART, SCIENCE, AND THE CHANGING CONVENTIONS OF ANATOMICAL REPRESENTATION, 1500 TO THE PRESENT

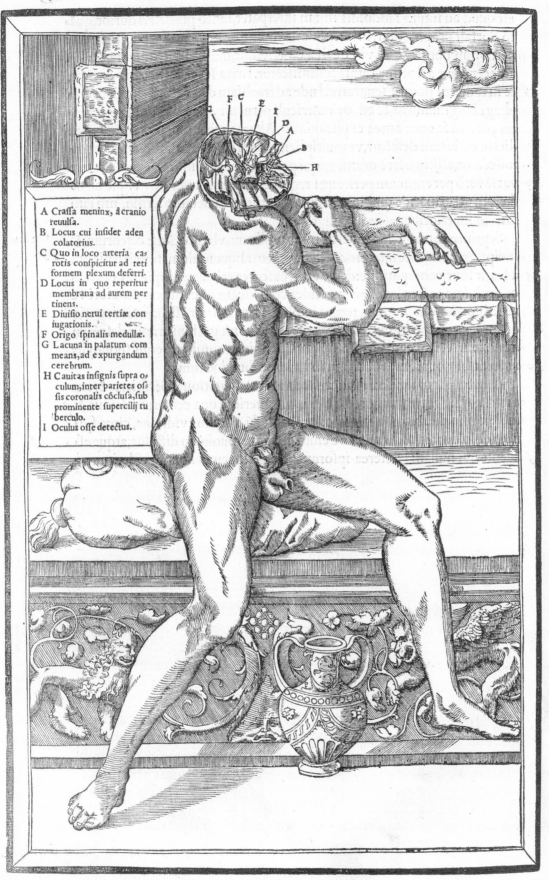

A Craſſa meninx, à cranio
 reuulſa.
B Locus cui inſidet aden
 colatorius.
C Quo in loco arteria ca-
 rotis conſpicitur ad reti
 formem plexum deferri.
D Locus in quo reperitur
 membrana ad aurem per
 tinens.
E Diuiſio nerui tertiæ con
 iugationis.
F Origo ſpinalis medullæ.
G Lacuna in palatum com
 means, ad expurgandum
 cerebrum.
H Cauitas inſignis ſupra o-
 culum, inter parietes oſ-
 ſis coronalis côcluſa, ſub
 prominente ſupercilij tu
 berculo.
I Oculus oſſe detectus.

ANATOMY IS US

. . . Let me be
Thy cut anatomie,
And in each mangled part
My heart you'l see.

—Richard Lovelace, 1659

This essay is about a set of longstanding issues in the history of anatomical representation. It is about the conventions that govern the collaboration between artists and anatomists, the setting of boundaries between art and anatomical science, the dialogue between artist and anatomist. And it is about how such matters affect, and even shape, our own conceptions of self, our ideas about what it means to be a person, our beliefs about who and what we are. The early illustrated anatomical treatises of the sixteenth and seventeenth centuries—the works of Johann Dryander, Charles Estienne, and even Andreas Vesalius's revolutionary 1543 *De humani corporis fabrica*—featured a rich ensemble of imaginary figurations and artistic embellishments, with much morbid humor, and literary and religious allusion. Sometime between then and now, something happened to anatomy. Nowadays scientific anatomies stick to a straight and narrow path: they don't allow for any deviations, any correspondences between the anatomical body and the moral world, the political world, the social world. They don't allow for any fun, don't permit, or acknowledge, the pleasures of anatomy.

All of this matters because it's personal. Anatomy is our inner reality. Anatomy is us. Even if we haven't formally studied it, even if we don't know all the details, we carry around with us an anatomical image of self, a pocket map that divides us into

3. Charles Estienne (ca. 1504–1564) [author]. Étienne de la Rivière (d. 1569) [anatomist]. *De dissectione partium corporis humani....* Paris, 1545. Page 250. Woodcut. National Library of Medicine.

Max Ernst and other 20th-century surrealists adopted Estienne's anatomical figures and their imaginary settings as icons of the alienated dream self and a forerunner of the new aesthetics of grotesquerie.

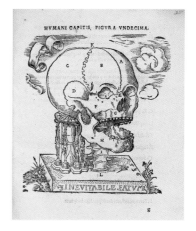

4. Johannes Eichmann (also known as Dryander; 1500–1560) and Mondino dei Luzzi (d. 1326) [anatomists]. *Anatomia Mundini, ad vetustissimorum....* Marburg, 1541. Humani Capitis, Figura Undecima. Woodcut. National Library of Medicine

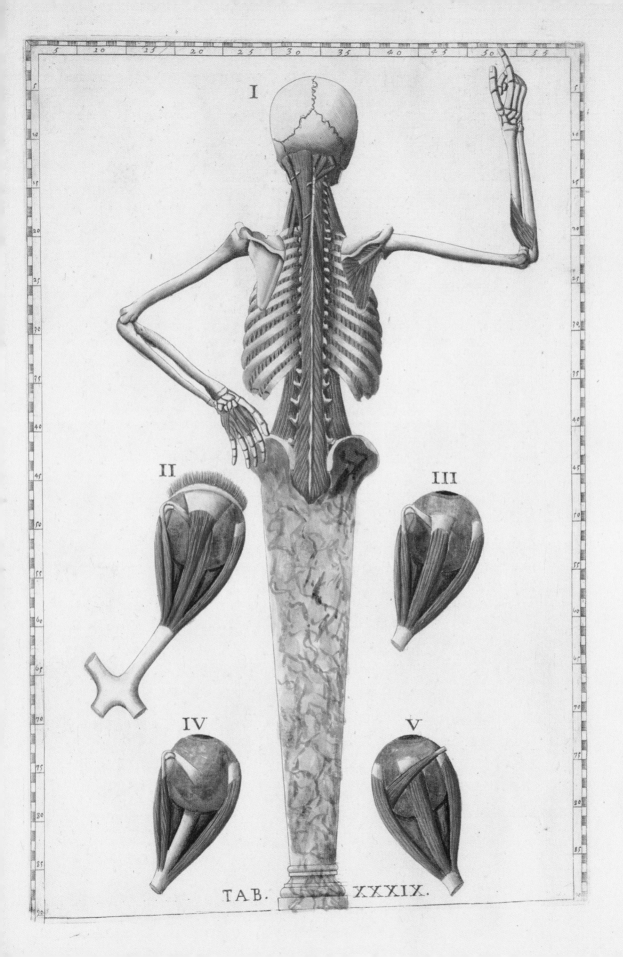

TAB. XXXIX.

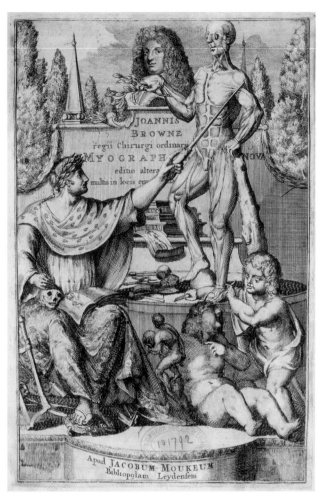

6

5

5. Bartolomeo Eustachi (d. 1574) [anatomist]. Giulio de' Musi (fl. 1535–1553) [artist]. *Romanae archetypae tabulae anatomicae novis....* Rome, 1783. Tab. XXXIX. Colored copperplate engraving. National Library of Medicine.

A skeleton jauntily turns its back on the reader. Its pelvis, fused to the top of a columnar pedestal, metaphorically suggests the structural function of hips and legs. The giant eyeballs and colorization are 18th-century additions.

6. John Browne (1642–ca. 1702) [anatomist]. *Myographia nova....* Leiden, 1687. Frontispiece. Copperplate engraving. National Library of Medicine.

Periwigged anatomist John Browne presides over a fanciful iconographic overview. Figures representing art, science, life, death, spirit, and matter all harmoniously take pleasure in the anatomical enterprise.

7. Paul Almasy [photographer]. *Machines of Modern Medicine.* Photograph. World Health Organization. National Library of Medicine.

8. Bartolomeo Eustachi (d. 1574) [anatomist]. Giulio de' Musi (fl. 1535–1553) [artist]. *Romanae archetypae tabulae anatomicae novis....* Rome, 1783. Titlepage. Copperplate engraving. National Library of Medicine.

A modern anatomist performs a dissection before figures that represent classical learning. In the foreground, dogs fight over the scraps.

9. Pietro Berrettini da Cortona (1596–1669) [artist]. *Tabulae anatomicae....* Rome, 1741. Tab. XVI. Copperplate engraving. National Library of Medicine.

A dissected man gazes on a picture of a dissection of the back of his head, a playful reference to anatomical self-consciousness. Dissections of the cranium and brain, visual quotations from Vesalius, float in the air and on the pediment.

regions and territories, with internal place names and borders and topographical features. And this anatomical self-image has a history—which is the history of anatomical representation—a long history of collaboration and negotiation between anatomists, artists, engravers, patrons, printers, and readers. Until the invention of X-ray imaging, sonograms, CT scans, MRIs, and the like, the only way to see into ourselves was through the dissection of dead human beings. The dissected cadaver was our mirror.

Early modern anatomists peered into that mirror—and made faces. A spirit of play pervaded the anatomy of Vesalius, and his predecessors and successors. They earnestly investigated our structure, tried to accurately describe and represent the body, but they also sought to entertain, morally instruct, and amaze students and colleagues and patrons and themselves, with a captivating charm. They were a feisty bunch, constantly challenging and insulting each other, trying to outdo each other with flashier dissections, and bigger, more expensive picture books, filled with more beautiful and artful and witty illustrations. In the pages of their books and in museum displays, anatomists were puppeteers who made their cadavers dance and pose. Anatomists dissected their cadavers and delivered their lectures in the pit of the anatomical theater, for audiences that included the local aristocracy, magistrates, and the clergy, as well as medical students and colleagues. The anatomist was a performer. Anatomy required showmanship.

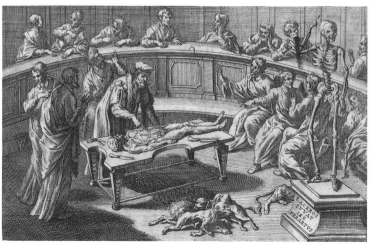

8

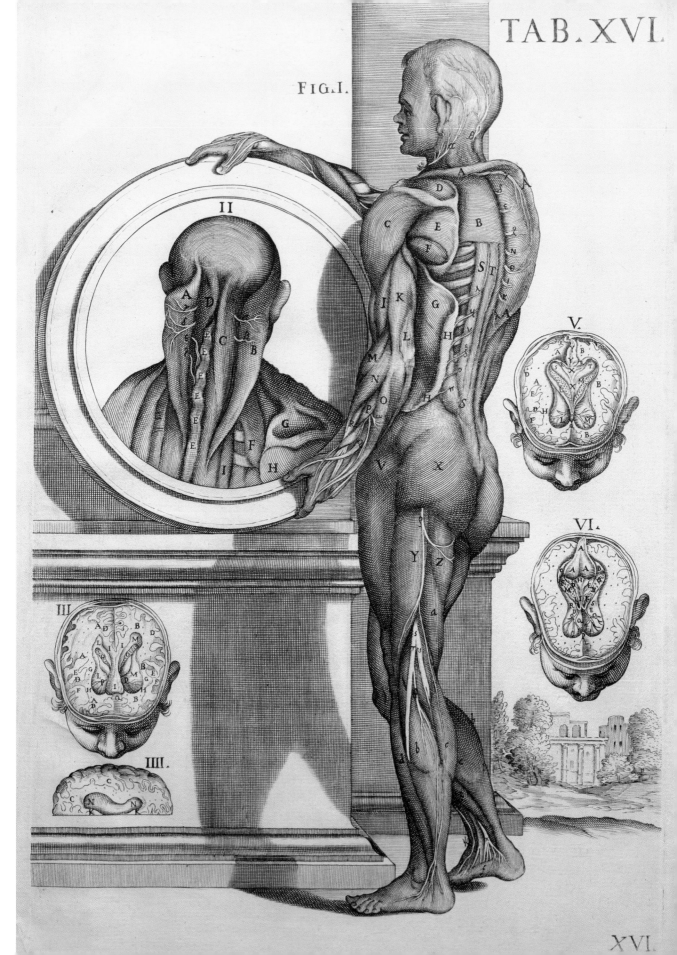

TAB. XVI.

FIG. I.

XVI.

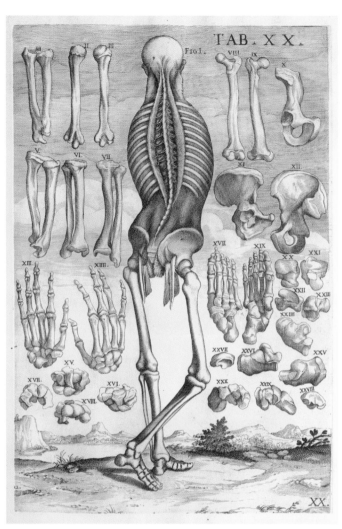

8

10. Pietro Berrettini da Cortona (1596–1669) [artist]. *Tabulae anatomicae novis....* Rome, 1783. Tab. XX. Copperplate engraving. National Library of Medicine.

Berrettini's exuberant figures partake of the theatricalism of baroque drama, dance, and court entertainments.

11. Frederik Ruysch (1638–1731) [anatomist]. Rosamond Purcell (b. 1942) [photographer]. Jar containing hand grasping the rim of an eyesocket, from the collection of B. S. Albinus (1697–1770). Leiden, early 1700s. Anatomical specimen. Boerhaave Museum, Leiden. Photograph, 1991. National Library of Medicine.

The specimens of early modern anatomists like Ruysch and Albinus typically feature bizarre juxtapositions and were designed more to astonish and entertain than to instruct.

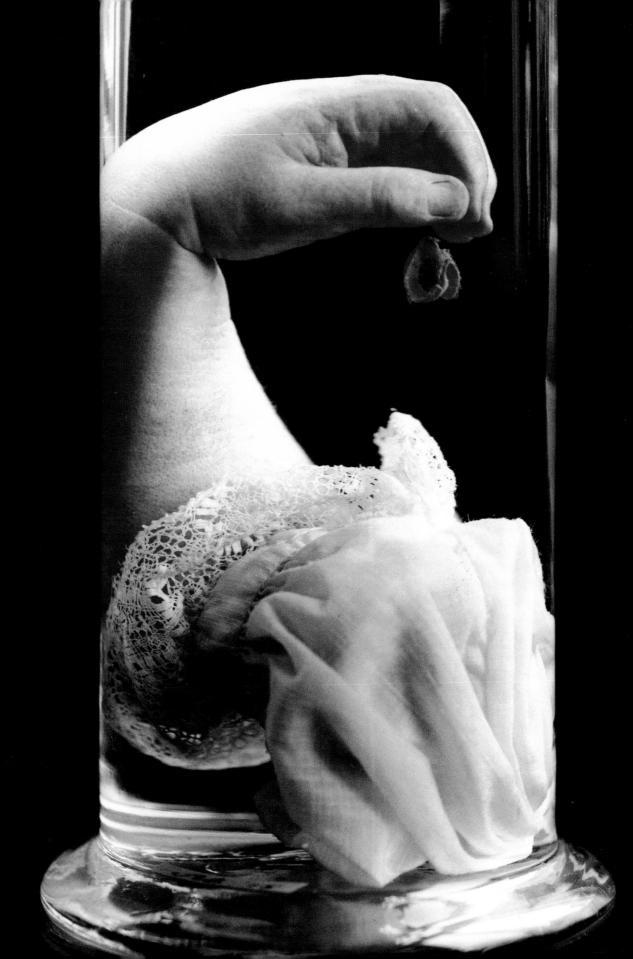

TAB. XIIII.

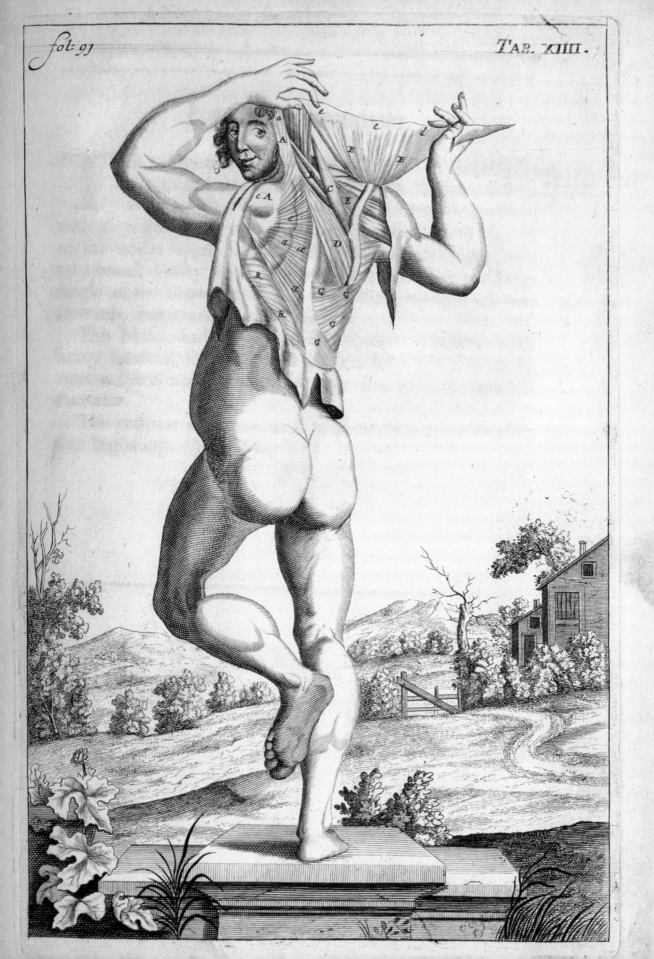

PLAYING WITH DEATH
FUN WITH SCIENCE

Our pictures… will give particular pleasure to those who do not have the opportunity of dissecting a human body or who… although fascinated and delighted by the study of man…, yet cannot bring themselves to ever attend a dissection.

—Andreas Vesalius, 1543

The anatomical revolution associated with Vesalius produced knowledge about the body through the medical appropriation and study of the dead. Anatomy was a dark science. It acquired its mystique from its willful transgressions of funerary custom, its incursions across the boundary that separates life and death. Anatomists took—often stole—dead bodies, cut them open, pulled them to pieces, read them aloud, encrypted them into a terminology of Greek and Latin, a shared secret.[1] Dissection became the preeminent ritual that inducted young men into the fraternity of medical knowledge. Medicine became something of a death cult.

12. John Browne (1642–ca. 1702) [anatomist]. *A compleat treatise of the muscles, as they appear in the humane body, and arise in dissection….* London, 1681. Tab. XIII. Copperplate engraving. National Library of Medicine.

13. Mansūr ibn Ilyās (fl. ca. 1390) [author]. *Tashrih-i badan-i insan.* Iran, ca. 1488. MS P18, folio 18A. Manuscript illustration. National Library of Medicine.

The crudely schematic illustrations in this rare Persian manuscript are not keyed to the text and it is unlikely that the artist actually ever witnessed a human dissection.

14. Andreas Vesalius (1514–1564) [anatomist]. Stephen van Calcar and the Workshop of Titian [artists]. *De humani corporis fabrica….* Basel, 1543. Page 472. Woodcut. National Library of Medicine.

De fabrica, the foundational text of modern anatomy, was written in Latin, the language of elite learning. Only a small group of scholars and gentlemen had the education and resources to gain access to the book.

11

13

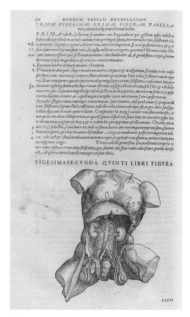

14

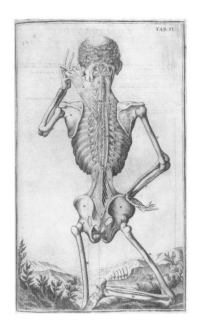

15. Giulio Casserio (ca. 1552–1616) [anatomist]. Odoardo Fialetti (1573–1638) [artist]. *Tabulae anatomicae….* Venice, 1627. Lib. IV, Tab. VI. Copperplate engraving. National Library of Medicine.

Early modern anatomical figures put on a *danse macabre* in which the dead mock the contrived gestures of the living.

12

Scientific anatomy, of course, was more than just dissection: it translated views of the body's interior from the dissecting table to the pages of a book, and back again to the dissecting table. Visual representation was one of the key innovations of the new science of anatomy. Ancient and medieval anatomical treatises consisted largely or entirely of written descriptions of the body; illustrations were rare (and, when they did supplement the text, crude and schematic). After Vesalius, the authoritative anatomical treatise had to be illustrated, had to have richly detailed and intensively captioned pictures of the dissected body and body parts. You couldn't just describe the complexity of the interior of the body, you had to show it.

And what was shown was the dead body. Early modern representations of the anatomical body took death head-on: the dead mocked the living; the living mocked the dead. The cadaver was an effigy of social types: the courtier, the flirt, the harlequin, the fecund woman, the heathen warrior. At the same time, the cadaver was Death, with a capital D. It served as a reminder of our mortality, our fallibility, our folly—the fragility of human life and civilization. Anatomy cited or parodied or augmented long-established iconic traditions and subjects—natural wonders, the classical ideal, *memento mori,* heraldry, *danse macabre,* Christian and classical martyrology—and newer genres such as still life, which featured human mortality as one of its tropes. Early modern anatomists and their artist collaborators made their work their pleasure and their pleasure their work. But it was morbid play, death play.

It was also a great deal of work—especially after Vesalius transformed the study of anatomy in the 1530s and '40s. Vesalius took unprecedented care in getting it right. He studied Galen, the great anatomist of antiquity, who for over a thousand years was considered the greatest authority on human anatomy. But unlike Galen, who only dissected animals, Vesalius dissected human

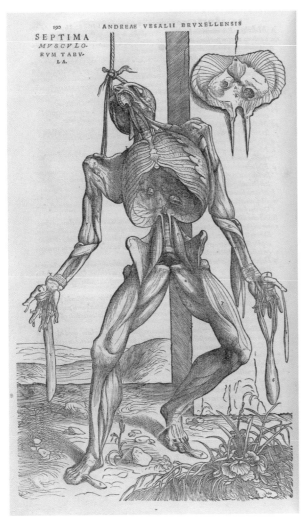

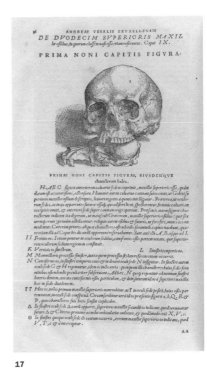

16

17

16–17. Andreas Vesalius (1514–1564) [anatomist]. Stephen van Calcar and the Workshop of Titian [artists]. *De humani corporis fabrica….* Basel, 1543. Woodcut. National Library of Medicine.

De fabrica's illustrations are keyed to alphabetical captions and commentary. The integration of image and text was a revolutionary innovation.

In the image on the right, a human skull sits atop that of a dog's skull, signifying that Galen mistakenly based his descriptions of human anatomy on his dissections of dogs and other animals.

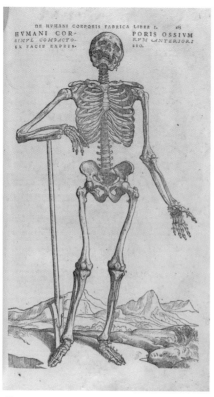

18

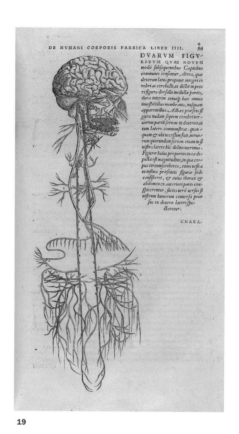

19

18–20. Andreas Vesalius (1514–1564) [anatomist]. Stephen van Calcar and the Workshop of Titian [artists]. *De humani corporis fabrica.…* Basel, 1543. Woodcut. National Library of Medicine.

Left, a skeleton digs its own grave.

bodies, and made a detailed study of his dissections. When he compared his observations to what Galen had written, the wisdom of the ages was in many instances overthrown. Vesalius *wrote* about the errors of Galen's ways. But he also made sure to *depict* them. The clincher was the illustration. Some were done in a highly finished naturalistic manner: here is the real body, they seem to say. Others, while taking care to be accurate, are less naturalistic. But naturalistic or not, there is much contrivance. Images with non-existent muscles make the point that Galen mistakenly described nonexistent anatomical structures. A human skull sits atop a dog's skull to signify that Galen erred because his knowledge of anatomy was obtained from the dissection of dogs and other animals, not

DECIMA
QVARTA
MVSCVLO-
RVM TA-
BVLA.

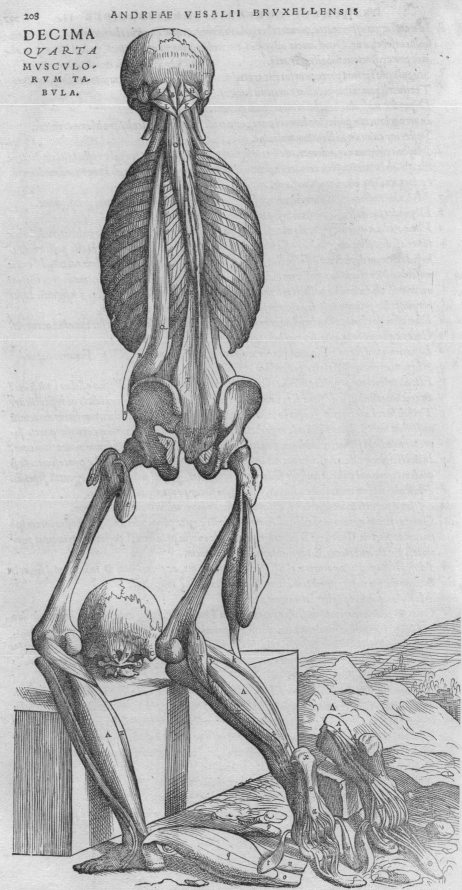

21. Giulio Casserio (ca. 1552–1616) [anatomist]. Odoardo Fialetti (1573–1638) [artist]. In Adriaan van Spiegel (1578–1625), *De formato foetu....* Padua, 1626. Tab. IIII. Copperplate engraving. National Library of Medicine.

A pregnant woman is dissected so that the flaps resemble petals of a flower, with the baby at the center.

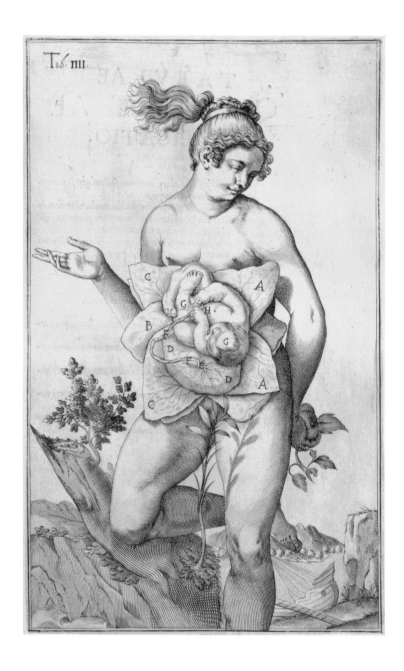

22

22. Amé Bourdon (ca. 1636–1706) [author]. Daniel Le Bossu (fl. 1671–1678) [engraver]. *Nouvelles tables anatomiques.* Paris, 1678. Table 8. Copperplate engraving. National Library of Medicine.

people. Still other illustrations combine naturalism with symbolic elements, serve as reminders of mortality, use anatomy to wittily illustrate common sayings, playfully enact visual metaphor, or set the cadavers in poses that dramatize their classical proportions or monstrosity. Neither Vesalius nor his artists could conceive of, or desire, a work governed entirely by austere naturalism. Quite the contrary, they wanted to entertain their readers and themselves. They responded to a pervasive cultural expectation that governed printed images in early modern Europe: the illustration should be, in some way, delightful, and should tell a story. So when Vesalius entered the scene, things got more scientific, but also wittier and more theatrical.

Between 1550 and 1700, anatomists and their illustrators took this cultural logic to new extremes: anatomy entered the Baroque. In this period, forms of theater, dance, and literature

23. John Browne (1642–ca. 1702) [anatomist]. *Myographia nova….* Leiden, 1687. Tab. XIII. Copperplate engraving. National Library of Medicine.

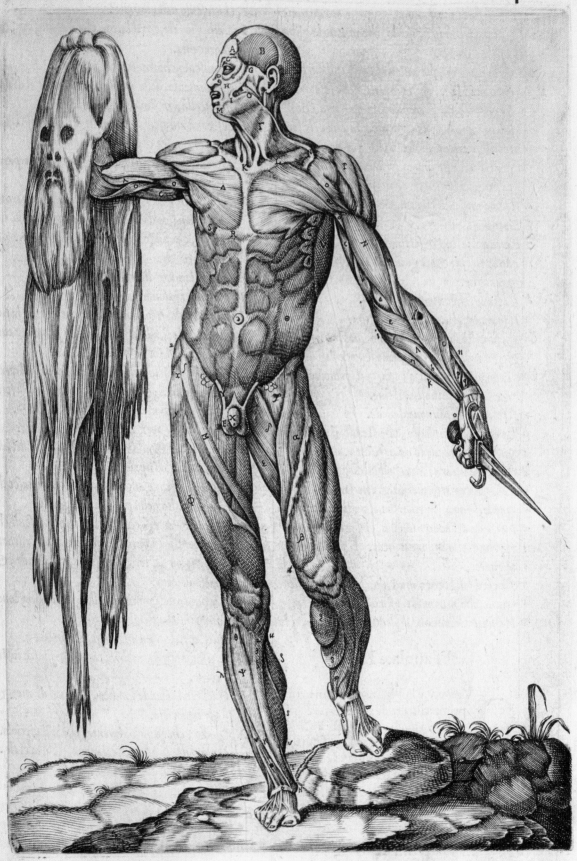

emerged that are recognizably modern: the ballet and opera, and all kinds of court entertainments. This was the era of Shakespeare, Montaigne, Molière, Donne, and Cervantes. It was a time in which great courts and salons and circles emerged, places where people vied to outdo each other, with manners and repartée and fashion and learning. And it was a time in which people began to perform, and develop, the idea of unique individuality and personality that literary historian Stephen Greenblatt calls "Renaissance self-fashioning." [2]

In their dissections, written works and book illustrations, early modern anatomists fashioned themselves, and modeled the fashioned self, in all its variety. The producers and audience for anatomical representation expected, even demanded, that anatomical illustration represent the human body morally, socially, theologically, theatrically, balletically, literarily, erotically as well as scientifically. Anatomists and their artists taught the moral and scientific truth of the human body, and fooled around for no reason other than to have fun. Early modern anatomical illustrations and objects operated in multiple dimensions of meaning, and served multiple functions. The anatomist studied dissected cadavers, and enjoyed manipulating and presenting them; readers and viewers studied dissected cadavers, and enjoyed looking. And this convergence of work and play, this multiplicity of function and meaning, was not problematic. [3]

24. Juan Valverde de Amusco (ca. 1525–ca. 1588) [anatomist]. Gaspar Becerra (1520?–1568?) [artist]. *Anatomia del corpo humano….* Rome, 1559. Page 64. Copperplate engraving. National Library of Medicine.

A flayed cadaver holds his skin in one hand and a dissecting knife in the other. The skin's distorted face has the appearance of a ghost or a cloud, suggesting that spirit has been separated from, or peeled off of, the fleshy inner man.

19

25. Pietro Berrettini da Cortona (1596–1669) [artist]. *Tabulae anatomicae….* Rome, 1741. Book open to page 38. Copperplate engraving. National Library of Medicine.

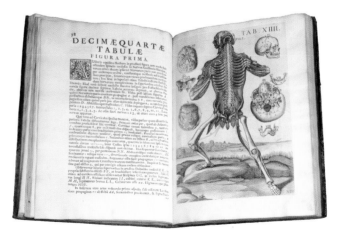

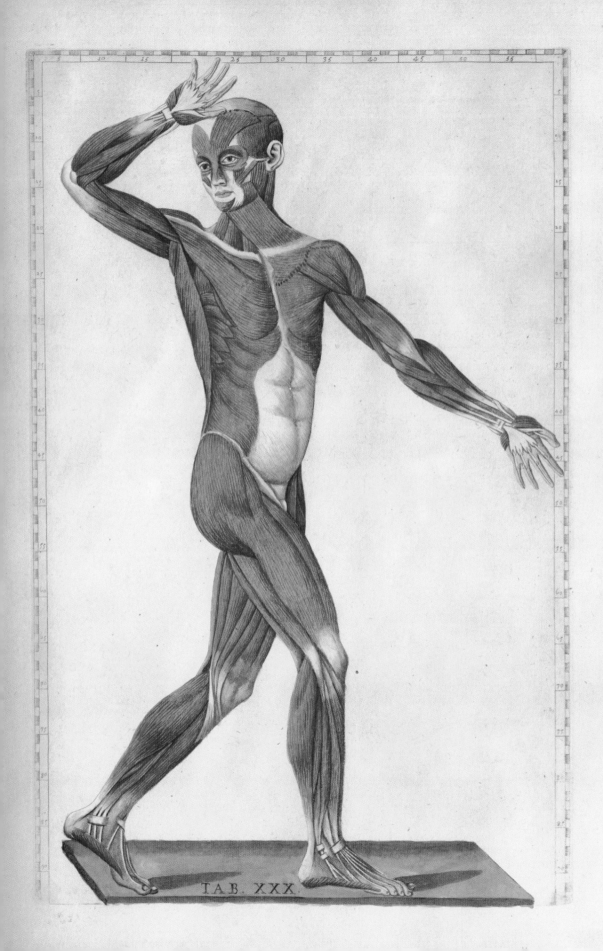

TAB. XXX.

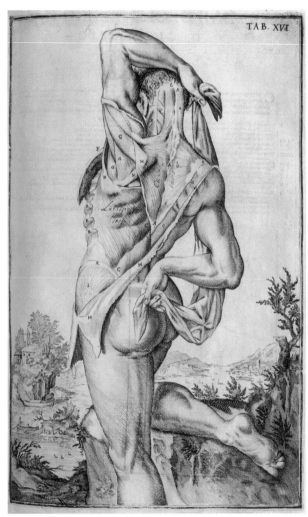

27

21

26. Bartolomeo Eustachi (d. 1574) [anatomist]. Giulio de' Musi (fl. 1535–1553) [artist]. *Romanae archetypae tabulae anatomicae novis....* Rome, 1783. Tab. XXX. Colored copperplate engraving. National Library of Medicine.

27. Giulio Casserio (ca. 1552–1616) [anatomist]. Odoardo Fialetti (1573–1638) [artist]. *Tabulae Anatomicae....* Venice, 1627. Tab. XVI. Copperplate engraving. National Library of Medicine.

Next page
28. Frederik Ruysch (1638–1731) [anatomist]. *Alle de ontleed-genees-en heelkindige werken....* Vol. 3. Amsterdam, 1744. Page 568. Etching with copperplate engraving. National Library of Medicine.

Ruysch's morbidly whimsical "repository of curiosities" included displays of infant and fetal skeletons, placed in landscapes of human and animal body parts.

29. Juan Valverde de Amusco (1525–ca. 1588) [anatomist]. Gaspar Becerra (1520?–1568?) [artist]. *Anatomia del corpo humano....* Rome, 1559. Page 95. Copperplate engraving. National Library of Medicine.

Viscera dissected not just through skin, but through a suit of Roman armor. The free-floating body parts on the right are copied from Vesalius.

DREAM ANATOMY

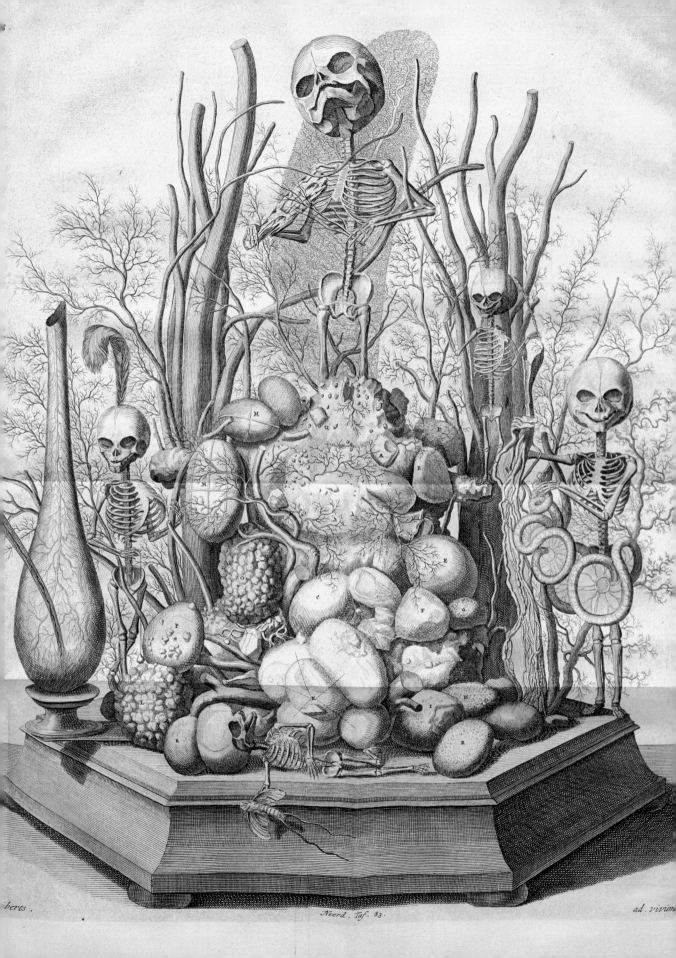

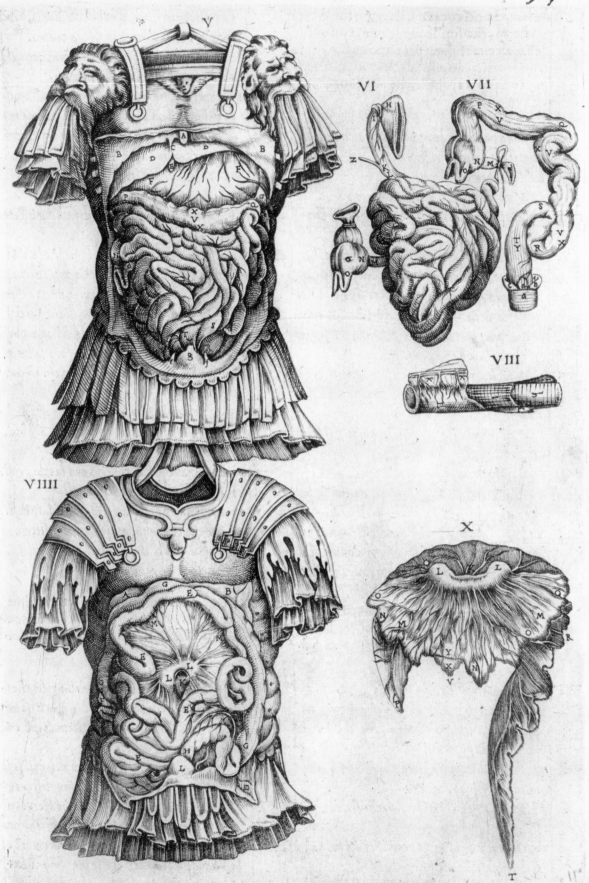

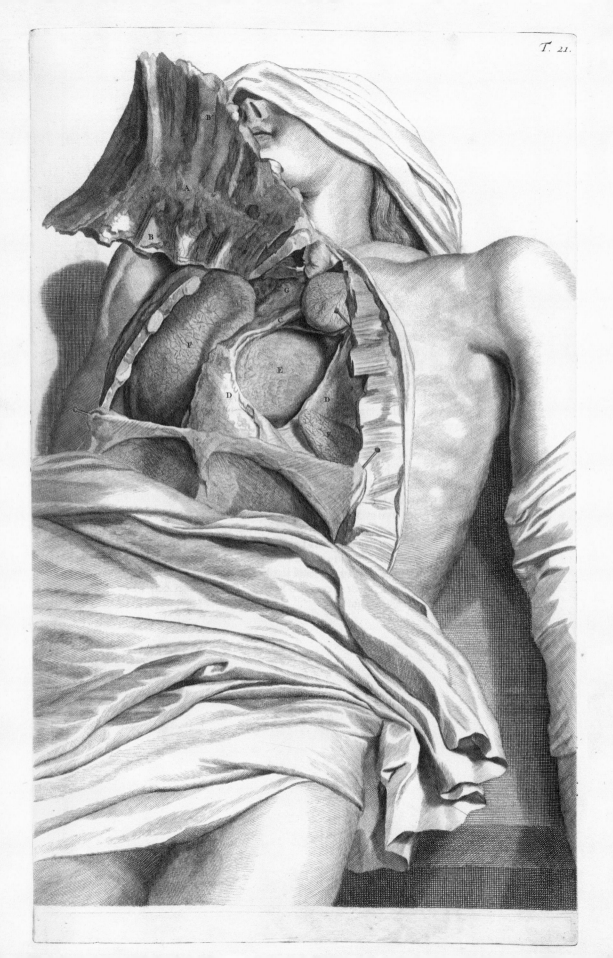

GETTING REAL

THE NEW AESTHETICS OF SCIENTIFIC ILLUSTRATION

Anatomical figures are made in two very different ways; one is the simple portrait, in which the object is reproduced exactly as it was seen; the other is a representation of the object under such circumstances as were not actually seen, but conceived in the imagination. . . . [T]he first . . . carries the mark of truth, and becomes almost as infallible as the object itself.

—William Hunter, 1774

Then it all changed. Between 1680 and 1800, the conventions, meanings, audience, and uses of anatomical representation shifted. Anatomists began to develop new criteria for what constituted acceptable scientific illustration. Play and the pursuit of truth became incompatible. The cadaver was no longer made to pose and dance. The artist was no longer asked or permitted to embellish the background, to provide fantasy architecture and landscapes for the anatomical figures to frolic in. The reader was no longer asked to meditate on human mortality. The high spirits and intoxicated humor of anatomical representation were no longer wanted. The structure of the body, in all its particularity and specificity, took up the entirety of representational space. Science, anatomists argued, needed to focus. Suddenly a boundary separated art and science—a rift that ran right through death and the dead body. Art and science came to be defined in mutually exclusive ways. That separation still has force today.

The boundary did not come out of whole cloth. In its origin it was only a potential in early scientific discourse, an unrealized plank in an unrealized program. In the sixteenth century, natural magic and natural philosophy were allies, but a century later that alliance fell apart. Like other seventeenth-century natural

30. Govard Bidloo (1649–1713) [anatomist]. Gérard de Lairesse (1640–1711) [artist]. *Ontleding des menschelyken lichaams....* Amsterdam, 1690. T. 21. Copperplate engraving with etching. National Library of Medicine.

philosophers, Francis Bacon engaged in polemics against the belief that similarities between things are causative or meaningful—one of the tenets of natural magic. Magic was condemned as superstition. This condemnation was a big net and representational art got caught: its stock and trade was allegory and metaphor. In *The Great Instauration* (1620), Bacon hoped to foster the emergence of a class of men "who aspire not to guess and divine, but to discover and know, who propose not to devise mimic and fabulous worlds of their own…." These seekers after truth, Bacon argued, would "examine and dissect the nature of this very world itself" and "go to facts themselves for everything." Bacon invoked anatomy as an exemplary science, a method of systematic observation and discovery that went beneath the surface of things and discerned the parts of a larger natural order that could only be known through detailed, piecemeal exploration. Not surprisingly then, Bacon deployed an anatomical trope ("examine and dissect the nature of this very world") in a polemic partly directed against the use of tropes in science.[4] More than four decades later, in his *History of the Royal Society,* Thomas Sprat defined scientific discourse in opposition to a metaphor-laden rhetoric and fancy phraseology:

> Who can behold, without indignation, how many mists and uncertainties,…specious Tropes and Figures have brought on our Knowledg[e]?…, this vicious abundance of Phrase, this trick of Metaphors, this volubility of Tongue…. [T]he only Remedy, that can be found for this extravagance …[is] to reject all the amplifications, digressions, and swellings of style: to return back to the primitive purity, and shortness, when men deliver'd so many things, almost in an equal number of words.[5]

Even so, in the 1660s, in both pictures and text, learned anatomies were full of "metaphors", "amplifications", "digressions" and "swellings of style."

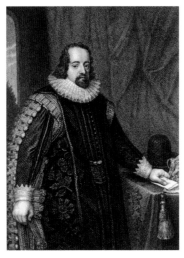

31. Edward Scriven (1775–1841) [artist]. *Francis Lord Bacon.* Copperplate engraving. National Library of Medicine.

32. Govard Bidloo (1649–1713) [anatomist]. Gérard de Lairesse (1640–1711) [artist]. *Ontleding des menschelyken lichaams….* Amsterdam, 1690. T. 14. Copperplate engraving with etching. National Library of Medicine.

The detailed depiction of the mutilation that dissection causes, along with the nails and pins that serve as prosthetic aids to anatomical study, demonstrate the unsparing realism of the new style of illustration initiated by Bidloo in collaboration with De Lairesse.

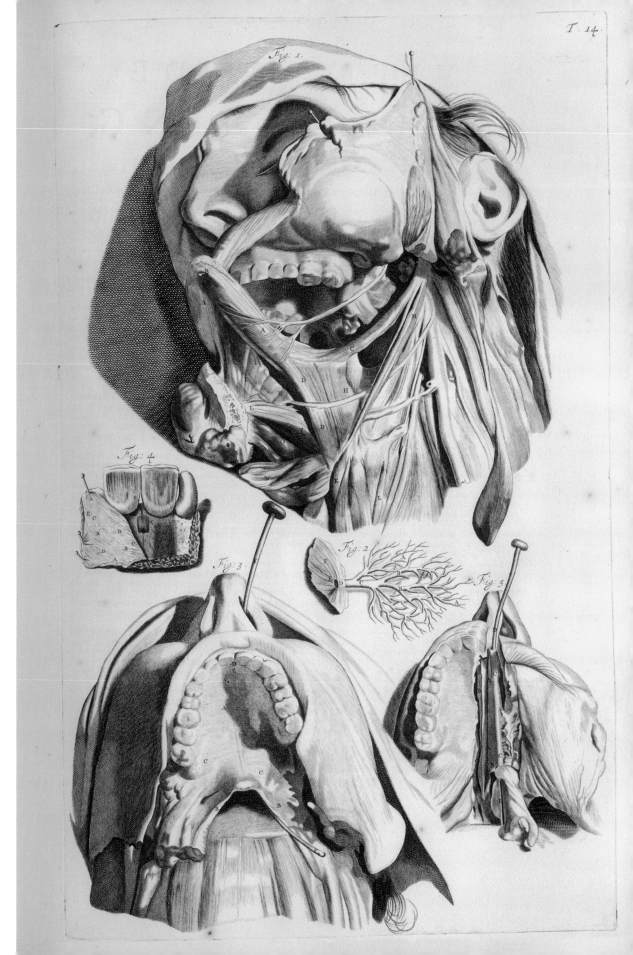

Fig: 1.

Fig: 4.

Fig: 3.

Fig: 2.

Fig: 5.

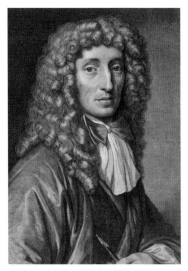

33. Govard Bidloo (1649–1713) [anatomist]. Gérard de Lairesse (1640–1711) [artist]. *Ontleding des menschelyken lichaams....* Amsterdam, 1690. Frontispiece portrait of Bidloo. Copperplate engraving with etching. National Library of Medicine.

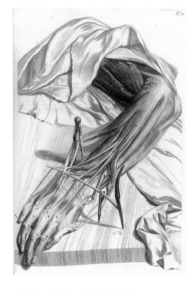

34. Govard Bidloo (1649–1713) [anatomist]. Gérard de Lairesse (1640–1711) [artist]. *Ontleding des menschelyken lichaams....* Amsterdam, 1690. T. 70. Copperplate engraving with etching. National Library of Medicine.

35. William Hunter (1718–1783) [anatomist]. Jan van Riemsdyk (fl. 1750–1788) [artist]. *The anatomy of the human gravid uterus.* Birmingham, 1774. Tab. VI. Copperplate engraving. National Library of Medicine.

Over the next hundred and fifty years, those niceties were expunged from anatomical discourse and illustration. The key text in the new anatomical realism was Govard Bidloo's 1685 *Anatomia humani corporis,* with illustrations by artist Gérard de Lairesse. Although Bidloo included a smirking skeleton holding an hourglass and artfully arranged anatomical still lives, he also featured images unlike any that had ever been printed. Dissected bodies and body parts are rendered in harshly realistic detail. The viewer is spared nothing: we see the raggedness of the flesh and the prosthetics of dissection (pins, hoists, ropes, the dissecting table) and mutilated faces. The overall effect is at the same time ugly and beautiful—Lairesse's illustrations, finely engraved by Abraham Blooteling and Pieter van Gunst, are absolute masterpieces of composition and texture—a disturbing nightmare anatomy. Later, William Hunter (with artist Jan van Riemsdyk) and Albrecht von Haller (with artist C. J. Rollinus) consolidated the new style and theorized it. They entirely excised death figures, symbols and grace notes. Like Bidloo, they concentrated on the particulars of a single, specific dissection of the body or body part—and tried to show it as the artist and anatomist saw it—there are no composites, no artistic embellishments. The new anatomy had a relentless gaze that seemed almost to terrorize its subjects and its viewers. There was also a technological corollary: the imperative to render precise views of the body made anatomists more reliant on technically masterful draftsmanship and sophisticated printing techniques such as etching and copperplate engraving which permitted more detailed representation. The drawings of Rollinus, Riemsdyk and Lairesse have an almost photographic quality, which suggests that they may have employed (or been influenced by) the camera obscura. Technological innovation and technical mastery encouraged the new hyper-realistic style, and vice versa.

28

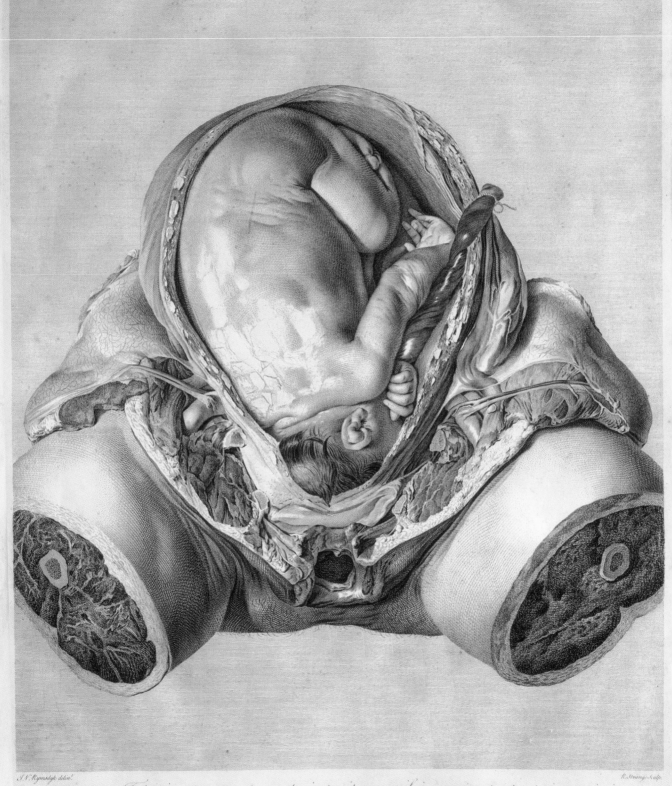

TAB. VI. *Fœtus in utero, prout a naturâ positus, rescissis omnino parte uteri anteriori,*
ac Placentâ ei adhærente.

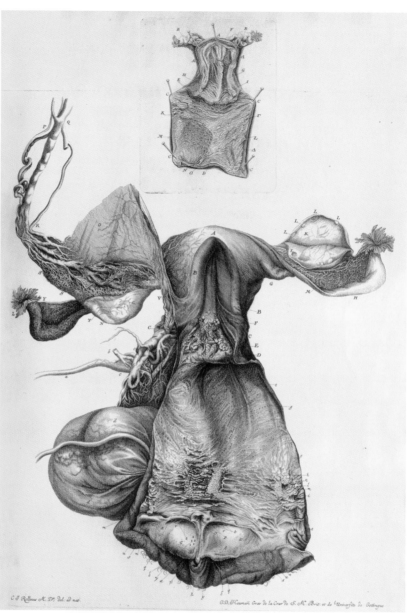

30

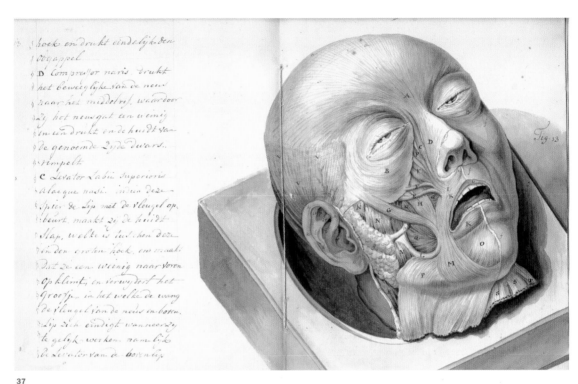

37

36. Albrecht von Haller (1708–1777) [anatomist]. C. J. Rollinus [artist]. *Icones anatomicae…* Vol. 2. Göttingen, 1756. Fascicle II, Lectori S, Figurae I and II. Copperplate engraving. National Library of Medicine.

37. Author/artist unknown. Anatomical and physiognomic study, Netherlands, ca. 1790. Manuscript. Pen and ink, with watercolor. National Library of Medicine.

In the 18th and 19th centuries, doctors and students often made paintings and drawings of their dissections, or copies from book illustrations, for private study. Such artwork was regarded as a form of intensive study.

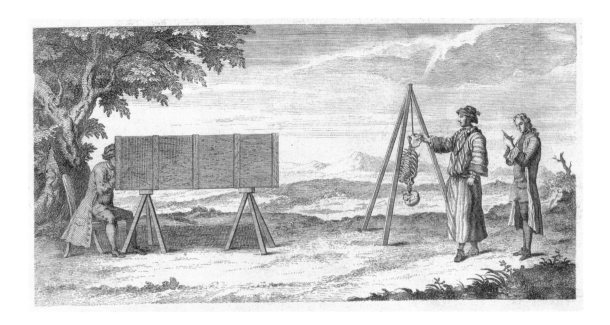

32

38. William Cheselden (1688-1752) [author]. Gerard Van der Gucht (1696–1776) [artist].
Osteographia. London, 1733. Titlepage. Copperplate engraving. National Library of Medicine.

An artist using a *camera obscura* to make a drawing of a specimen. The light going through
the pinhole at the back of the camera will project an inverted scene (the specimen is hung
upside down to compensate).

In thinking about realism, a term that was only coined in the early nineteenth century, art historians tell us: be careful. The goal of realism is to maintain an almost airtight correspondence between the visual representation and the subject of the representation, which often leads to the conflation of object with its representation. For example, talking about the material world, we sometimes point to a realistic drawing or photograph of a dissected body or some other object, and say something to the effect that "this is what is real"—even though the photograph or drawing is just an image, not the thing itself. To guard against this slippage, we need to remind ourselves that realism is a mode of visual representation that has particular characteristics, and technologies, and a particular history. Realistic images featured: abundant and extraneous detail; specificity of subject, place, time; the possibility of ugliness, accident, disorder; meticulously rendered textures, shadows, reflections, sometimes verging on *trompe l'oeil;* a ramped-up commitment to illusionistic perspective; and, above all, the intention of documenting what the eye sees (even if the scene is a contrived arrangement of objects, as in still life). Realism excluded: invention, metaphor, allusion, humor, schematic simplification, composite idealism. Realism was no fun.

Or rather a different order of fun. If the pleasures of wit, low comedy, dance, and allegory were no longer permitted in anatomical representation—if anatomy had to be serious or neutral in its public display—pleasure could never be entirely excluded. Instead it covertly lingered, even gained force, but only in certain unacknowledged and perverse registers: The pleasure of mastery

39. Govard Bidloo (1649–1713) [anatomist]. Gérard de Lairesse (1640–1711) [artist]. *Ontleding des menschelyken lichaams....* Amsterdam, 1690. T. 82. Copperplate engraving with etching. National Library of Medicine.

33

over death and the dead body; which was also the pleasure of mastery over oneself, the feeling of command that comes with the attainment of a high degree of clinical detachment. The pleasure of seeing, unveiled, sumptuary textures representing skin, breasts, back, legs and genitalia, especially of the female, a kind of anatomical voyeurism. The pleasure of mutilation, torment, and insult meted out to the anatomical subject; a malicious satisfaction in the anatomical violation of funerary honor (the privileges of social and intellectual rank). The pleasure of shocking the reader, who, unprotected from the nightmares of the dissecting room, suffers the momentary trauma of exposure to the ugliness and chaos of death, and to the interior of the body with its proliferating strangeness, asymmetries and contamination. Looking at Bidloo's *Anatomia,* we see disturbing echoes of sexual fetishism and political torture, a suggestion heightened by the creamy, sensual quality that Lairesse, the artist, and van Gunst and Blooteling, the engravers, impart (with amazing artistry) to the skin texture and shadows and folds of cloth. That the anatomical subject can be an object of desire, like the fruit in a still-life table arrangement, is a not very hidden potential in Bidloo's anatomy.

The erotics of anatomy, however, were not confined to the hyper-realistic style. Throughout much of the early modern period, dissection was regarded as a kind of undressing of the body (and sometimes a rape of the grave), and the anatomical illustration was the only legitimate domain in which male and female genitals could receive detailed representation. The anatomical illustration, by virtue of its proximity to the illegitimate domain of pornography, had a glow, a tingle. This potential was made

34

40. Govard Bidloo (1649–1713) [anatomist]. Gérard de Lairesse (1640–1711) [artist]. *Ontleding des menschelyken lichaams....* Amsterdam, 1690. T. 30. Copperplate engraving with etching. National Library of Medicine.

The cord around the wrists and rope around the neck are here used to help position the cadaver for the convenience of the anatomist and artist.

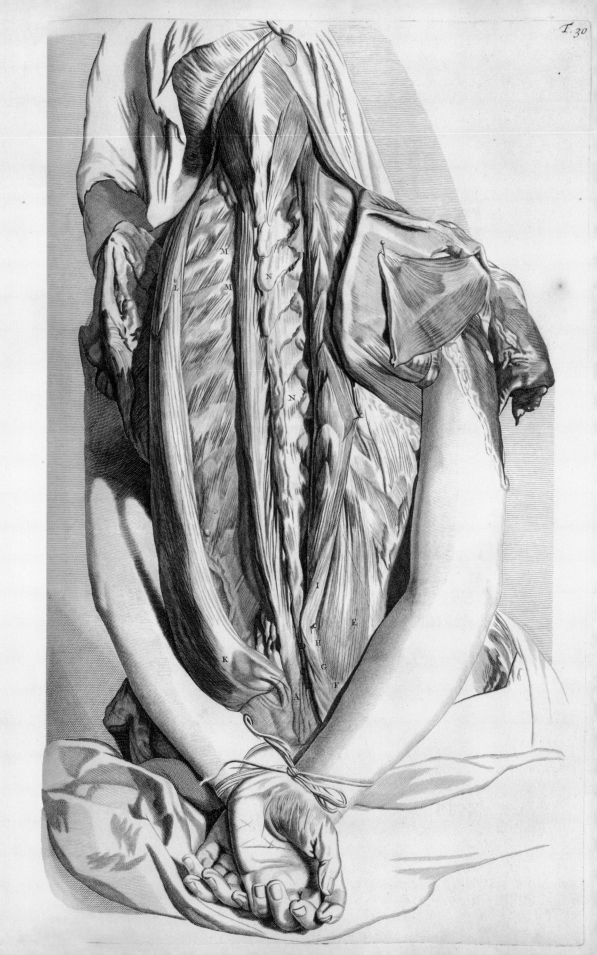

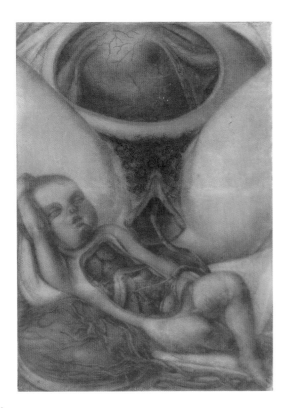 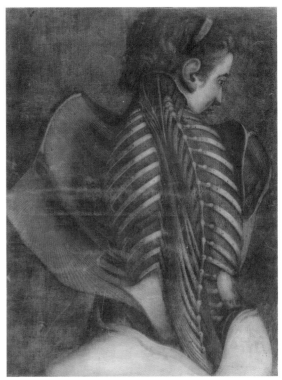

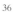 36

41. Jacques Fabien Gautier d'Agoty (1717–1785) [artist; printer]. *Anatomie générale des viscères en situation....* Paris, 1752. Planche 9. Color mezzotint. National Library of Medicine.

42. Jacques Fabien Gautier d'Agoty (1717–1785) [artist; printer]. *Myologie complette en couleur et grandeur naturelle....* Paris, 1746–1748. Fig. 14. Color mezzotint. National Library of Medicine.

Gautier D'Agoty's spectacular anatomical mezzotints showed off his mastery of innovative color print technology.

manifest in the work of Jacques Fabien Gautier D'Agoty, an artist and printer, not an anatomist, who reveled in the grotesquerie and eroticism of the dissected body. Although sometimes clumsily rendered, his technically masterful mezzotints transgressively point to the convergence of death, pathology, sex, and monstrosity through a bravura deployment of lurid colors and creamy textures, and, in some works, monumental scale. You didn't need to have anatomical realism to have anatomical eroticism. But Gautier's sensationalist approach was atypical—he was an innovative master printer who used extravagant images of the dissected body and body parts to show off his command of the art and technology of printing (and thereby gain patronage in high places; for his pains he was awarded an aristocratic title by the king). Gautier employed anatomists, but usually it was the other way around: the anatomist employed the artist. And, in mid and late eighteenth-century Europe, coolly detached realistic depiction was the most prestigious mode of anatomical representation, a celebrated cultural achievement.

This is not to say that art and aesthetics were completely expunged from the realistic school of anatomical illustration as handed down from Bidloo to Hunter and Haller—only a particular kind of art and aesthetics. The artful representation of anatomical objects remained a crucial part of the science of

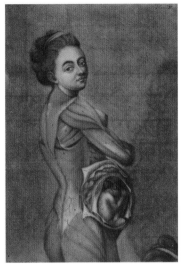

43. Jacques Fabien Gautier d'Agoty (1717–1785) [artist; printer]. *Anatomie des parties de la génération de l'homme et de la femme.* Paris, 1773. Plan. V. Color mezzotint. National Library of Medicine.

anatomy. Anatomists continued to work with artists, and continued to value high artistry, but only of one type: the art of the real. In the waning years of the eighteenth century, the Scottish anatomist John Bell marked the change, truculently denouncing "the vitious practice of drawing from the imagination," instead of "truly from the anatomical table." Bell hated anatomical figures

> formed from the imagination of the painter merely; sturdy and active figures, with a ludicrous contrast of furious countenances, and active limbs, combined with ragged muscles, and naked bones, and dissected bowels, which they are busily employed in supporting…or even demonstrating with their hands.[6]

His solution to the "continual struggle between the anatomist and the painter" was to get rid of the artist entirely and do his own (notably harsh) illustrations (which, to our eyes, have a naïve, almost lurid, crudity). Bell's colleagues didn't, or couldn't, follow his example: they ceded representation to artists, but took complete command of the iconography. The artist, who had almost always been intellectually and socially subordinate to the anatomist, lost creative control, even of the margins.

But why did this rupture between science and art happen? And why in northern Europe, between the 1680s and 1800? What forces were at work? Where should we look for causes? Literary historian Richard Sha argues that medical authorities like William Hunter experienced, or were responding to, some kind of "epistemological panic," a crisis of cultural authority and representation, which in turn intensified the need to visibly demonstrate learned medicine's power to describe and understand the human body.[7] If so, it was a crisis of long duration. Historians tell us the scientific revolution of the 1600s—the natural philosophy

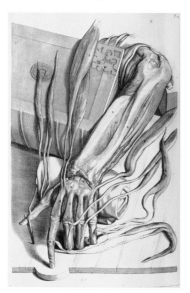

44. Govard Bidloo (1649–1713) [anatomist]. Gérard de Lairesse (1640–1711) [artist]. *Ontleding des menschelyken lichaams….* Amsterdam, 1690. T. 71. Copperplate engraving with etching. National Library of Medicine.

A dissected arm emerges from a book, iconographically signifying that true anatomical knowledge comes from dissection of the human body and from the production of books based on such dissections.

38

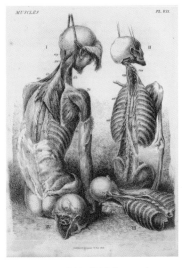

45. John Bell (1763–1820) [anatomist; artist]. *Engravings of the bones, muscles, and joints, illustrating the first volume of the anatomy of the human body.* 2nd ed. London, 1804. Plate VII. Etching. National Library of Medicine.

Bell criticized "the subjection of true anatomical drawing to the capricious interference of the artist, whose rule it has too often been to make all beautiful and smooth, leaving no harshness" His own drawings and etchings are notably harsh.

of Descartes, Bacon, Boyle, and Newton, the founding of the Royal Society and other early institutions of science—was in part a reaction to anxieties produced by the devastating religious wars between Protestants and Catholics, and among various Protestant sects, a reaction to civil and theological turmoil.[8] In response to radical religious attacks on established hierarchies, inequitable economic relations, and theological orthodoxies—attacks that were authorized by claims of divinely inspired revelation—an elite network of educated and ingenious gentlemen, in collaboration with a flourishing and ambitious artisanal class, developed a method for discerning the true nature of phenomena, based on careful empirical observation and experimentation. The new science was a means of acquiring knowledge, but also of legitimating (and delegitimating) an order of things that was seen as natural, political and theological. In sequestered spaces, away from the violent struggles of competing religious sects, social groups, political factions, dynasties and nations, the natural philosopher could produce and accumulate dependable knowledge of the material world: unadorned, sober, reliable facts. And one of the models of the new science was anatomy, which in turn received and adopted

40

46. Govard Bidloo (1649–1713) [anatomist]. Gérard de Lairesse (1640–1711) [artist]. *Ontleding des menschelyken lichaams....* Amsterdam, 1690. T. 89. Copperplate engraving with etching. National Library of Medicine.

Bidloo wanted to show the anatomical object just as the artist sees it, but also included a few illustrations in the popular *still-life* genre (which sometimes used anatomical objects as symbolic reminders of human mortality and signifiers of the new science).

the new ethos of the natural philosophers in its representational style: an almost fetishistic attachment to descriptive detail, the picture as visual observation and documentation of study.

But this explanation assumes that politics, theology, and philosophy exercised a superordinate influence on anatomical illustration. It doesn't reckon with picture-making and picture collecting as a cultural practice, and doesn't account for the cultural origins of the realist aesthetic. In the 1600s and 1700s, artists vied to make ever more realistic portraits, scenes of everyday life, and depictions of still-life table arrangements. This intensifying aesthetics of realism emerged from the demands of the marketplace, from competition between collectors of art — members of hereditary, civic, commercial and religious elites — for ever more spectacular trophies of painterly virtuosity to adorn their homes, and civic and religious spaces. And from collectors' desire to represent themselves, their possessions and civitas within the frame of the picture. The competition between collectors in turn

fostered competition between artists to show off their technical abilities in realistic representation to gain attention from patrons and buyers of art, as well as the public and colleagues. (A similar competition occurred among humanist scholars and among anatomists for collegial recognition, patronage, and readers.)

This was a situation that especially obtained in the Low Countries (present–day Netherlands and Belgium). In the course of the seventeenth-century, having secured independence from Spain, the Netherlands emerged as a vibrant center of world trade, and entered into a period of dazzling prosperity. It also emerged as the center of a particularly brilliant style of realistic depiction—the art of Vermeer, Ter Borch, Bailly, Van Eyck. According to art historian Svetlana Alpers, in the Italianate tradition of Renaissance painting, the "world was a stage on which human figures performed significant actions based on the texts of the poets" or scripture. Renaissance painting was "a narrative art." [9] But seventeenth-century Dutch painters, Alpers tells us, wanted to render what the eye saw, not tell a story. The artist gifted with technical mastery regarded himself as an instrument for reproducing views, and therefore producing knowledge, of the physical world. Picture-making was "the art of describing": the "discovery of the world and…crafting of it" were "presumed to be as one." [10] This was a congenial aesthetic for early modern anatomy and some of its origins can be found in Vesalius, who famously argued that the body can only be known in all its exact particulars through dissection, commentary and illustration. *De fabrica,* we should remember, served not only as a founding text for scientific anatomy, but also for art anatomy. The final book of *De fabrica,* on

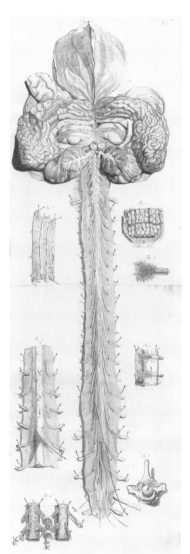

41

47. Govard Bidloo (1649–1713) [anatomist]. Gérard de Lairesse (1640–1711) [artist]. *Ontleding des menschelyken lichaams....* Amsterdam, 1690. T. 10. Copperplate engraving with etching. National Library of Medicine.

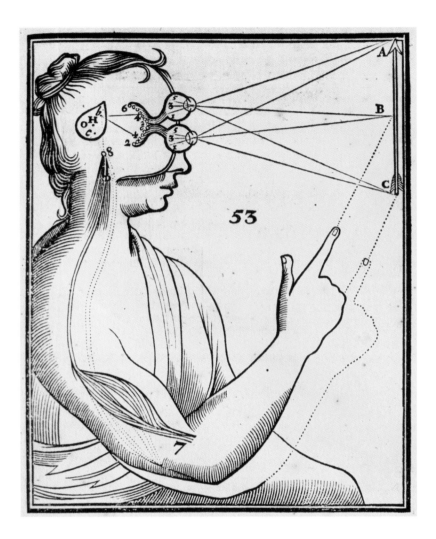

48. René Descartes (1596–1650) [author]. *Tractatus de homine, et de formatione foetus....* Amsterdam, 1677. Woodcut. National Library of Medicine.

A diagrammatic sketch of the translation of image from eye to brain—the physiological equivalent of a camera obscura.

the anatomy of the brain, features especially realistic images that perhaps anticipate the Dutch emphasis on hyper-realism; the artist attempts to render what he sees, even the cadaver's face with all its particularities, as it sits on the table.

But Dutch artists took realism much further. Dutch painting and the new science of Bacon and Boyle were nurtured at the same breast, and imbibed the same ethos. Still-lifes often featured natural objects, obtained from voyages of trade and discovery, that were part of philosophical collections: coral, feathers, skulls and bones. Simon Luttichuys' still-life of ca. 1635 depicts the convergence of realist art, anatomy and Baconian science, by showing a table arrangement that includes an anatomical book (opened to an illustration derived from Vesalius), along with painted and drawn portraits, a globe, human skull, and convex mirror.[11] Anatomists lagged behind artists by a few decades, but between 1685 and 1800 they gradually adopted the visual vocabulary of Netherlandish pictorial realism. (In the eighteenth century, when England and Scotland emerged as centers of anatomical study, many of the British anatomists who attained wide influence did so in collaboration with Dutch artists and engravers.) An apparent paradox then: The aesthetics of realism played a role in encouraging the exclusion of aesthetic elements in anatomical art—an exclusion that became the defining characteristic of the new style of anatomical representation. The influence also traveled in the opposite direction. If, as Alpers argues, the artist thought of his eye as a camera obscura that transferred views of the physical world onto his brain, and from there through his hand to paper or canvas—and so produced knowledge—then natural philosophy (which sought to purge itself of aesthetic elements) played a role in theorizing the aesthetics of Dutch realism.[12]

But this still only defers the larger question: at the level of day-to-day practice, what was going on in seventeenth- and

49. Andreas Vesalius (1514–1564) [anatomist]. Stephen van Calcar and the Workshop of Titian [artists]. *De humani corporis fabrica*…. Basel, 1543. Page 605. Woodcut. National Library of Medicine.

Vesalius's *De fabrica* laid the foundation for the new anatomical realism. The illustrations dealing with the anatomy of the brain are especially naturalistic, even showing the identifiable features of a face.

43

Tab. II Conspectus viscerum abdominalium a latere dextro partibus continentibus Thoracis, et Hypochondrii ac maxima omento parte sublatis.

50. William Hunter (1718–1783) [anatomist]. Jan van Riemsdyk (fl. 1750–1788) [artist]. *The anatomy of the human gravid uterus.* Birmingham, 1774. Tab. II. Copperplate engraving. National Library of Medicine.

An eminent anatomist and "man-midwife", Hunter focused on a specific topic (late pregnancy) and a single "subject" (a woman who died near the end of term). Illustrations that represent only "what was actually seen," he argued, carry "the mark of truth" and are "almost as infallible as the object itself."

eighteenth-century Europe, and especially the Netherlands, that fostered this cultural valuation of realistic images in anatomical illustration and art generally? Here, I would like to suggest that the cognitive changes manifest in the new aesthetics and practice of realistic art were fostered by emergent market practices, emergent social identities, emergent public spheres, and the ongoing process of state formation. In early modern economic exchange, voyages of discovery and trade, war, and the social world of courts, voluntary associations, coffeehouses, taverns and salons—all proliferating features of European life—there was a growing appreciation of the need to differentiate the real and the true (reliable and profitable information) from delusion, superstition, and falsification. A realistic appraisal of the material and social world was seen as necessary and proper to the successful pursuit of commerce, conquest, and social standing.

At the same time, as new persons and social groups prospered in an increasingly prolific economy and culture of consumption, there was also a new valuation of, and pleasure in, texture: not just the textures of cloth, wood, and food (which loom large in seventeenth-century Dutch painting), but also the representation of texture in painting, printing, drawing, and sculpture. Added to this was a new valuation of the finer things in life and in art, especially the demanding techniques of naturalistic representation.

And, finally, there was a concomitant growth of cultural practices of valuation. People were increasingly assessing, and devising means of assessing, the value of things, increasingly engaging in a spoken and written discourse of evaluation. The ethos of critical thinking and connoisseurship that flourished in Renaissance Europe intensified, part of an expanding culture of buying, trading, speculation, consumption, and self-fashioning presentation of possessions and self.

None of these things exactly caused the development of new standards and ideals of anatomical representation—but all of them contributed to the atmosphere that nourished it. By the

51. Albrecht von Haller (1708–1777) [anatomist]. C. J. Rollinus [artist]. *Icones anatomicae…* Vol. 2. Gottingen, 1756. Fascicle III, Tab. V. Copperplate engraving. National Library of Medicine.

52. Philipp Galle (1537–1612) [author]. Johann Collaert (d. ca. 1622) [artist]. *Conspicilla.* Photoprint of an engraving. National Library of Medicine.

In the 17th century, Holland became a center of world trade and experienced a "golden age" of prosperity and cultural creativity.

45

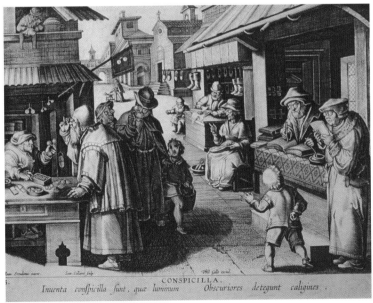

CONSPICILLA.
Inuenta conspicilla sunt, quae luminum Obscuriores detegunt caligines.

52

53. Bernhard Siegfried Albinus (1697–1770) [anatomist]. Jan Wanderlaar (1690–1759) [artist]. Andrew Bell (1726–1806) [engraver]. *Tabulae sceleti e musculorum corporis humani.* Edinburgh, 1777. Tab. IV. Copperplate engraving. National Library of Medicine.

54. Bernhard Siegfried Albinus (1697–1770) [anatomist]. Jan Wandelaar (1690–1759) [artist]. *Tabulae sceleti e musculorum corporis humani.* London, 1749. Tab. IV. Etching with copperplate engraving. National Library of Medicine.

end of the eighteenth century, at the highest echelon of anatomical achievement, realism prevailed. One telling example: in the 1740s and '50s, anatomist B. S. Albinus was lauded for the precision, beauty and grandeur of his anatomical plates, which were the largest ever published. People marveled at the anatomical figures (the product of a long collaboration with Dutch artist Jan Wandelaar), and also at the fanciful, extravagant backgrounds that they were posed in. But by the late eighteenth century this marriage of anatomy and fancy could no longer be justified. Later editions omit the backgrounds.

The triumph of anatomical realism was not, however, the end of history. Toward the end of the eighteenth century another anatomical style emerged, which featured composite, idealized, and often intensely colored views of the body. In this style, bodies and body parts floated in air, free of all context: anatomy was cleansed of its association with death. The process of dissection was expunged; the prosthetics of dissection and the dissecting table were suppressed. Everything except the body or body part was regarded as a distraction. The particularity of the dissection and of the view that the eye sees, so prized in the harsh style, itself becomes an obstacle to the truth: a specific body always has pathologies and idiosyncrasies that obscure the "general" or "typical" characteristics of bodies, organs, and systems. But the distinction between anatomical realism and universalism was not absolute. Some works featured both styles, or had illustrations that blended the two; and most universalist works retained the realistic emphasis on precise detail.

The other hallmark of the new universalist style was the use of color to visually separate out the parts. In the late eighteenth century this was a difficult task: Gautier's mezzotint process demanded a degree of technical virtuosity that was nearly impossible to imitate. In the early nineteenth century, John Lizars and

TAB. IV.

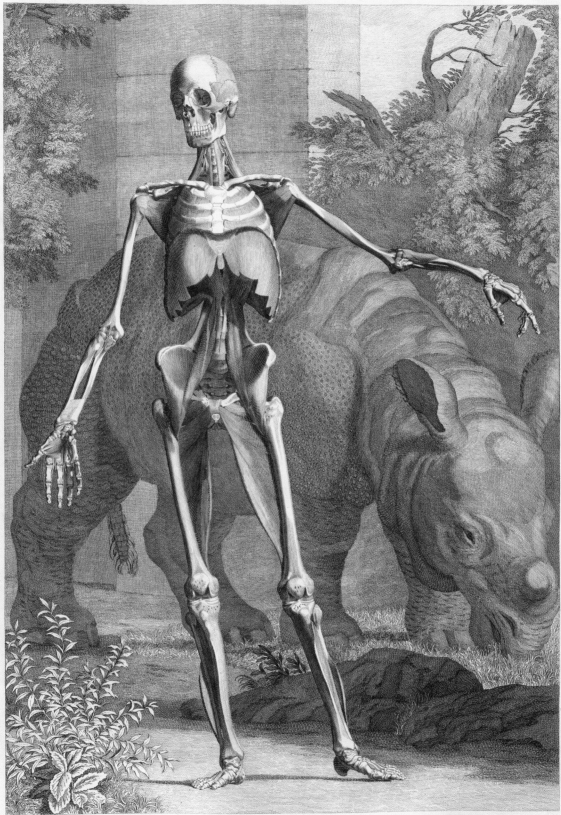

C. Grignion Sculp.

Impensis I. & P. Knapton Londini. 1747.

Paolo Mascagni used other methods, highly demanding and labor intensive, but with the development of chromolithography and other commercially feasible technologies of color printing, the universalist style took off. Anatomists continued to produce works in the mode of anatomical realism, especially in pathological and surgical anatomy—and many cheap medical books continued to recycle crude woodcut illustrations derived from much older works, even Vesalius—but by the 1830s and '40s, anatomical universalism began to predominate. It is familiar to us as the style of *Gray's Anatomy* and as the style of the most widely circulated twentieth-century anatomies.

Both anatomical realism and anatomical universalism suppressed iconographic, theatrical, and ornamental elements. Science dealt with the real, with the truth of the body and the physical universe. Art was given everything else: moral truth, history, aesthetics, embellishment, metaphor, myth. The seventeenth- and

55. Jean Baptiste Sarlandière (1787–1838) [author]. Louis Courtin (fl. 1809–1841) [artist]. *Anatomie méthodique....* Paris, 1829. Plate 13. Chromolithograph. National Library of Medicine.

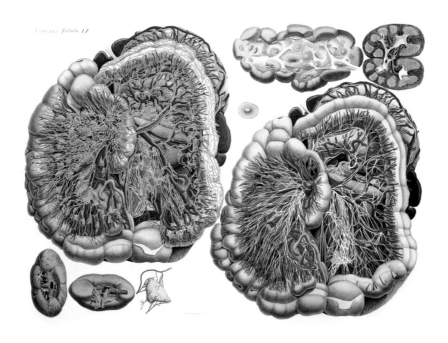

56. Paolo Mascagni (1755–1815) [anatomist]. Antonio Serantoni (1780–1837) [artist].
Anatomia universale.... Pisa, 1823–1832. Viscera. Tabula VI. Overprinted and hand-
colored copperplate engraving. National Library of Medicine.

A gifted anatomist, Mascagni produced a comprehensive and unprecedented series
of brilliantly colored, oversized, anatomical plates. In the omission of background and
intensive use of color, his anatomical figures exemplify the new free-floating style of
anatomical representation.

Tab. III.

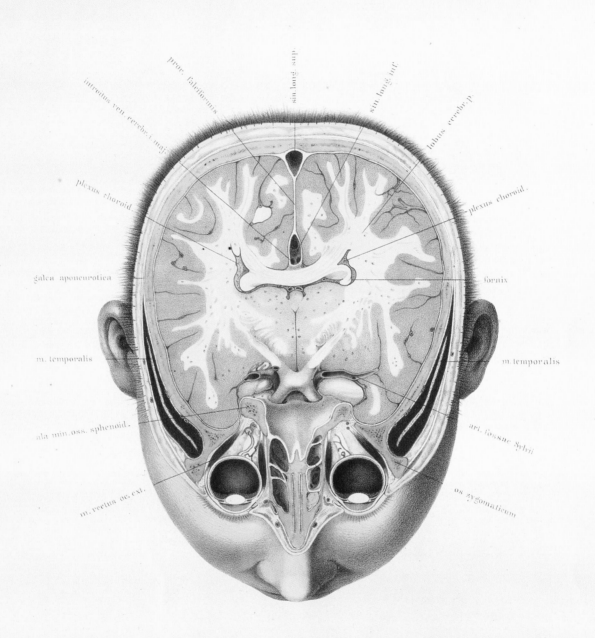

proc. falciformis

sin. long. sup.

sin. long. inf.

introitus ven. cerebr. i maj.

lobus cerebr. p.

plexus choroid

plexus choroid.

galea aponeurotica

fornix

m. temporalis

m. temporalis

ala min. oss. sphenoid.

art. fossae Sylvii

m. rectus oc. ext.

os zygomaticum

57. Wilhelm Braune (1831–1892) [anatomist]. C. Schmiedel (fl. mid-1800s) [artist]. *Topographisch-anatomischer atlas nach durchschnitten an gefrorenen cadavern….* Leipzig, 1872. Tab. III. Chromolithograph. National Library of Medicine.

58. George Viner Ellis (1812–1900) [anatomist]. George Henry Ford (1809–1876) [artist]. *Illustrations of dissections in a series of original coloured plates, the size of life, representing the dissection of the human body….* London, 1867. Plate XXV. Chromolithograph. National Library of Medicine.

59. John Lizars (1787?–1860) [anatomist]. W. H. Lizars (1788–1859) [artist; engraver]. *A system of anatomical plates of the human body….* Edinburgh, ca. 1825. Plate I. Hand-colored copperplate etching. National Library of Medicine.

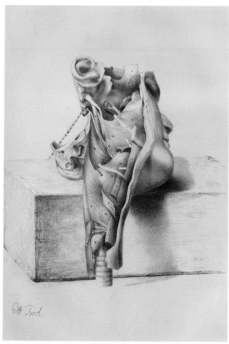

58

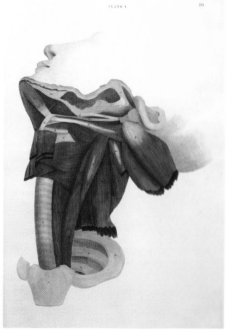

59

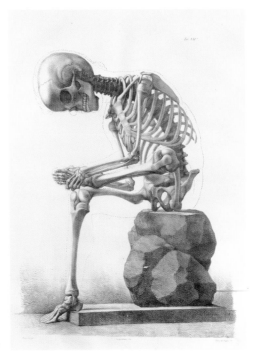

60

60–61. Francesco Bertinatti (fl. 1829–1839) [anatomist]. Paolo Morgari [artist] *Elementi di anatomia fisiologica applicata alle belle arti figurative.* Turin, 1837–1839. Lithograph. National Library of Medicine.

Art anatomy used cadavers and skeletons as models for sculpture and painting. It concentrated on skeletal and muscular anatomy and omitted everything else. The anatomical study—of real, imaginary, and prospective sculptures and paintings—became a genre in its own right.

eighteenth-century rise of formal institutions of medicine and science coincided with the rise of formal institutions of art, the art academies where, just as in medicine, professors of anatomy taught students and performed anatomical dissections, and anatomy held a place of prestige in the curriculum. In academic art, fantastic, humorous, and allegorical representations of the anatomical body still flourished, especially on the theme of human mortality. The anatomical study, as preparation for a history painting or a sculpture, or as an artwork in its own right, became a familiar genre of art.

But anatomical representation exceeded both scientific illustration and fine art. As innovations in print technology made it possible to produce cheap illustrated books, newspapers and posters, moral and metaphorical representations of the anatomical body circulated widely. Anatomy could be found in the

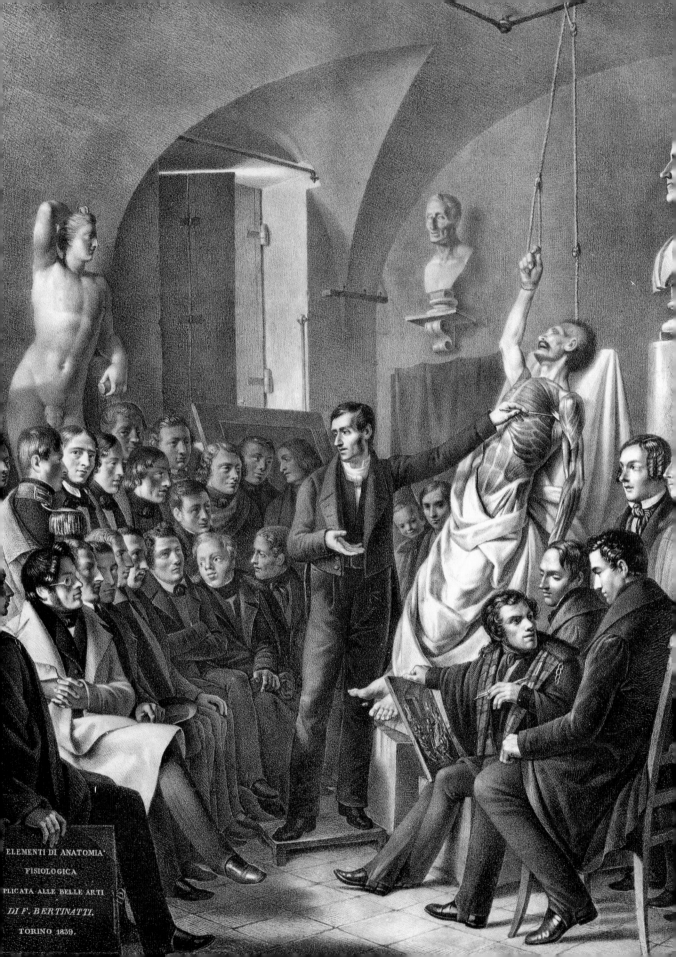

ELEMENTI DI ANATOMIA
FISIOLOGICA
PLICATA ALLE BELLE ARTI
DI F. BERTINATTI.
TORINO 1839.

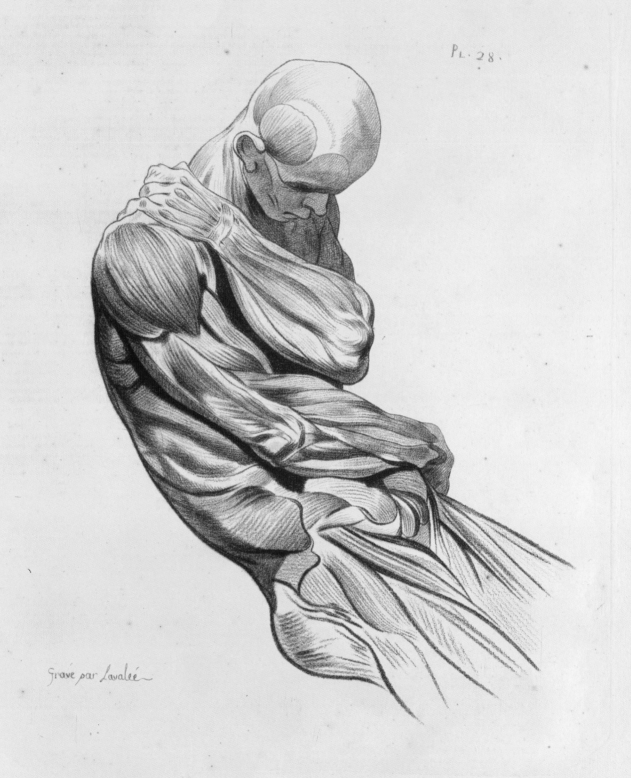

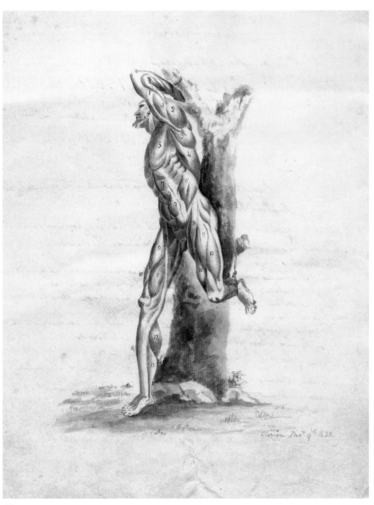

63

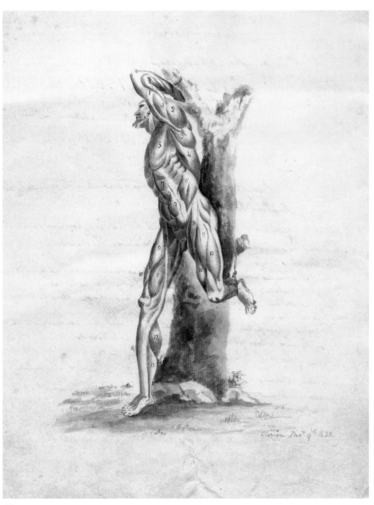

62. Jacques Gamelin (1739–1803) [artist]. *Nouveau recueil d'ostéologie et de myologie.* Toulouse, 1779. pl. 1. Etching. National Library of Medicine.

63. "Clorion" [artist]. Anatomical illustration. New Harmony, Ind., 1830. Manuscript. Pen and ink, with water color. National Library of Medicine.

A preoccupation with musculature was characteristic of much of art anatomy, which often emphasized the striations of the muscles to show their twisting, rope-like quality. The elevation of form over content gave such illustrations a feeling of high abstraction.

64. Henry Hall Sherwood (1769–1847?) [author]. *The motive power of the human system, with the symptoms and treatment of chronic diseases....* New York, 1841. Page 13. Wood engraving. National Library of Medicine.

65. Mary S. Gove (1810–1884) [author]. *Lectures to ladies on anatomy and physiology.* Boston, 1842. Frontispiece. Wood engraving. National Library of Medicine.

66. Frederick Hollick (1818–ca. 1875) [author]. *The origin of life: a popular treatise on the philosophy and physiology of reproduction, in plants and animals, including the details of human generation....* New York-St. Louis, 1845. Frontispiece. Lithograph, from daguerrotype. National Library of Medicine.

Hollick, a popular writer on health, gave public lectures on human anatomy to large and enthusiastic audiences in Boston, New York, St. Louis, New Orleans and other cities. This frontispiece portrait shows him fraternizing with an anatomical model used in his stage show.

proliferating domain of popular health, where authors used arresting images to attract and instruct a mass readership; in advertising art, especially for products that related in some way to health or the human body; and in novels, political cartoons, animated film, and other more remote regions of popular culture. In those territories, the creative imagination and anatomy did business together, and still do.

64

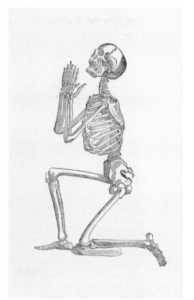

65

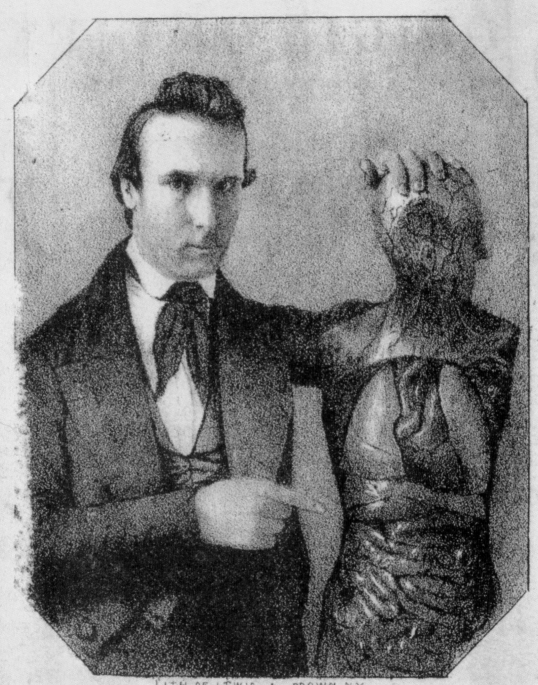

LITH OF LEWIS & BROWN, N.Y.

F. HOLLICK, M.D.

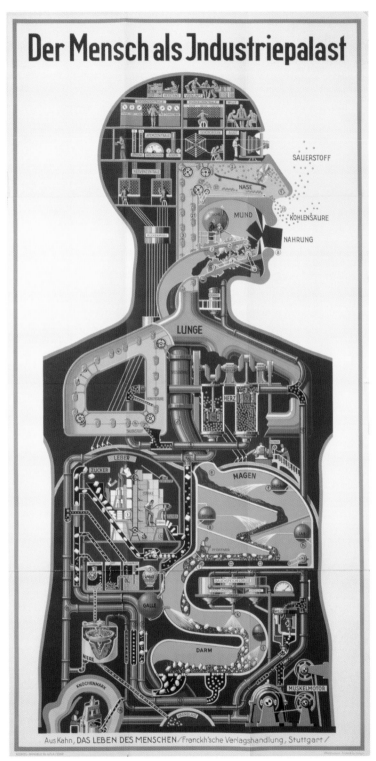

Der Mensch als Industriepalast

Aus Kahn, DAS LEBEN DES MENSCHEN / Franckh'sche Verlagshandlung, Stuttgart /

58

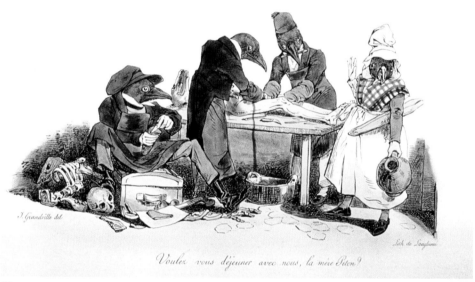

Voulez vous déjeuner avec nous, la mère Piton?

68

67. Fritz Kahn (1888–1968) [artist]. *Der mensch als industriepalast.* Stuttgart, 1926. Chromolithograph. National Library of Medicine.

Kahn's modernist visualization of the digestive and respiratory system as "industrial palace," really a chemical plant, was conceived in a period when the German chemical industry was the world's most advanced. The poster was enormously influential and translated into many different languages.

68. J. J. Grandville (1803–1847) [artist]. *Voulez vous déjeuner avec nous, la mère Piton?* France. Chromolithograph. National Library of Medicine.

In the 19th century, cartoons often used anatomical images and themes. Here a group of crows dissect, and consume, an anatomical subject.

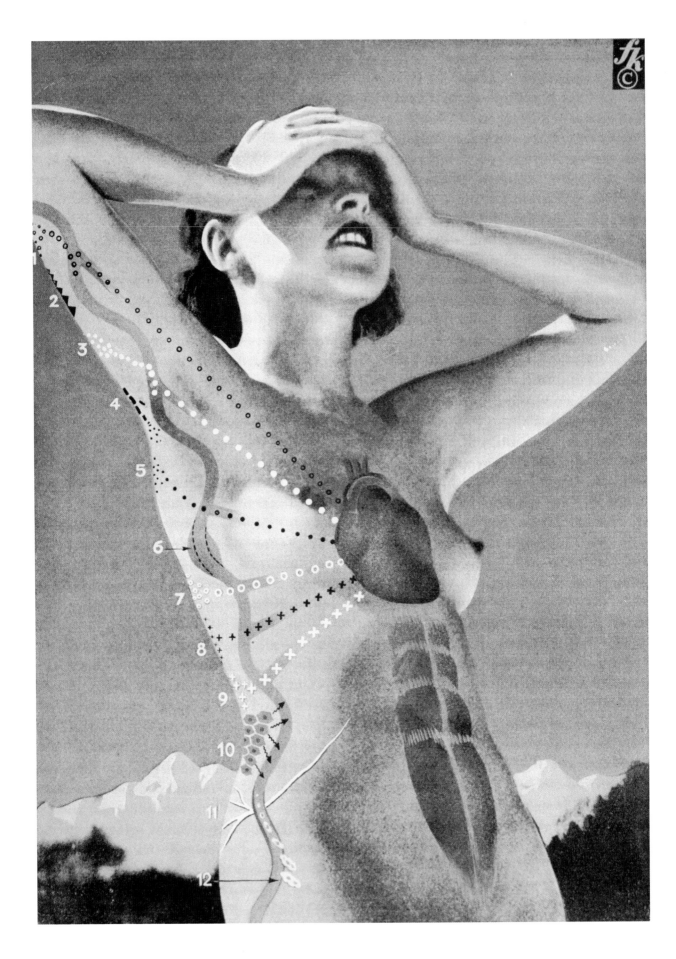

OUR CADAVERS, OURSELVES
OR THE RETURN OF THE ANATOMICAL REPRESSED

I want to live in an age which sees similar beauty in a flower and in the severed limb of a human being.

—Joel-Peter Witkin, 1997

In our study of Anatomy there is a mass of mysterious Philosophy....

—Thomas Browne, 1643

This essay began with the assertion that we think of ourselves as anatomical beings, a self-image derived from the work that anatomists and artists have collaboratively produced over the centuries. We all have multiple identities, some loudly proclaimed, some understated or even implicit. Anatomical identity is one of the latter. It's so pervasive, so routine, that we don't usually take notice. In the year 1700 most people in Europe and North America thought of themselves as an unstable amalgam of meat, spirit, reason, and corruption, or as a microcosm of the universe. Only a thin upper crust of learned physicians and gentlemen had ever seen a detailed anatomical illustration or conceived of themselves as anatomical entities. That is obviously no longer the case—in

69. Fritz Kahn (1888–1968) [author; artist]. *Der mensch gesund und krank, menschenkunde 1940....* Vol. 2. Zürich-Leipzig, 1939. Page 471. Relief halftone. National Library of Medicine.

70. Taite Alyson Puhala [artist]. *The Human Body.* East Granby, Conn., 2003. Color crayon. National Library of Medicine.

Today, a section on human anatomy is often included in the elementary school curriculum.

61

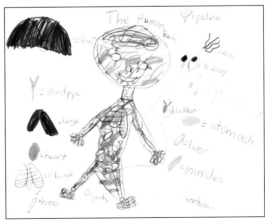

70

many schools, the first unit on human anatomy occurs in kindergarten. But even if we had never been taught it in a classroom setting, we would still see our own bodies represented in figurative painting and sculpture, X-rays, and other imaging technologies, and see the anatomical body in the doctor's office posters, magazine ads, anatomical adventure films like *Fantastic Voyage* (1966) and *Osmosis Jones* (2001), and gory horror films like *The Texas Chain Saw Massacre* (1974), *Re-Animator* (1985), and *The Silence of the Lambs* (1991). In the last ten years or so, the anatomical body has even begun to appear on television, especially the new round of forensic shows like *CSI* (2000). So the subject of anatomical representation and the boundaries between art and science is not purely academic: it has reference to our own experience.

If we believe anatomy is our inner reality, then science has the most legitimate claim to be the highest authority over it. But the artist also has claims to be a privileged representer of inner realities. Since the advent of romanticism in the early nineteenth century, the artist has assumed the role of prophet, a reader of augers and signs. And, even in the era of modernism and postmodernism, that conception of the artist as a visionary seeker of hidden truths that we conceal from ourselves, still obtains. In the academic art tradition, which still has many adherents, anatomy is the technical knowledge out of which the artist crafts representations of the human figure that somehow convey the reality of the human condition. The new art anatomy is more conceptual. It plays with anatomy as a vocabulary of selfhood, an emblem of political, social, cultural, and existential realities, a template of human identity, or maybe the Other, the alien inner world that we are permanently estranged from.

62

71. *U.S. Naval Hospital, San Diego, CA: X-Ray Department.* Photograph, ca. 1960. National Library of Medicine.

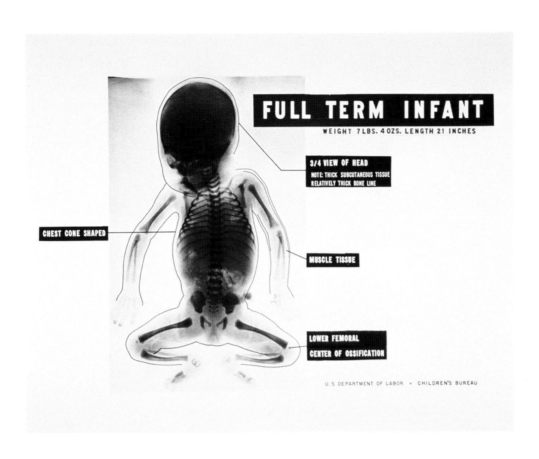

72. *Infant Growth and Development.* U.S. Department of Labor, Children's Bureau. Washington, DC, ca. 1943. Photo offset poster. National Library of Medicine.

After the discovery of the X ray, radiological imagery circulated widely in posters, advertisements and cartoons. The X ray became part of our visual vocabulary of selfhood.

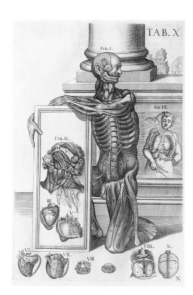

73. Pietro Berrettini da Cortona (1596–1669) [artist]. *Tabulae anatomicae....* Rome, 1741. Tab. X. Copperplate engraving. National Library of Medicine.

Berrettini's anatomical figures playfully stage the divided self.

Photographer Katherine Du Tiel, for example, projects anatomical illustrations onto the human body and plays with the discrepancy between the real body and the representation. Du Tiel highlights the impossibility of complete correspondence by making deliberate mistakes. She projects a front onto a back, a woman onto a man, a side onto a front. Sometimes she shows written labels and things out of scale, just to let us know that we're not looking at some new technology of anatomical imaging, that we're looking at ourselves, and something else. Something similar is accomplished in the work of Rosamond Purcell. Her brilliantly lit photographic compositions document a strange lost world of anatomical specimens, objects originally designed to exemplify the particulars of human anatomy and pathology, and also to amaze. And which now amaze us with their grotesquerie and beauty, and utter divorcement from the bodies from which they were obtained—and from us.

For the new conceptual anatomical artists, anatomy is simultaneously the icon of the body as it exists under the regime of Science and Reason—the world that governs us, that makes our bodies legible, controllable, mappable—and the undomesticated body, which is outside our control. We identify with the images of anatomy, which are fashioned from real bodies, but the match is never exact, always requires adjustment. The works of Damien Hirst, Marc Quinn, Alexander Tsiaras, Carolyn Henne and other anatomical artists seem to say that the self is a fragile construction, cobbled together from fallible technologies and a biological given of flesh and fluids, liable to breakage and spoilage. Hirst famously created sculptures out of actual dissections of animals. Quinn

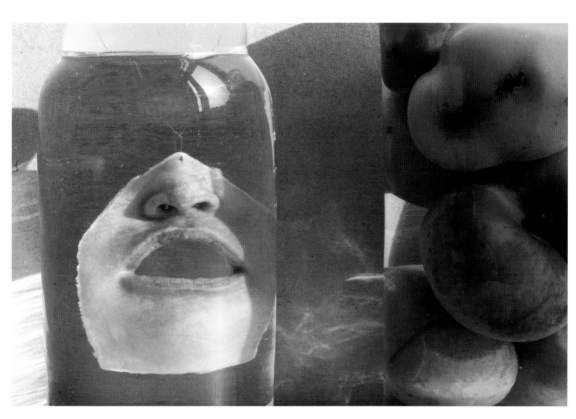

74. Rosamond Purcell (b. 1942) [photographer]. Unknown anatomist. *Jar containing face and double apples.* Anatomical specimen, date unknown. Boerhaave Museum, Leiden. Photograph, 1986. National Library of Medicine.

Rosamond Purcell's photograph of a fanciful centuries-old anatomical specimen hauntingly evokes bodily fragmentation and alienation.

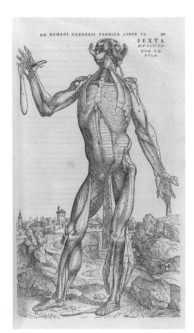

75. Andreas Vesalius (1514–1564) [anatomist]. Stephen van Calcar and the Workshop of Titian [artists]. *De humani corporis fabrica….* Basel, 1543. Page 187. Woodcut. National Library of Medicine.

Anatomical representation makes the insides of our bodies visible and familiar, but also reveals a strangeness, an otherness. In dramatizing the dissected body, Vesalius contributed to a new visual iconography of monstrosity.

made a portrait bust of himself, using his own frozen blood. The piece, entitled "Self," would have a very different meaning had it been made from stage blood instead of the real stuff. Ditto with Hirst's animal dissections: their realness is the whole story.

The same could be said about the controversial exhibitions and performances of Gunther von Hagens, who makes full-body anatomical specimens and stages them as a large-scale exhibition for the general public called *Body Worlds*. Von Hagens has invented a process, called "plastination," that removes the water from a cadaver and replaces it with preservative plastic. Von Hagens doesn't bid for cultural authority by calling himself an artist. He is a well-known anatomist and has scientific credentials to confer legitimacy on his work, if the spectacle of his anatomical productions doesn't sufficiently testify to his special expertise. But he also claims to be reviving the playful tradition of sixteenth- and seventeenth-century anatomy, an age in which the distinction between scientific work and pleasure had not been consolidated. His specimens often reference sports or games: a cadaver sprints as the flesh trails off him, another plays chess, and another basketball. The displays recall the era of Ruysch and Albinus, when the fanciful anatomical museum was first invented. In some pieces, von Hagens restages scenes from early modern anatomical illustration, but in three dimensions, using dead bodies as his medium. His prolific presentations of real dissected bodies are pitched somewhere between work and pleasure, a tension that appeals to a larger-than-customary crowd of museum and exhibition goers, but annoys the anatomical profession and cultural *policiers,* who dislike the crossing of lines. *Body Worlds* has had runs in London,

Munich, Los Angeles, and Seoul, and has attracted hundreds of thousands of visitors, and much coverage in the press. Von Hagens has also courted controversy by performing a dissection before a live audience for broadcast on Great Britain's Channel Four.

Von Hagens, Quinn, and Hirst are often accused of attention-mongering, vulgarity, cheap sensationalism, and an unhealthy self-preoccupation amounting to narcissism. (Quinn and Hirst were introduced to the American and British public in a controversial group show called *Sensation*.) The charge has some justification: given the crowded cultural marketplace, it's no surprise that artists and exhibitors will resort to almost any subject or medium to get attention. But let's not judge them too harshly: Vesalius and his colleagues and successors also vied for attention, for readers and students and patronage, and also depended on their ability to amaze: the science of anatomy, with its dissection performances and strange representations of dissection, was an early modern version of the "stupid human trick" (a very smart

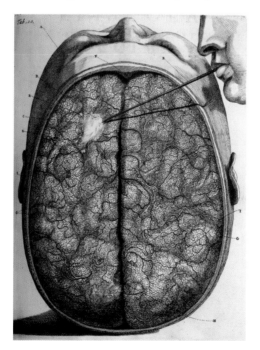

76. Frederik Ruysch (1638–1731) [anatomist]. *Epistola anatomica, problematica nona....* Amsterdam, 1679. Tab. 10. Etching with copperplate engraving. National Library of Medicine.

Ruysch was a great anatomical showman. Here he shows how he could blow on a straw inserted into the dura mater to show off its texture.

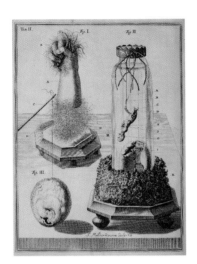

77. Frederik Ruysch (1638–1731) [anatomist]. *Alle de ontleed-genees-en heelkindige werken*... Vol. 2. Amsterdam, 1744. Tab. II. Engraving. National Library of Medicine.

A selection of bizarre anatomical specimens.

78. Fritz Kahn (1888–1968) [artist]. *Man in Structure and Function...*. New York, 1943. Page 161. Relief halftone. National Library of Medicine.

 Kahn, a physician, popular medical writer and artist, used modernist visual styles to show the body in motion, and motion in the body.

stupid human trick). It's easy to resent and deplore the way that anatomical artists recruit our attention, and capitalize on it. Our culture privileges reason and spirit over the flesh, and substance over surface. On that basis perhaps we can indict anatomical art for bad faith. But it's a fact of life: our culture also revels in fleshiness and sumptuous outer wrappings and coverings. Only the flashiest grandstanders can make themselves visible in the blizzard of competing cultural productions. The new anatomical artists try to play it both ways: they want to make us think, but also make us look. Like pornography, the viewer's reaction to their body art is immediate, a conditioned response. We want to see. (And maybe also to feel superior to what we see.)

But to stop there is too easy. Why is anatomical art so popular in the present moment? Why does the new conceptual art anatomy speak so powerfully to us? Here's my theory: For hundreds of years, the anatomist and artist did ventriloquism with cadavers, making them speak, sing, dance, and tell jokes. Eventually the tables turned: the images of anatomy became part of us, started speaking through us. We became the ventriloquist's dummy, an effigy of the anatomical self. Anatomical identity inhabits us, even as it coexists with, and infuses, other representations of the body.

We swim in a sea of body images: beautiful bodies, funny bodies, athletic bodies, dead and dying bodies, on television and film, and the web, and in newspapers and magazines. As the bodies float by, they constantly exhort, cajole, and incite us to think about our own bodies: how we look, how we feel. And the whole thing works: we survey and shape and transform and fret over ourselves. We diet, train at the gym, do physical exercise, yoga, swing dance, martial arts, more than any other people in history. We examine ourselves for acne and breast cancer and a thousand other serious and not so serious conditions. Our attention is continually directed toward our bodies, and we attend. We are glutted with body images, services, technologies, sensations.

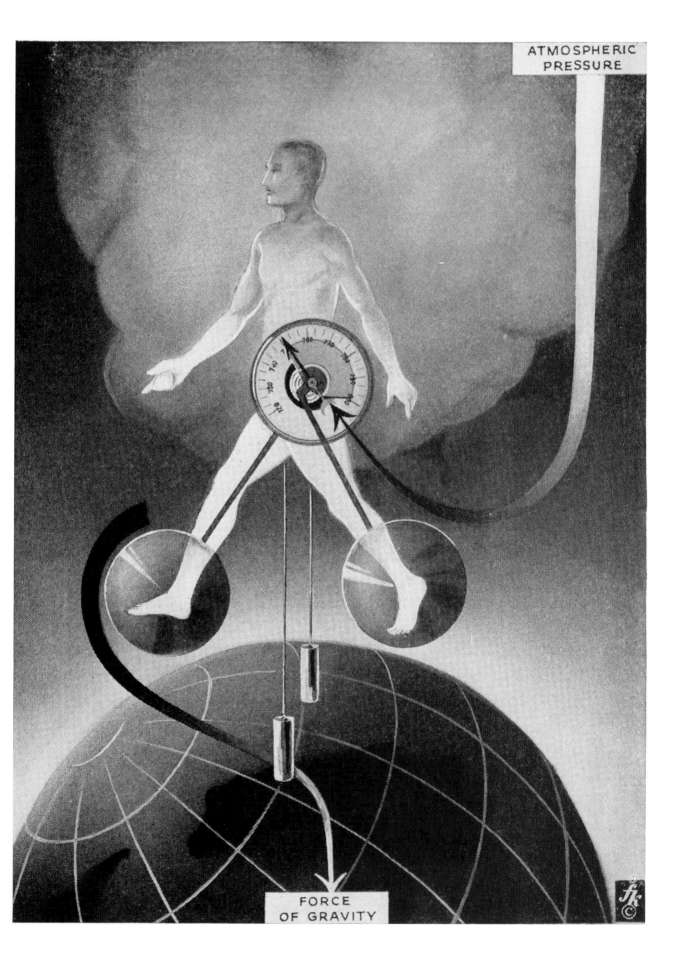

ATMOSPHERIC
PRESSURE

FORCE
OF GRAVITY

Yet we also feel disembodied. We spend much of our lives sitting in cars, or in front of computers and television screens, doing almost nothing with our bodies. We prefer packaged versions of things that substitute for more fully experiential activities: we buy a plastic bag of food, open it, and feel like we're cooking. And we understandably prefer to purchase products and services that protect us from the sting of embodied discomfort, pain, anxiety and loss. We buy aspirin and more powerful drugs, and we're protected from the experience of pain. We pay for the services of health and funerary professionals to place veils between us and death, and the dead body. The cumulative result is that we are haunted by an unaccountable loss, or maybe feel like ghosts ourselves: we deprive ourselves of the experiences of bodily life; our bodies are absent.

And we need something strong to reconnect ourselves to our bodies, to make contact with life and with death. An aura of realness—the real body, real anatomies, the real self—emanates from the art of Du Tiel, Purcell, Henne, Hirst and Quinn, and the displays of the Mütter Museum, Hunterian Museum, National Museum of Health and Medicine, and *Body Worlds.* Art is good for you, science is good for you—so we are supplied with moral justification—but what brings the customers through the turn-

70 **79.** Robert Seymour (1798–1836) [artist]. *Cholera "Tramples the victors & the vanquished both."* London, 1831. Chromolithograph. National Library of Medicine.

The iconography of human anatomy has an intimate connection with the iconography of death.

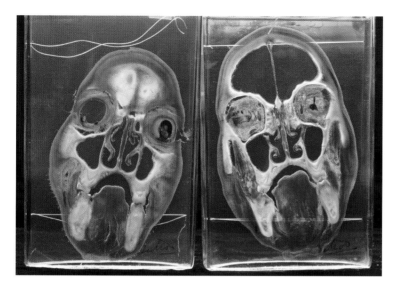

stile is the pleasure of looking at real bodies and body parts, even two-dimensional visual representations based on "the real body." Some high-minded people might dismiss this as the voyeurism, or maybe narcissism, of the herd. They forget that anatomists, microscopists, radiologists, endoscopists, and many other medical professionals, know such pleasures, but would rather not publicly acknowledge them. At least not since Govard Bidloo and his successor anatomists began to draw the line, some 250 years ago.

From a safe distance, we enjoy the art of the "new anatomists," which permits multiple interpretations, deliberate ambiguity, irony, and alienation.[13] We also appreciate the drawings and objects of early modern anatomy, for their wit and charm, for their artfulness or crudity, for their historical role in the progressive increase of knowledge of the human body, and as markers of a bygone era. A great divide separates such productions from our own scientific illustrations of the body. The illustrations in our anatomical textbooks are not meditations on death and human mortality, do not refer back to Christian or classical martyrs, or any literary or theological or mythological character or tale. They are not posed in any landscape or cityscape; they don't dance or

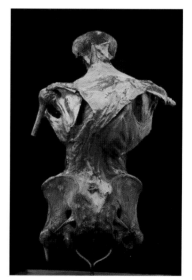

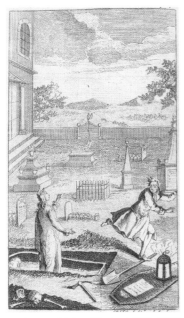

82. Jacques Bénigne Winslow (1669–1760) [author]. "A grave robber flees from a corpse that has come to life." *The Uncertainty of the Signs of Death*. London, 1746. Woodcut. National Library of Medicine.

Before the passage of laws, in the 19th century, that gave medical schools the right to take the bodies of the unclaimed poor, anatomists (or their agents) robbed graves to get their cadavers.

83. Jacopo Berengario da Carpi (ca. 1460–ca. 1530) [anatomist]. *Isagoge breves perlucide ac uberime, in anatomiam humani corporis….* Venice, 1535. Page 7. Woodcut. National Library of Medicine.

Berengario's illustrations give little anatomical detail, but visually represent the sense of wonder that attends the opening of the body.

flirt, or express any emotion. An anatomical illustration or specimen, we expect, shouldn't have to sing for its supper. It shouldn't try to scare us. It shouldn't try to remind us of our inevitable fate. It shouldn't have any allegorical or metaphorical registers. It shouldn't make us laugh or smile.

That refusal to acknowledge the pleasures of anatomical knowledge has a positive as well as negative valence. We believe that respect for the dead should be a universal right: anatomy's culture of discretion is not only a defining characteristic of the contemporary profession, it is also our version of funerary honor. We prevent ourselves from looking and playing with the dead because they, and prospectively we, are entitled to respect. And that boundary helps define our version of human dignity and human rights. We believe it's wrong to sell our body parts or bodies, wrong to make shows out of the dead, or parts thereof, for strictly commercial gain.

These ideas are deeply rooted in anatomical history. For centuries, anatomists took their bodies where they wanted, and made sport of them, to the distress of a large segment of the public. In Great Britain and America, there was much resistance to the anatomical taking of bodies. In the late eighteenth and early nineteenth centuries, there was a stigma attached to anatomical dissection; anatomists knew that their transgressions might provoke a crowd of angry townspeople to storm the school and take back their dead. But the profession never fully acknowledged the legitimacy of their opponents' objections. As the source of anatomical material switched from illegal bodysnatching to legal (but still involuntary) appropriation of the bodies of the poor, through laws that permitted medical schools to take the bodies of people who died in the poorhouse, a shroud of discretion descended upon the anatomical enterprise. That discretion has, if anything, deepened, now that anatomists get most of their bodies through

72

In hac figura habes Duos musculos obliquos ascendentes: qui se incruciat cũ duobus Descendẽtibus in alia figura positis: qui q̃ dẽ Descẽdẽtes sunt supra istos ascendentes: & totus vnus ex p̃dictis musculis de scendẽtib⁹ supra positis in alia figura cũ cordi sua superequitat oblique musculũ vnum ex istis ascẽdẽtib⁹ oblique: & faciunt simul figurã. x. lr̃e græce: & istorum musculor̃ etiã parscarnea

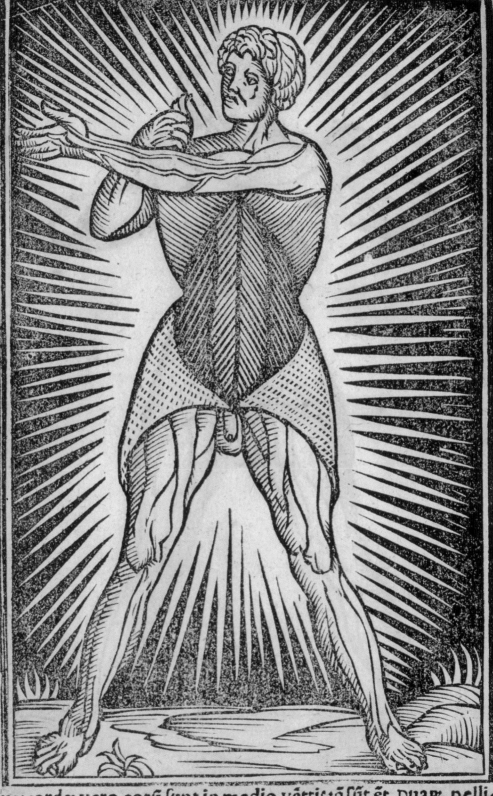

est a lateribus: cordæ vero eorũ sunt in medio vẽtris: q̃ sũt ẽt duar̃ pelliculac: & habent vnã pelliculã tantũ superequitãte musculos lungos: alia vero pellicula est infra musculos lungos: q̃ adheret cordis latitudinaliũ musculog: & ist̃ cordæ ẽt terminãtur in linea: q̃ ẽ i medio vẽtris: ut vides.

84. William Austin (1721–1820) [artist]. *The Anatomist Overtaken by the Watch… Carrying off Miss W–ts in a Hamper.* London, 1773. Colored etching. National Library of Medicine.

Fleeing the scene of a failed bodysnatching is Dr. John Hunter, the brother of William Hunter and a celebrated anatomist in his own right.

voluntary donation programs, and are faced with the practical need to show respect for their cadavers so as not to offend the feelings of those who donate their bodies, and the need to adhere to the ethical standards of informed consent that came in the wake of the exposure of Nazi medical experiments, the Tuskegee study and other abuses.[14]

Thus the professional anatomist vehemently insists that the dissection, manipulation and presentation of dead bodies should have only one purpose: to produce and disseminate reliable, scientific knowledge of the body. Anatomy is not for pleasure and not for profit—although history tells us that, in some ways, it always has been. This anatomical insistence on sober study and scientific disinterestedness is self-justifying but also legitimating. Anatomical knowledge benefits all mankind, but only the anatomist knows the secrets of the body. And the keeping of the secret is both to protect the public (which might be traumatized by too much familiarity with the facts of death) and to protect the profession. It is only since the 1970s (when bioethics was finally born, as a field of study and a body of regulations), that anatomists can make any legitimate claim to be concerned with protecting the dead.

Not surprisingly then, the anatomical profession, and a segment of the public, are alarmed when anatomical artists rip off the shroud. They are professional provocateurs, who smuggle bodies and body parts across the boundaries of propriety, and use them as effigies to mark the spot. The founders of the profession—Vesalius, Ruysch, Bidloo and Hunter—had no professional principles in this regard: they felt free to take the bodies of criminals, outcasts, and indigents and use them as they wished. The moral boundary was then still unmarked. Whereas now, the moral boundary—like the boundary between art and science—seems almost a fact of nature. And we take pleasure and umbrage when anatomical artists put on their extravaganzas, and remind us: not so.

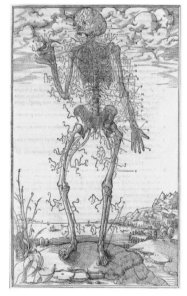

85. Charles Estienne (ca. 1504–1564) [author]. Étienne de la Rivière (d. 1569) [anatomist]. *De dissectione partium corporis humani…*. Paris, 1545. Page 59. Woodcut. National Library of Medicine.

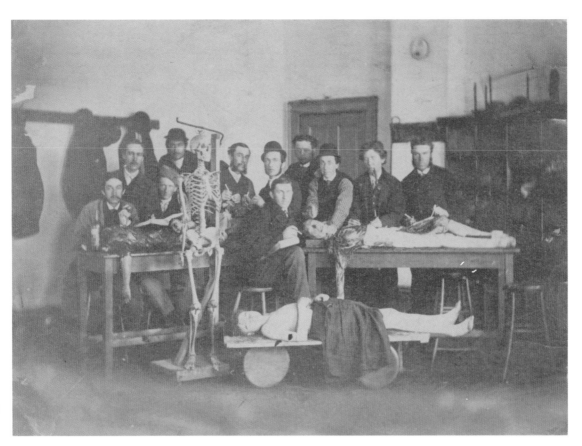

86. *Interior of an unidentified classroom, students posing next to three cadavers and a skeleton.* United States, ca. 1910. Photograph. National Library of Medicine.

Notes

1. The well-born few were, to some extent, also sharers of the secret, privy to the public performance of dissection in the anatomical theater. They were permitted to witness the spectacle of transgression and mutilation, and the display of learned language and procedures. Similarly, apart from physicians and surgeons, in the early modern period, only a small upper crust of learned readers and collectors had access to, and knowledge of, illustrated anatomical books.

2. Stephen Greenblatt, *Renaissance Self-Fashioning: From More to Shakespeare* (Chicago: University of Chicago Press, 1980).

3. The only people not having fun were those whose bodies were conscripted for use as anatomical subjects. The indigent poor, criminals, suicides, prostitutes, and anyone executed for capital crimes, served as the raw material from which anatomical knowledge was mined and minted, and suffered a terrible fate: the utter loss of funerary honor.

4. Francis Bacon, *The Great Instauration* (London, 1620) in *The Works of Francis Bacon,* Vol. 8; trans. James Spedding, Robert Leslie Ellis, and Douglas Denon Heath (Boston: Teggard & Thompson, 1863), proem.

5. Thomas Sprat, *The History of the Royal-Society of London for the Improvement of Natural Knowledge* (London, 1667; rpt., St. Louis: Washington University Press, 1958), 111.

6. John Bell, *The Anatomy of the Human Body* (2d ed.; London, 1804), vi.

7. Richard C. Sha, "Scientific Forms of Sexual Knowledge in Romanticism," *Romanticism on the Net* 23 (August 2001) http://users.ox.ac.uk/~scat0385/23sha.html

8. See for example, Steven Shapin, *A Social History of Truth* (Chicago: University of Chicago Press, 1994); Margaret Jacob, *The Cultural Meaning of the Scientific Revolution* (New York: Knopf, 1988).

9. Svetlana Alpers, *The Art of Describing: Dutch Art in the Seventeenth Century* (Chicago: University of Chicago Press, 1983), xix.

10. Ibid, 270.

11. Simon Luttichuys (1610-1661), Still Life with Skull, ca. 1635-40, oil on canvas, National Museum, Gdansk, Poland.

12. Samuel van Hoogstraten's 1678 treatise on the art of painting refers to the image cast by a camera obscura as a "truly natural painting"; Alpers, 27.

13. "The New Anatomists" was the name of an art exhibition that opened in March 1999 at the Wellcome Trust's Two 10 Gallery, London. Here I use the term broadly to denote the larger group of artists currently working with anatomical themes and materials, outside the older academic art tradition.

14. In the UCLA body parts scandal of 2004, the director of the university's willed body program was arrested for selling body parts for commercial gain amounting to hundreds of thousands of dollars. In the Alder-Hey scandal in Great Britain, a medical professor took organs from the bodies of dead children without asking permission from parents. Both cases demonstrate that an older imperative also continues to motivate the anatomical culture of professional discretion: the desire to cover up the abuses of the profession.

REVISITING DREAM ANATOMY

The interior of our bodies is hidden to us. What happens beneath the skin is mysterious, fearful, amazing. In antiquity, the body's internal structure was the subject of speculation, fantasy, and some study, but there were few efforts to represent it in pictures. The invention of the printing press in the fifteenth century—and the cascade of print technologies that followed—helped to inspire a new spectacular science of anatomy, and new spectacular visions of the body. Anatomical imagery proliferated, detailed and informative but also whimsical, surreal, beautiful, and grotesque—a dream anatomy that reveals as much about the outer world as it does the inner self. Over the centuries anatomy has become a visual vocabulary of realism. We regard the anatomical body as our inner reality, a medium through which we imagine society, culture and the human condition.

The National Library of Medicine's *Dream Anatomy* exhibition ran from October 9, 2002 to July 31, 2003. Drawn principally from the Library's collections, *Dream Anatomy* displays the anatomical imagination in some of its most astonishing incarnations, from the fourteenth century to the present.

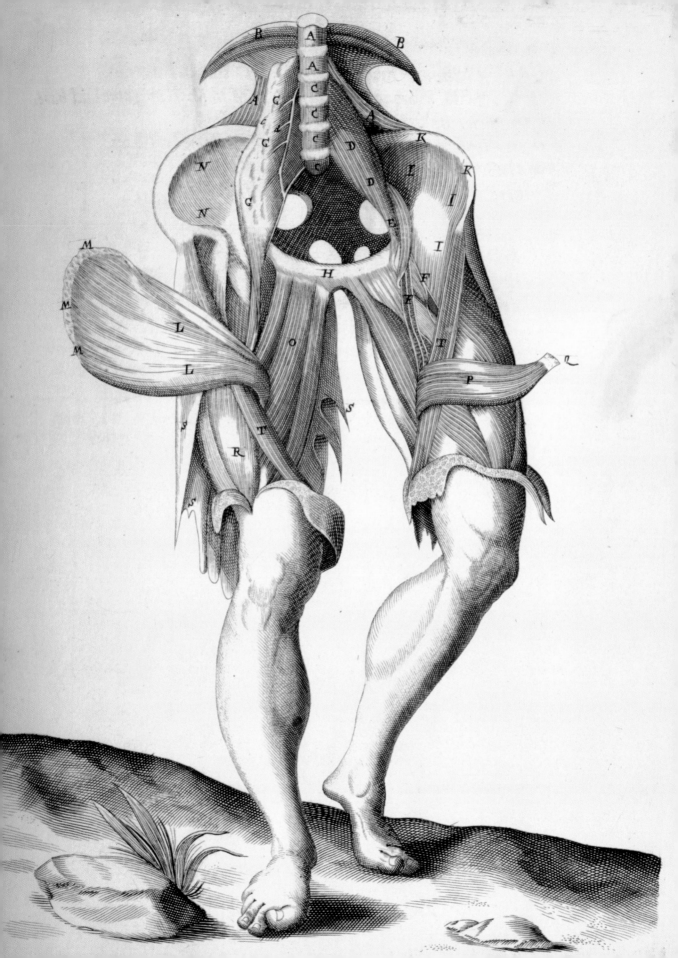

ANATOMICAL DREAM TIME
THE EARLY MODERN ERA

With the founding of the first medical schools in medieval Europe, anatomy ascended to a prominent position in the medical curriculum. Human dissection was performed as a ritual that illustrated the treatises of revered ancient authors—and that dramatized the power and knowledge of the medical profession. The mid-fifteenth-century invention of the printing press, and the rise of a new spirit of critical inquiry associated with the Renaissance, inspired a scientific revolution in anatomy. Anatomists began to dissect in order to investigate the structure of the body, and produced texts illustrated with images based on their dissections.

In the early modern era (1450–1750), the boundary between art and science was ill-defined. Anatomists and their artist collaborators made use of familiar modes of representation—the iconography of landscape, nudity, mythology and Christianity. Artists tried to create illustrations that were accurate, but also amazing, beautiful, and entertaining.

Pre-modern Anatomies

Fascination with the interior of the body goes back to the dawn of humanity. The ancient Egyptians had specialized knowledge in some areas of human anatomy, which they used in mummification and, to a limited degree, surgery. Even before the advent of large organized cultures, prehistoric peoples performed rituals with remains that indicate familiarity with gross anatomy. Because they hunted and slaughtered large animals for food, the Inuit and Australian aborigines developed a detailed knowledge of mammalian anatomy, and a complex vocabulary of anatomical terms, which they applied to animals and humans.

Rock paintings dating back to the Neolithic in Europe, Africa and Australia feature schematic and expressive representations of the human interior, as do some pre-modern European, Islamic and Asian manuscripts.

82 **87.** Rock painting, Kakadu National Park, Northern Territory, Australia. ca. 6000 B.C.E. © Archivo Iconografico, S.A./Corbis.

88. Mansūr ibn Ilyās (fl. ca. 1390) [author]. *Tashrih-i badan-i insan.* Iran, 1488. MS P19, folio 18A. Manuscript illustration. National Library of Medicine.

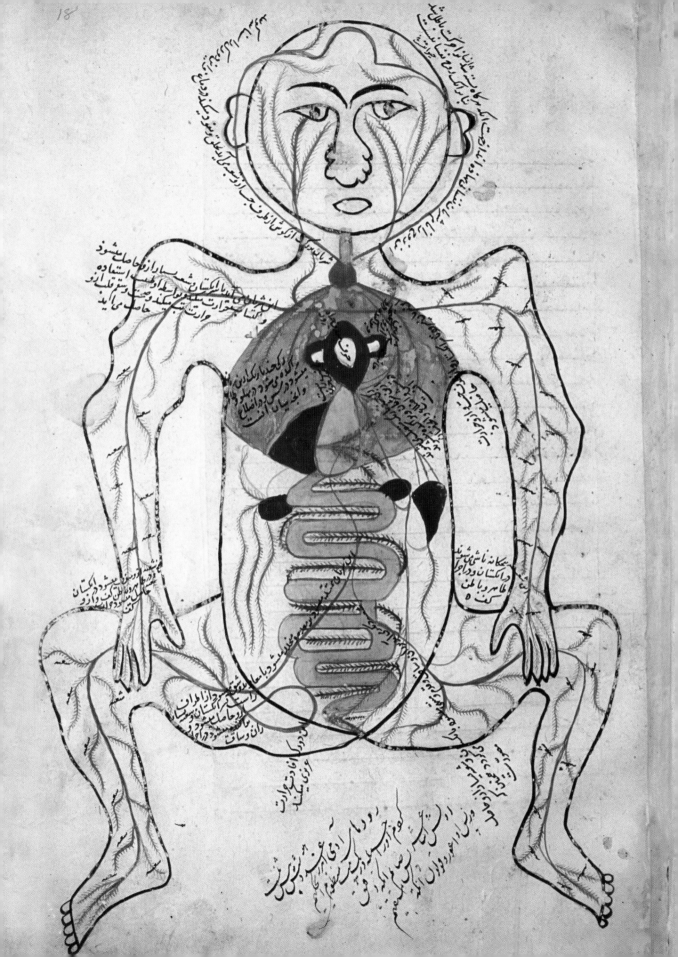

84

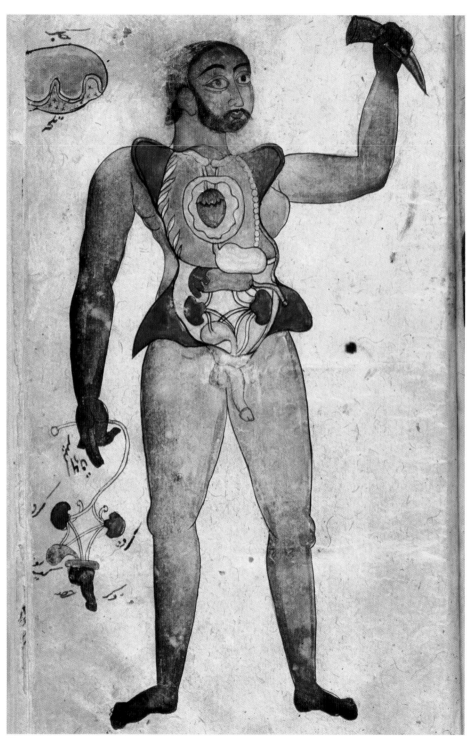

89

Figura de situ viscerum.

90

85

89. Anonymous [artist]. Anatomical illustration. In Muhammad Akbar (also known as Muhammad Arzani) (d. 1722) [author]. *Tibb al-Akbar (Akbar's Medicine).* [Iran or Pakistan], ca. 1680–1750. Ink and watercolor. National Library of Medicine.

90. Magnus Hundt (1449–1519) [author]. *Antropologium de hominis dignitate, natura et proprietatibus, de elementis, partibus et membris humani corporis.* Leipzig, 1501. Page 119. Woodcut. National Library of Medicine

Anatomical Primitives

The invention of the printing press in the 1450s, and the development of woodcut and copperplate engraving, made it possible to publish multiple copies of illustrated treatises on anatomy. Whimsical, surreal, beautiful, and often grotesque, the new anatomical images were rendered with varying degrees of skill and sophistication, in a hodgepodge of styles.

After the publication of the first modern anatomy, Andreas Vesalius's revolutionary *De humani corporis fabrica* (1543), illustrations in the Vesalian manner proliferated. But images with limited or no Vesalian influence continued to be featured in surgical manuals, almanacs, encyclopedias and philosophical treatises, alongside discussions of astrology, alchemy and theology.

86 **91.** Johannes de Ketham (fl. late 15th century) [author]. *Fasciculus medicinae.* Venice, 1500. Woodcut. National Library of Medicine.

In medieval anatomy, the anatomist didn't soil his hands by touching the cadaver. Here, at a podium above the action, the anatomist reads from an anatomical text. A lower-ranking barber-surgeon performs the dissection.

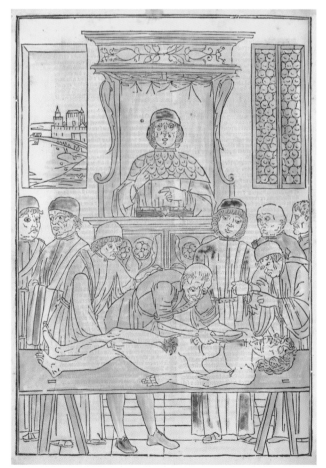

90

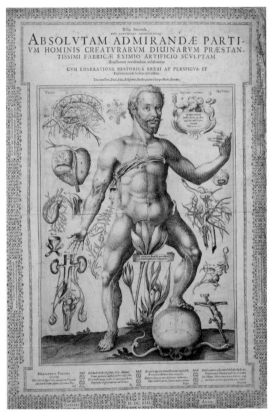

92

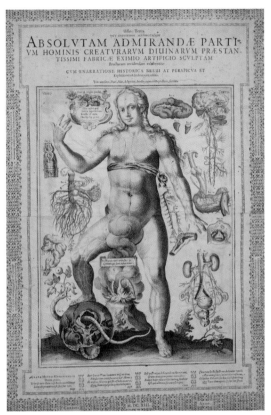

93

92–93. Johann Remmelin (1583–1632) [anatomist; artist]. *Catoptrum microcosmicum....* Augsburg? 1619. Copperplate engraving; cut-out flaps attached to a base print. National Library of Medicine.

This anatomical Adam and Eve mix scientific anatomy with religious and mythological icons. The pair are "dissected plates," with flaps that open to reveal the organs underneath the skin.

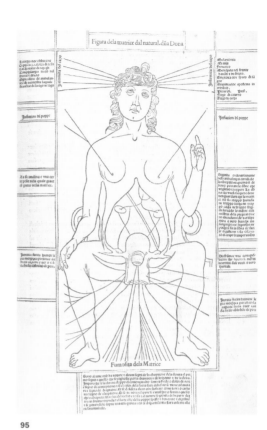

94

95

94–95. Johannes de Ketham (fl. late 15th century) [author]. *Fasiculo de medicina.* Venice, 1494. Woodcut. National Library of Medicine.

Fasciculus medicinae, the first printed illustrated medical compendium, was published in 1491 and republished in subsequent editions in Latin, Italian and other languages. Alongside its straightforward anatomical illustrations are other views of the body: an "astrological man" and a "wound man."

96. Toviyah Kats (ca. 1652–1729) [author]. *Ma'a'seh Toviyah.* Venice, 1708. Folio 106 Recto. Woodcut. National Library of Medicine.

This illustration from a Hebrew encyclopedia pairs the interior of a human with the interior of a house, a visual metaphor. The organs, like rooms in a house, have different functions. Kats, one of the first Jews to study medicine at a German university, received his degree at Padua and served as court physician to the Ottoman Sultan.

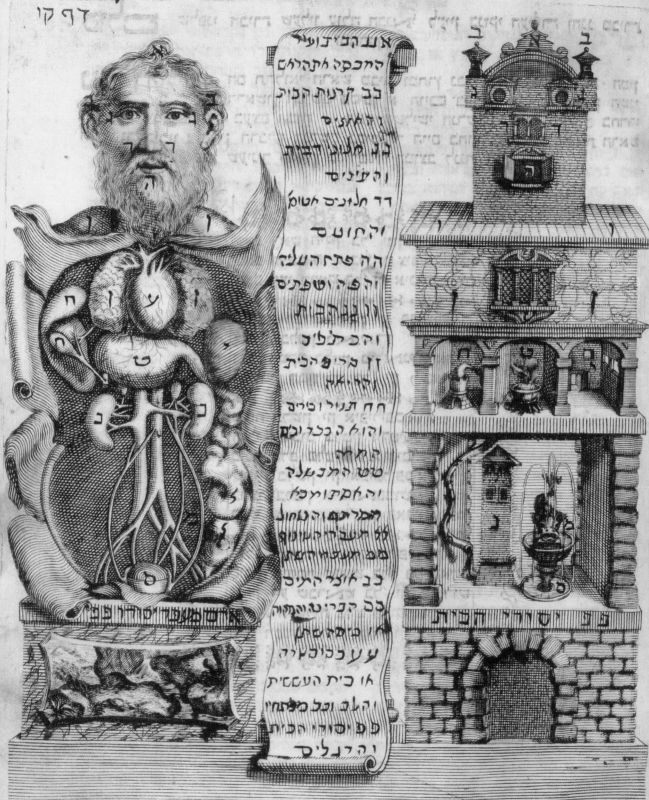

Chabes bñe
optimã figu/
ram matricis
cũ fuis comi/
bus anchis al
ligata/infra ӡ
funt tefticuli i
fuo loco na /
turali alligati
vafis femina/
rijs/ӡ vafa ter
minantur ad
corpus matri
cis vt vides:
oritur fupra
matricẽ circa
regione renuӡ
ab emulgente
ʒ auena chili:
vt fupra dictũ
eft/ʒ hec ma/
trix eft figura
ta magna ac
fieffet pgnãs
in parte cuius
anteriori natu
ra locauit ve/
ficaӡ cum fuis
poris vritidi/
bus/ʒ collum
veficae termi/
natur in collo
matricis parũ
fupra fiffurã/
ӡ dicitur vul/
ua:haec tamẽ
melius viden
tur anatomi/
ʒando foemi/
nã pgnantem
ʒ etiam nõ p
gnantem.

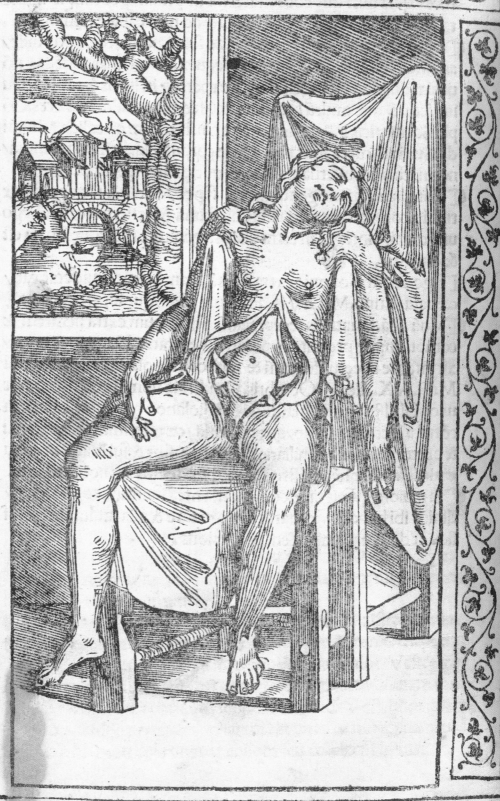

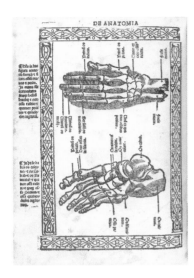

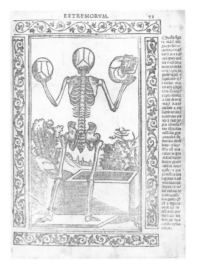

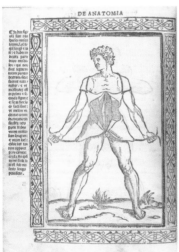

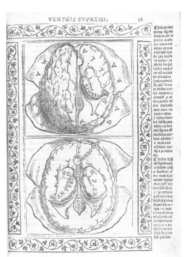

97–101. Jacopo Berengario da Carpi (ca. 1460–ca. 1530) [author]. Hugo da Carpi (1455–1523) [artist]. *Isagogae breves….* Bologna, 1523. Woodcut. National Library of Medicine.

Berengario, an Italian surgeon and physician, refashioned the 14th-century anatomical treatise of Mondino de'Liuzzi for print publication. The illustrations are not keyed to the text, and are in a variety of styles, including the *danse macabre*.

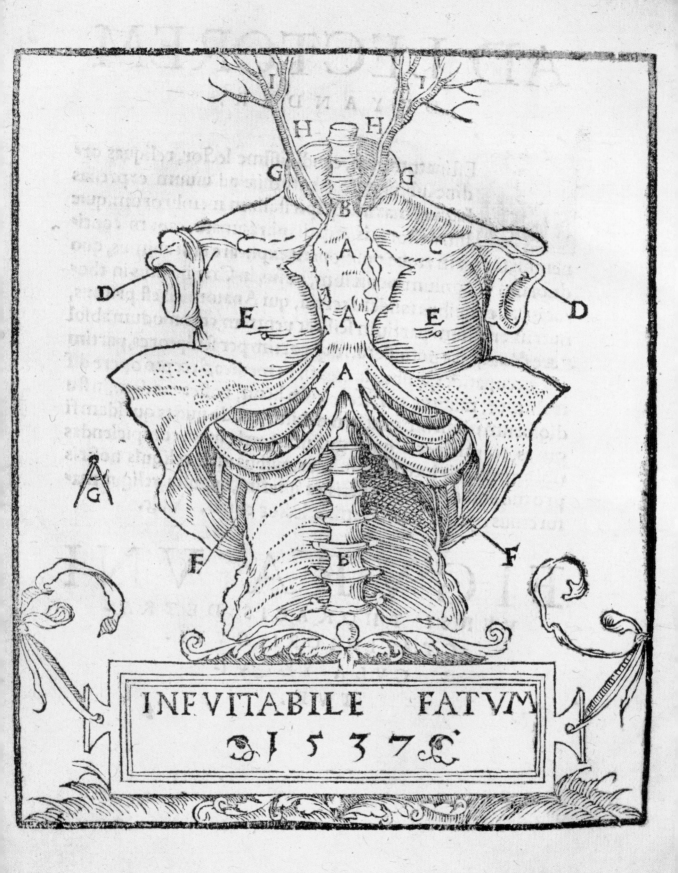

INEVITABILE FATVM
1537

102–103. Johannes Eichmann (also known as Dryander) (1500–1560) [anatomist]. *Anatomiae, hoc est, corporis humani dissectionis....* Marburg, 1537. Woodcut. National Library of Medicine.

Dryander, a German professor of anatomy, revised the works of Berengario and Mondino. In the left figure, torso serves as an anatomical coat of arms. The phrase *inevitabile fatum* (inevitable fate) links the illustration to the iconography of death.

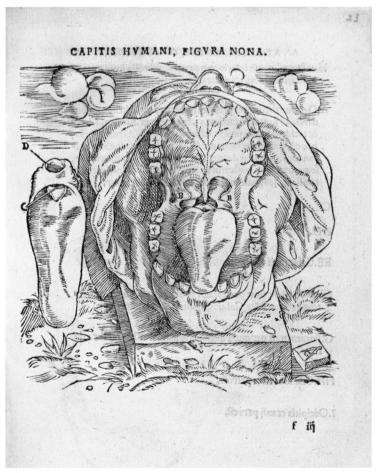

CAPITIS HVMANI, FIGVRA NONA.

103

Cadavers at Play: The Anatomical Visions of Charles Estienne

Charles Estienne's 1545 *De dissectione partium corporis* ("On the dissection of the parts of the human body") would have been the first lavishly illustrated anatomy, had publication not been delayed by a lengthy legal dispute with anatomist–collaborator Étienne de la Rivière. The woodcuts, while imaginative, lack the rigor and detail of Vesalius's 1543 *De fabrica*—and unlike *De fabrica* posed no challenge to the authority of the ancient anatomists. To cut costs, Estienne took some of his illustrations from non-anatomical books, replacing the middle of the woodblock with an insert that depicted the body's interior. In these figures, the boundary of the insert is revealed by a faint white line.

94 **104–105.** Charles Estienne (ca. 1504–1564) [author]. Étienne de la Rivière (d. 1569) [anatomist]. *De dissectione partium corporis humani….* Paris, 1545. Woodcut. National Library of Medicine.

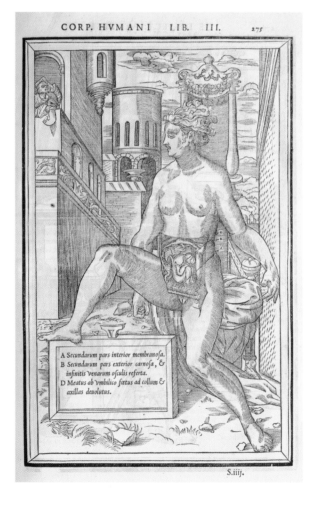

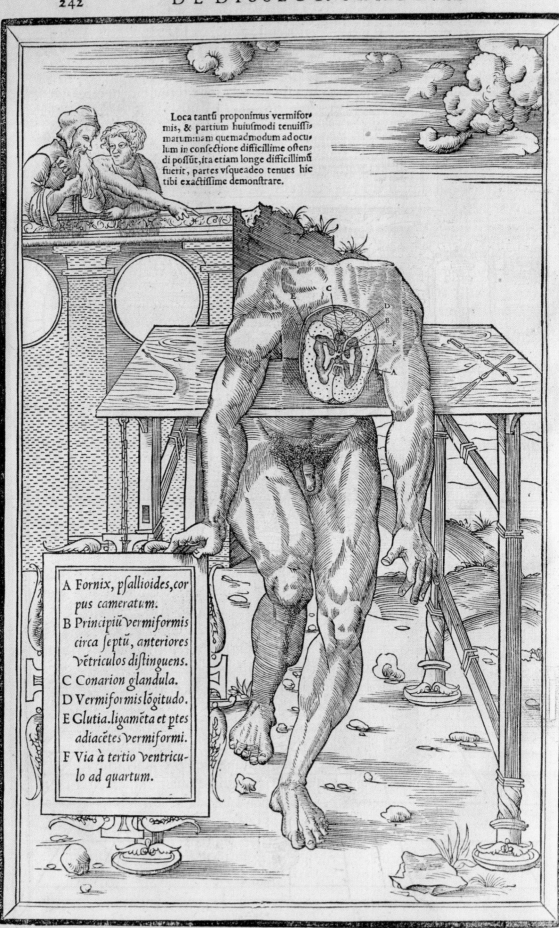

Loca tantũ proponimus vermifor-
mis, & partium huiufmodi tenuiffi-
marum:nam quemadmodum ad ocu-
lum in confectione difficillime often-
di poffũt, ita etiam longe difficillimũ
fuerit, partes vfqueadeo tenues hic
tibi exactiffime demonftrare.

A Fornix, pfallioides, cor-
 pus cameratum.
B Principiũ vermiformis
 circa feptũ, anteriores
 vẽtriculos diftinguens.
C Conarion glandula.
D Vermiformis lõgitudo.
E Glutia.ligamẽta et ptes
 adiacẽtes vermiformi.
F Via à tertio ventricu-
 lo ad quartum.

96

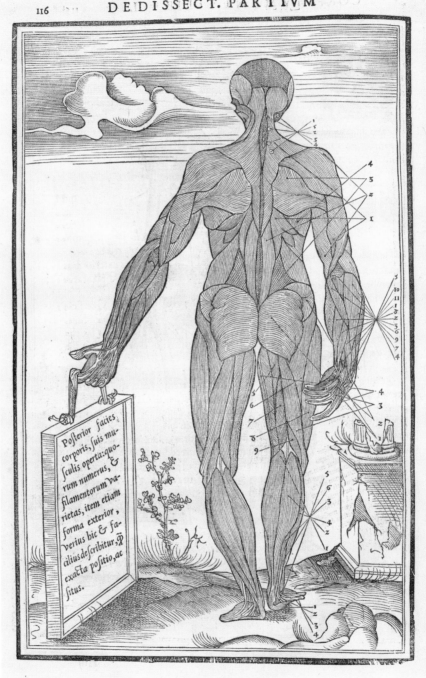

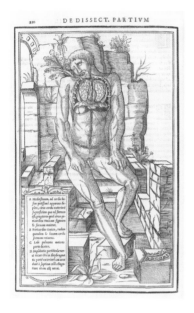

106–109. Charles Estienne (ca. 1504–1564) [author]. Étienne de la Rivière (d. 1569) [anatomist]. *De dissectione partium corporis humani….* Paris, 1545. Woodcut. National Library of Medicine.

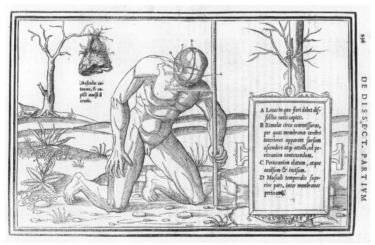

Anatomical Arts and Sciences

In 1543, Andreas Vesalius produced *De humani corporis fabrica,* the first profusely illustrated anatomy book. A brilliant dissector, the 28-year-old Vesalius insisted that reliable knowledge derives from examination of cadavers, not ancient texts. He subjected the old anatomical treatises to a rigorous test: a comparison with his own direct observations of the dissected human body. *De fabrica* became the founding text of modern anatomy and inspired a host of successors. Like Vesalius, they compared their results with existing texts, corrected errors, and produced new texts with illustrations. The production of images based on dissection became a central component of scientific anatomy.

98 **110–111.** Andreas Vesalius (1514–1564) [anatomist]. Stephen van Calcar and the Workshop of Titian [artists]. *De humani corporis fabrica....* Basel, 1543. Woodcut. National Library of Medicine.

(This page.) The only known first-hand likeness of Vesalius shows the formally attired anatomist grasping the dissected arm of a cadaver. Vesalius's head is disproportionately large compared to his body, but the cadaver is larger still—leading to speculation that the engraver pulled the composition together from several sources.

(Opposite page.) Vesalius dissects a cadaver in the center of a crowded anatomical theater, while Death hovers over the scene. Before *De fabrica*, depictions of dissection showed the anatomist presiding at some distance from the cadaver, while lower ranking barber-surgeons did the dirty work of dissection.

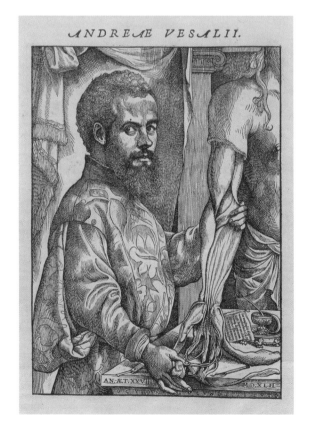

ANDREÆ VESALII.

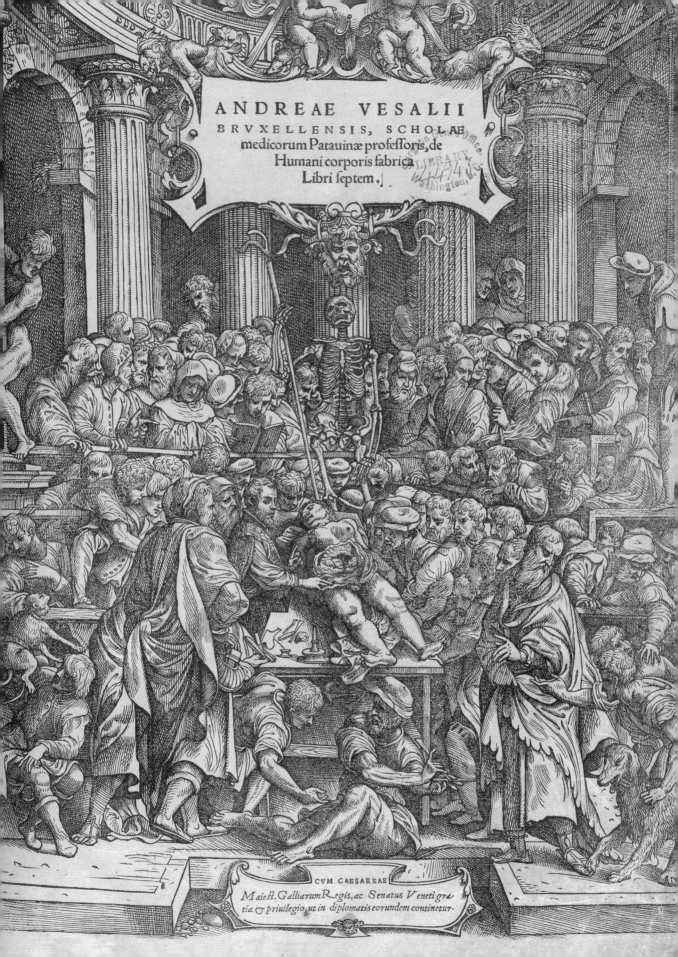

ANDREAE VESALII
BRVXELLENSIS, SCHOLAE
medicorum Patauinæ profeſſoris, de
Humani corporis fabrica
Libri ſeptem.

CVM CAESAREAE
Maieſt. Galliarum Regis, ac Senatus Veneti gra
tia & priuilegio, ut in diplomatis eorundem continetur.

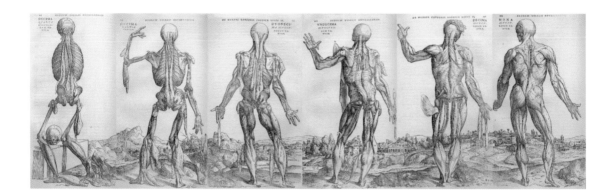

100

112–116. Andreas Vesalius (1514–1564) [anatomist]. Stephen van Calcar and the Workshop of Titian [artists]. *De humani corporis fabrica….* Basel, 1543. Woodcut. National Library of Medicine.

(Above.) In combination, the backgrounds of the muscle men illustrations form an idealized panoramic view of the Paduan landscape.

(Opposite page.) Vesalius hoped that his illustrations would be useful to artists as well as students of anatomy.

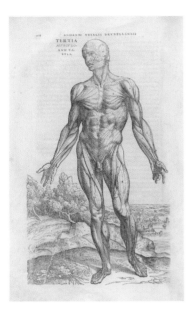

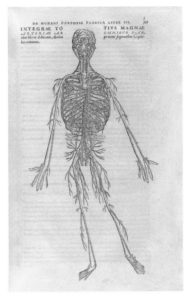

INTEGRAE TO TIVS MAGNAE

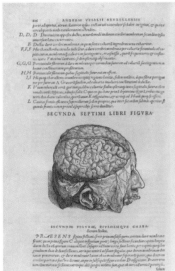

SECVNDA SEPTIMI LIBRI FIGVRA.

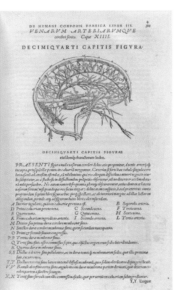

DE HVMANI CORPORIS FABRICA LIBER III.

VENARVM ARTERIARVMQVE

DECIMIQVARTI CAPITIS FIGVRA.

Vesalius's Progeny: Valverde and Eustachi

De fabrica inspired other anatomists to attempt their own books. Juan Valverde de Amusco studied with Realdo Columbo, Vesalius's pupil and successor. Valverde's *Historia de la composición del cuerpo humano* (1556) was the first anatomy published in Spanish. Valverde used Vesalius's work as a source for his own anatomical visions, which humorously played on identifications of self and other, and of matter and spirit.

Bartolomeo Eustachi (also known as Eustachius) was court physician to the Duke of Urbino and Cardinal Giulio della Rovere. In 1552 he prepared a series of playful anatomical plates that featured figures placed inside a box with graduated measurements to help readers identify the location and scale of the parts. Most of the plates were discovered and published in 1714, long after his death.

102 **117, 120–121.** Bartolomeo Eustachi (d. 1574) [anatomist]. Giulio de'Musi (fl. 1535–1553) [artist]. *Romanae archetypae tabulae anatomicae novis….* Rome, 1783. Colored copperplate engraving. National Library of Medicine.

 118–119. Juan Valverde de Amusco (1525–ca. 1588) [anatomist]. Gaspar Becerra (1520?–1568?) [artist]. *Anatomia del corpo humano….* Rome, 1560. Copperplate engraving. National Library of Medicine.

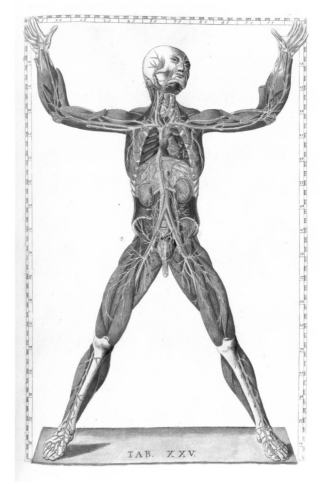

117

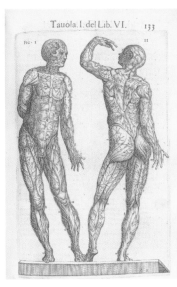

118

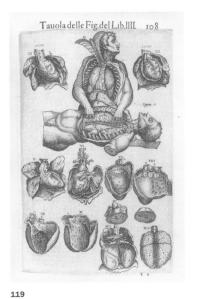

119

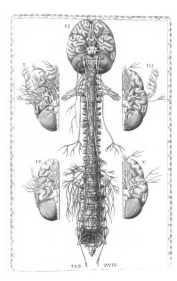

120

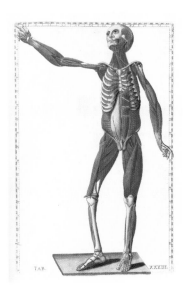

121

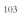

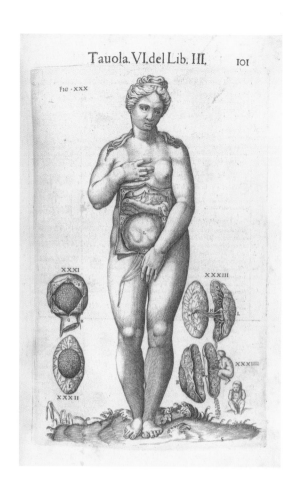

104

122–123. Juan Valverde de Amusco (1525–ca. 1588) [anatomist]. Gaspar Becerra (1520?–1568?) [artist]. *Anatomia del corpo humano....* Rome, 1560. Copperplate engraving. National Library of Medicine.

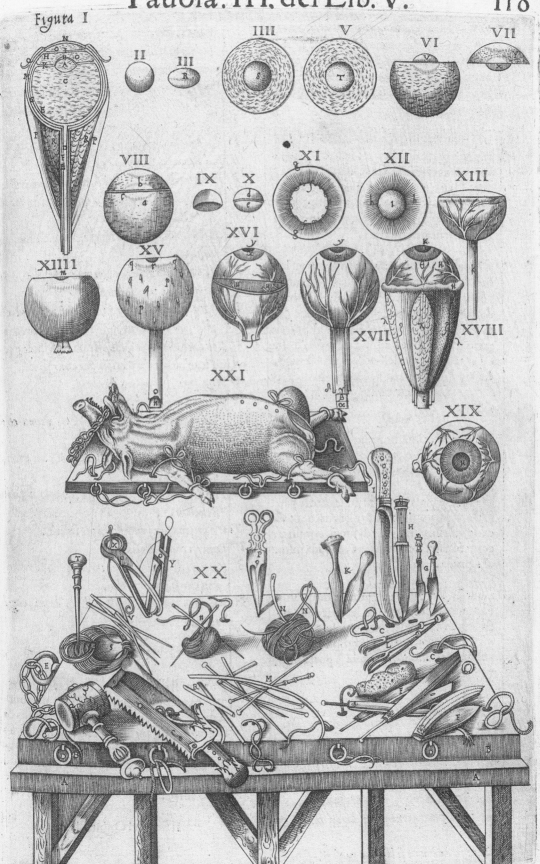

Figura I

A Peek in the Cabinet: Ruysch's Theater of the Body

Frederik Ruysch (1638–1731) was the first great exponent of the anatomical specimen. Visitors from all over Europe came to marvel at his "repository of curiosities." As Amsterdam's chief instructor of midwives and "legal doctor" to the court, Ruysch had ample access to the bodies of stillborns and dead infants and used them to create bizarre multi-specimen scenes. In making such displays, he claimed an extraordinary privilege: the right to collect and exhibit human material without the consent of the anatomized.

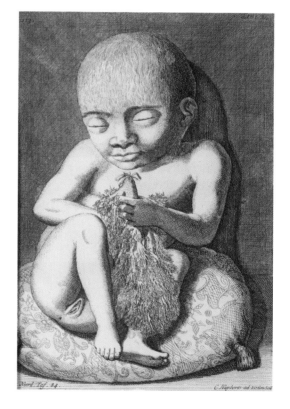

106 **124.** Frederik Ruysch (1638–1731) [anatomist]. *Alle de ontleed-genees-en heelkindige werken...* Vol. 3. Amsterdam, 1744. Taf. 85. Etching with copperplate engraving. National Library of Medicine.

An embalmed female baby, placed on a cushion, holds a tree of wax-injected air-passages from the lungs (the left main bronchus of the lung). The stem (trachea) of the trees is tied off with a ribbon, a typically Ruyschian touch of whimsy.

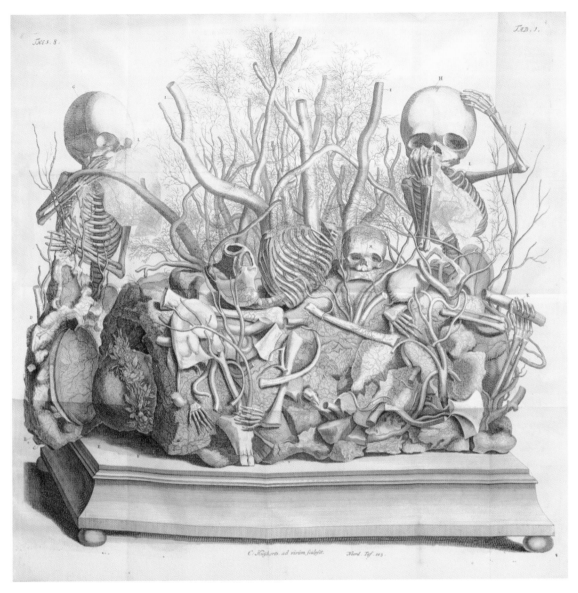

125. Frederik Ruysch (1638–1731) [anatomist]. *Alle de ontleed-genees-en heelkindige werken…* Vol. 3. Amsterdam, 1744. Page 32; foldout. Etching with copperplate engraving. National Library of Medicine.

Ruysch festooned infant skeletons with various objects, organic and non-organic, and arranged them in grotesque landscapes of body parts.

Body Part as Body Art: The Anatomical Specimen

In the late 1600s, a new anatomical art form emerged: the specimen. Anatomists began to collect and exhibit bodies and body parts. Their specimens were real—and they dazzled viewers. Like wax and marble, the human body served as a sculptural medium. The anatomist preserved his material, and then colored, costumed, and arranged it in glass cases or free-standing displays.

Anatomists produced objects using different methods in different media. "Natural" preparations, made from human or animal bodies, could be "wet" (submerged in alcoholic preservative in sealed jars) or "dry" (injected with resins or wax, and then dried). Anatomists also made "artificial" preparations from wax, papier mâché and other materials.

126. Unknown anatomist. Rosamond Purcell (b. 1942) [photographer]. Dissected, cleared and stained baby in a jar. Amsterdam, early 20th century. Anatomical specimen. Vrolik Museum, Amsterdam. Photograph, 1995. National Library of Medicine.

The transparency method of preparing specimens, using "green oil," was invented by German anatomist Werner Spalteholz (1861–1940). The blood vessels, injected with a stain, stand out from the transparent tissue. Most of Spalteholz's specimens were destroyed by bombing during World War II.

127. Unknown anatomist. Rosamond Purcell (b. 1942) [photographer]. Skeleton of a child. Anatomical specimen. Warren Museum, Harvard Medical School, Boston, 19th century. Photograph, ca. 1989. National Library of Medicine.

128. Unknown anatomist. Rosamond Purcell (b. 1942) [photographer]. Dissected hand with stretched tendons, mounted on a board. Dried anatomical specimen. University of Valladolid, Spain, 18th or 19th century. Photograph, 1995. National Library of Medicine.

126

127

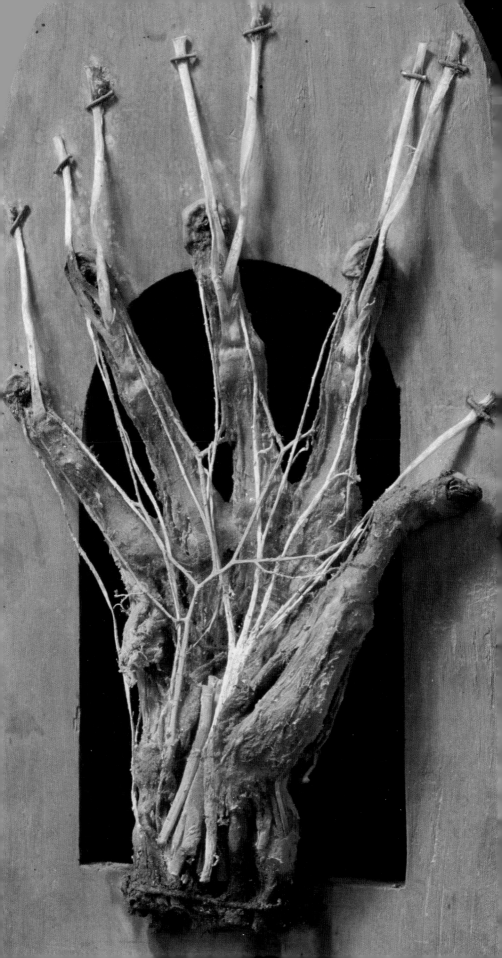

Show-Off Cadavers: The Anatomy of Self Display

The emergence of anatomical illustration in the period 1500–1750 coincided with a larger phenomenon: a new definition of personhood that was performed in salons, coffeehouses, country estates, theaters, marketplaces and at court. Inevitably, anatomists took up, commented on, and played with the contemporary obsession with self-fashioning and individuality—it was an era of manners, wit, foppishness, and coquetry. In the works of Giulio Casserio, John Browne and Pietro da Cortona, the illustrated anatomy book is a stage peopled with posing, prancing cadavers. Animated with an exuberant vitality, the corpses perform an anatomical show for the reader's gaze.

110 **129–131.** Giulio Casseri (1552–1616) and Adriaan van de Spiegel (1578–1625) [anatomists]. Odoardo Fialetti (1573–1638) [artist]. *De humani corporis fabrica libri decem.* Venice, 1627. Copperplate engraving. National Library of Medicine.

Dressed in bonnets, sashes, and undressed down to skin and layers beneath, Casserio's figures have the look of everyday people: peddlers, farmwives, artisans, laborers, prostitutes, debtors. Each one evokes a distinctive yet familiar personality, an attempt at realism with a hint of comic exaggeration. Some of the figures stage a not-so-subtle flirtation, a strip-show.

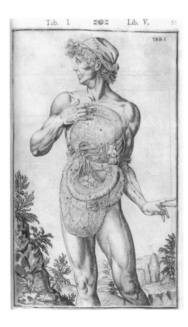

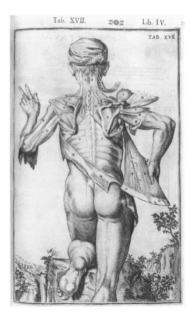

TAB. VI.

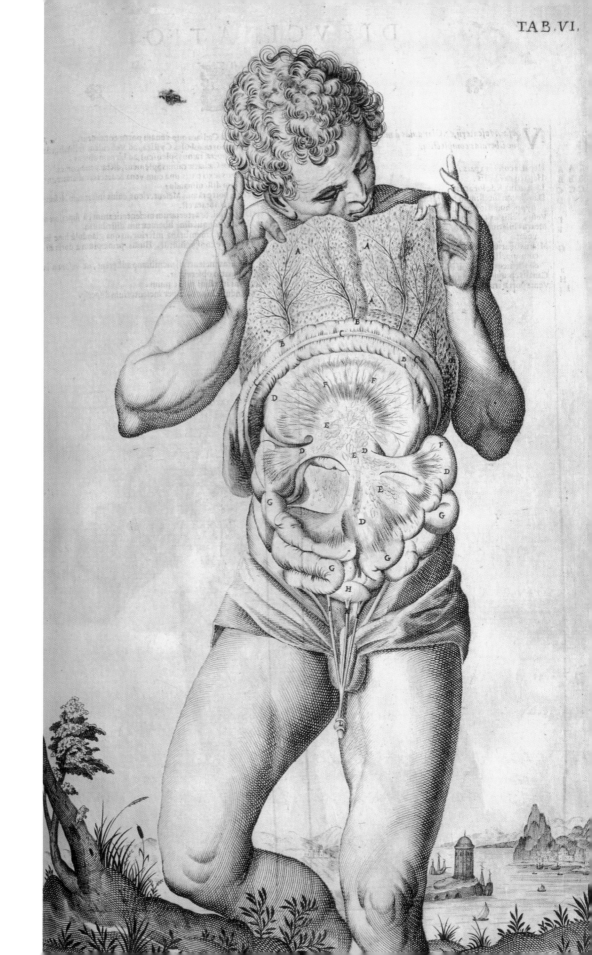

Tab. II

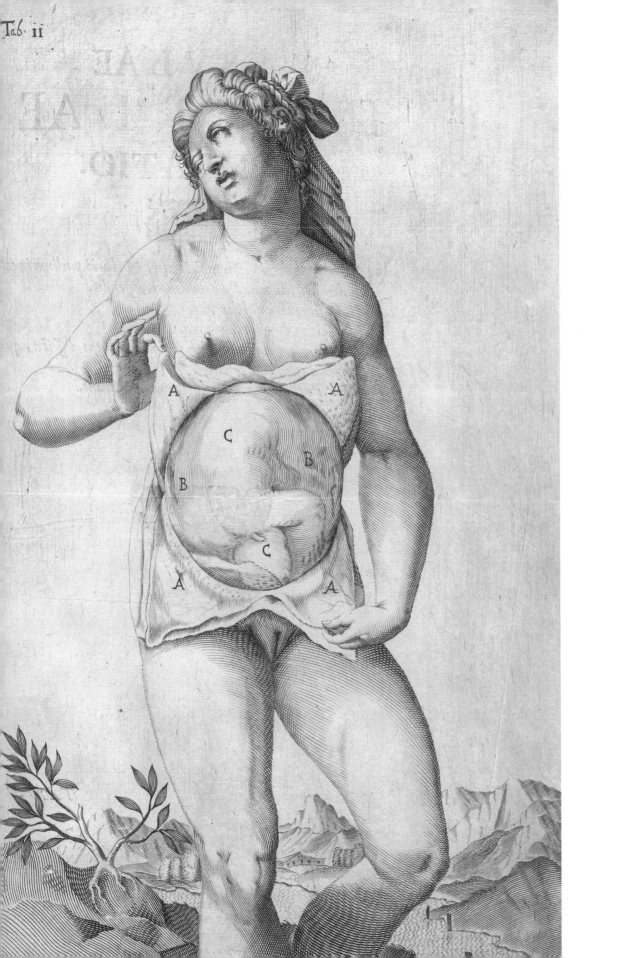

133

134

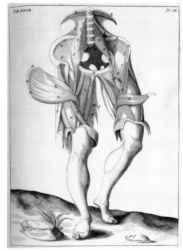

135

132. In Adriaan van de Spiegel (1578–1625), Giulio Casseri (1552–1616) [anatomists]. Odoardo Fialetti (1573–1638) [artist]. In *De formato foetu liber*.... Padua, 1626. Tab. II. Copperplate engraving. National Library of Medicine.

133–134. Giulio Casseri (1552–1616) and Adriaan van de Spiegel (1578–1625) [anatomists]. Odoardo Fialetti (1573–1638) [artist]. *De humani corporis fabrica libri decem*. Venice, 1627. Copperplate engraving. National Library of Medicine.

135. John Browne (1642–ca. 1702) [anatomist]. *A compleat treatise of the muscles, as they appear in the humane body, and arise in dissection*.... London, 1681. Page 98. Copperplate engraving. National Library of Medicine.

Fig. 1.
Pl. II

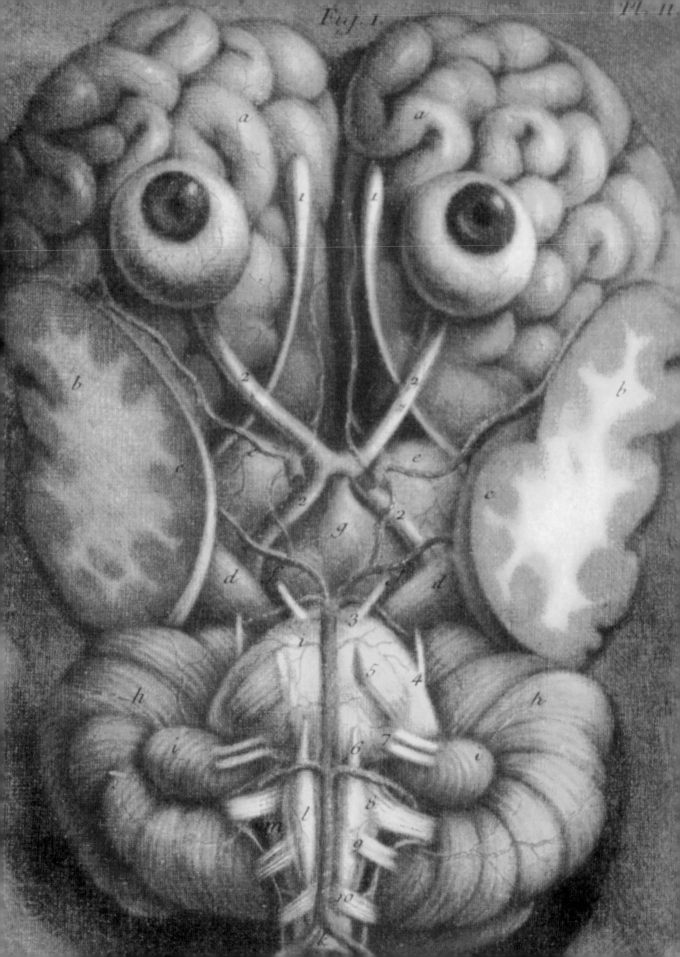

GETTING REAL
REMOVING METAPHOR AND FANCY FROM ANATOMY

Between 1680 and 1800, anatomists began purging imaginative elements from scientific illustration. The truth-value of anatomy, they argued, was compromised by visual metaphors, fantastic landscapes, and comic poses. As old print technologies were perfected and new ones invented, anatomical illustration began to achieve greater technical precision, and a brilliant and dreamlike hyper-aestheticism that showed off, with great artistry, a more sophisticated knowledge and heightened perception of the boundaries, surfaces and depths of the body.

Ultimately, two styles of anatomical realism emerged. One aimed to show the reality of dissection, the cutting open of a particular body with all the prosthetics, furniture and setting of dissection—and the ugliness of anatomical mutilation. The other aimed to show a higher reality, displaying beautified, cleaned-up, idealized bodies and body-parts that float in air, with no reference to any one dissection.

Monumental Books and Anatomical Pleasures

In the eighteenth century, the development of mezzotint, and printing methods that combined etching and engraving, made it possible to make illustrations of startling beauty and painterly texture. Published in monumental scale and on fine paper, these plates were spectacles of anatomical science, artistry and advanced print technology—the final act of anatomy's theatrical tradition. Two notable exponents of this extravagant anatomy were the German anatomist Bernhard Siegfried Albinus (1697–1770) and French artist-printer-publisher Jacques Fabien Gautier d'Agoty (1717–1785).

In the 1720s Albinus proposed to make the most beautiful and comprehensive anatomical atlas ever published, using stylized figures representing an ideal humanity. He never completed the project, but did produce *Tabulae sceleti e musculorum corporis humani* (1747). According to Albinus, the poetically evocative backdrops were designed to "agreeably" fill "the empty spaces" and make his figures look three-dimensional. Later editions omit the backgrounds— a concession to the movement to rid anatomy of extraneous elements.

Gautier d'Agoty perfected a method of printing colored layers of mezzotint (a technique that allows for subtle gradations of shading). The resultant illustrations looked like paintings on a page and were remarkable for their brilliance, eccentricity, and paradoxical combination of delicacy and crudity. The subject of anatomy, with its mass of fine details, was well suited to display Gautier's mastery of mezzotint. It also gave him license to show parts of the body not permitted in other genres of illustration.

116 **136.** Jacques Fabien Gautier d'Agoty (1717–1785) [artist; printer]. *Anatomie des parties de la génération de l'homme et de la femme.* Paris, 1773. Pl. 56. Color mezzotint. National Library of Medicine.

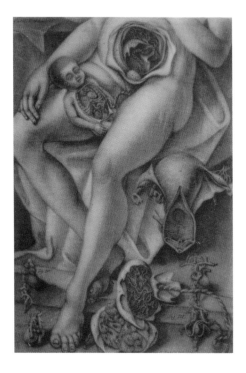

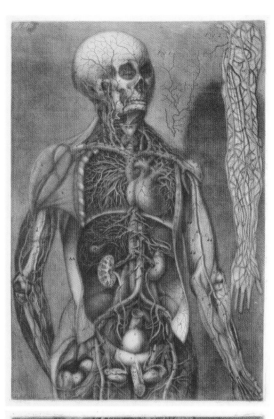

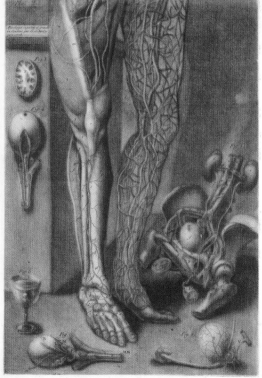

137. Jacques Fabien Gautier d'Agoty (1717–1785) [artist; printer]. *Anatomie des parties de la génération de l'homme et de la femme.* Paris, 1773. Pl. I and II. Color mezzotint. National Library of Medicine.

These two oversize prints can be put together to make a life-size anatomical chart. The grotesquerie of the subject matter, stiffness of the figure, and eccentric arrangement of the body parts make for a characteristic dreaminess that eerily anticipates 20th-century modernism. In the lower left corner a tiny fetus or homunculus floats in a wine-glass.

117

138–140. Bernhard Siegfried Albinus (1697–1770) [anatomist]. Jan Wandelaar (1690–1759) [artist]. *Tabulae sceleti e musculorum corporis humani. London,* 1747. Copperplate engraving with etching. National Library of Medicine.

Albinus intended his figures to exemplify an ideal of humanity and an ideal of anatomical illustration. The cadaver, chosen for its close approximation to classical ideals of proportion, stands against a variety of painterly backdrops, in various states of anatomical undress.

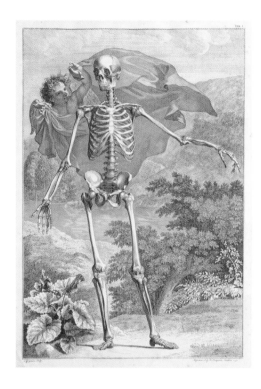

TAB. III.

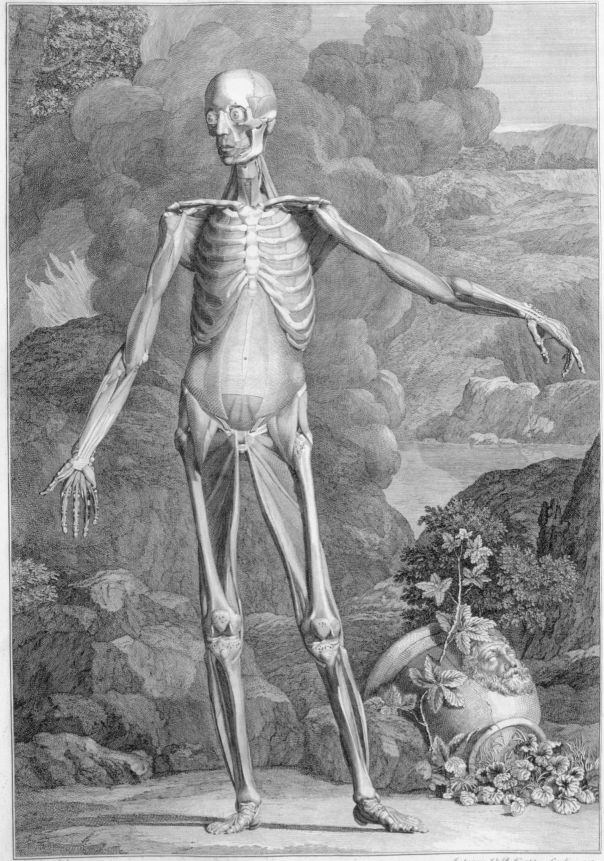

C. Grignion Sculp.

Impensis I. & P. Knapton Londini. 1747.

Beautiful Ugliness: Govard Bidloo and the Turn to Realism

With Dutch anatomist Govard Bidloo, anatomical representation entered a new era. Some of his plates retained iconographical elements, but most were devoid of landscape, metaphor, and classicism. With high artistry, Bidloo flaunted his commitment to empirical observation and naturalistic depiction by showing what other anatomies omitted: the prosthetics of dissection (ropes, props, nails, chains) and the mutilation and ugliness of the dissected body. In producing such images, the anatomist claimed the power to appropriate, and cut into, dead human beings—and demonstrated a masterful clinical detachment, a privileged indifference to the horrors of the anatomy room. The new style initiated by Bidloo was further developed, in the eighteenth century by William Hunter and Albrecht von Haller.

120 **141–142.** Govard Bidloo (1649–1713) [anatomist]. Gérard de Lairesse (1640–1711) [artist]. *Ontleding des menschelyken lichaams….* Amsterdam, 1690. Copperplate engraving with etching. National Library of Medicine.

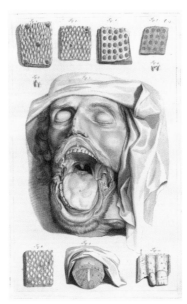

141

142

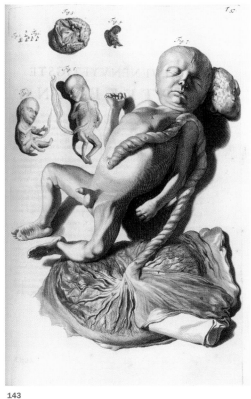

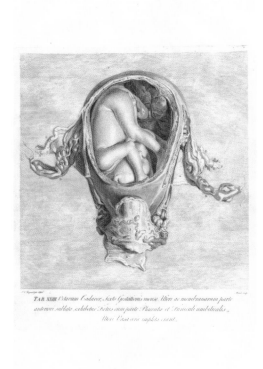

TAB. XXIII *Uterinum Cadaver, sexto Gestationis mense, Utero ac membranarum parte anteriori sublata, exhibetur Fœtus cum parte Placentæ et Funiculo umbilicalis. Uteri Vasa vero ampliora ostent.*

143

144

121

143. Govard Bidloo (1649–1713) [anatomist]. Gérard de Lairesse (1640–1711) [artist]. *Ontleding des menschelyken lichaams....* Amsterdam, 1690. T. 57. Copperplate engraving with etching. National Library of Medicine.

144. William Hunter (1718–1783) [anatomist]. Jan van Riemsdyk (fl. 1750–1788) [artist]. *The anatomy of the human gravid uterus.* Birmingham, 1774. Tab. 23. Copperplate engraving. National Library of Medicine.

The illustrations in Hunter's anatomy were drawn and printed life-size, to avoid distortions of scale.

Casting the Artist Aside: The Anatomy of John Bell

Scottish anatomist John Bell (1763–1820) condemned artists and their "vitious practice of drawing from imagination." There was, he insisted, a "continual struggle between the anatomist and the painter, one striving for elegance of form, the other insisting upon accuracy of representation." Bell solved the problem by drawing, etching, and engraving his own illustrations. These challenged nearly every convention of anatomical representation. His dissected bodies and parts lack sumptuous texture and graceful line, and are unleavened by any palliative beauty.

Designed to signify a commitment to empirical observation, the programmatic harshness of the illustrations exceeds the boundaries of realistic depiction, amounting almost to an oppositional aesthetic of ugliness.

122 **145.** John Bell (1763–1820) [anatomist; artist]. *Engravings of the bones, muscles, and joints, illustrating the first volume of the anatomy of the human body.* 2d ed. London, 1804. Plate III. Etching. National Library of Medicine.

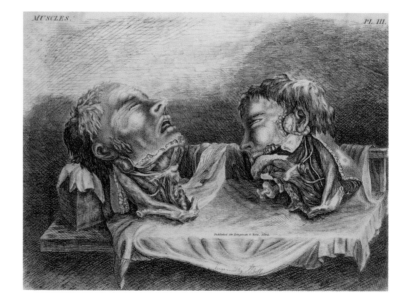

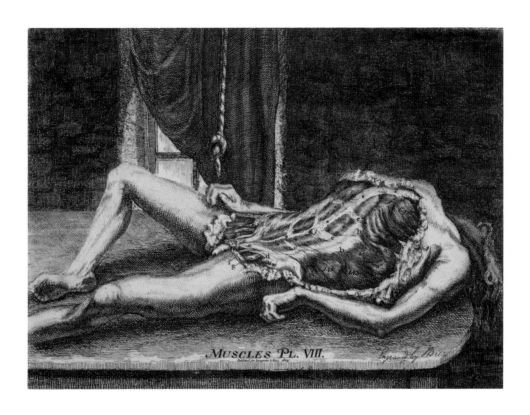

146. John Bell (1763–1820) [anatomist; artist]. *Engravings of the bones, muscles, and joints, illustrating the first volume of the anatomy of the human body.* 2d ed. London, 1804. Pl. VIII. Etching. National Library of Medicine.

Bell criticized "the subjection of true anatomical drawing to the capricious interference of the artist, whose rule it has too often been to make all beautiful and smooth, leaving no harshness" His own drawings and etchings are notably harsh.

Another Reality: The Colorized Human Project

By the late 1700s, the commitment to empirical representation of the body was increasingly asserted by an obsessive attention to detail that went beyond realism. The anatomy of the 1800s featured fine line, rich texture, intense color, and, often, the separation of object from background.

In realistic rendering, detail is sometimes obscured—the eye can't make certain things out. In the hyper-realism of the new anatomy, detail stands out in shocking, dream-like clarity, a demanding visual effect that requires high artistry and a deep understanding of bodily structure. In much of nineteenth-century anatomical illustration, the image is composite, idealized and beautified. Dissection and the anatomy room, the particularity of an anatomical object and its setting, are suppressed as an unnecessary distraction.

147. Jean-Baptiste Sarlandière (1787–1838) [anatomist]. Louis Courtin (fl. 1809–1841) [artist]. *Anatomie méthodique, ou Organographie humaine en tableaux synoptiques, avec figures.* Paris, 1829. Pl. 9. Chromolithograph. National Library of Medicine.

148. John Lizars (1787?–1860) [anatomist]. W. H. Lizars (1788–1859) [artist; engraver]. *A system of anatomical plates of the human body....* Edinburgh, ca. 1825. Plate IV. Hand-colored etching. National Library of Medicine.

John Lizars, a surgeon, teacher, and sometime partner of John Bell, collaborated with his artist brother, William Home Lizars. The Lizars brothers mixed fine line and texture with vibrant coloring, which they achieved through an innovative etching technique. They inked the surface of the plate, not the etched-away areas, as in traditional etching. After printing, each plate was painted by hand.

147

PLATE IV.

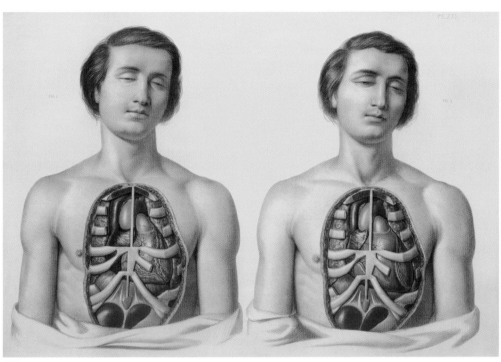

150

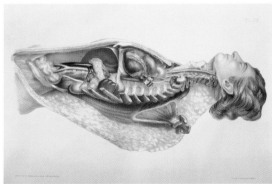

151

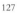

149. Paolo Mascagni (1755–1815) [anatomist]. Antonio Serantoni (1780–1837) [artist]. *Anatomia universale....* Florence, 1833. Strato Terzo Tav. X. Overprinted and hand-colored copperplate engraving. National Library of Medicine.

150–151. Francis Sibson (1814–1876) [anatomist]. William Fairland (fl. mid-1800s) [artist]. *Medical anatomy....* London, 1869. Chromolithograph. National Library of Medicine.

Sibson argued that anatomical illustrations mislead the viewer because preservative injections and the dissection itself disturb the relative position and texture of parts. His double illustration is designed to give a "true" picture of the dead body, alongside an imaginative reconstruction of the same interior in a living body. The vivid colors help the reader to distinguish the parts, even though the resultant picture is far from what the eye would actually see.

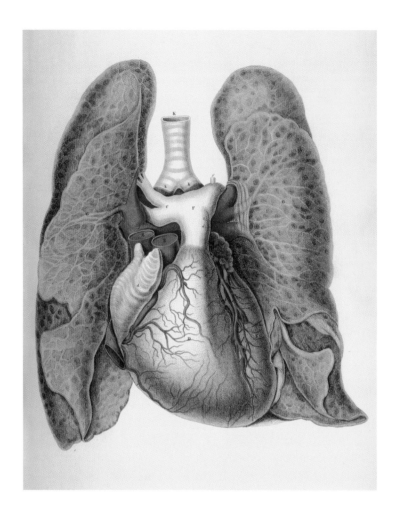

152–153. John Lizars (1787?–1860) [anatomist]. W. H. Lizars (1788–1859) [artist; engraver]. *A system of anatomical plates of the human body....* Edinburgh, ca. 1825. Hand-colored etching. National Library of Medicine.

Scottish anatomist John Lizars was a surgeon, teacher, and sometime partner of John Bell. His brother, William Home Lizars, worked on *Birds of America* for James J. Audubon. Despite the expense of publication, their strikingly colored anatomy sold well. Its success helped the eccentric and contentious John Lizars gain an appointment as Professor of Surgery at the prestigious College of Surgeons of Edinburgh.

PLATE I.

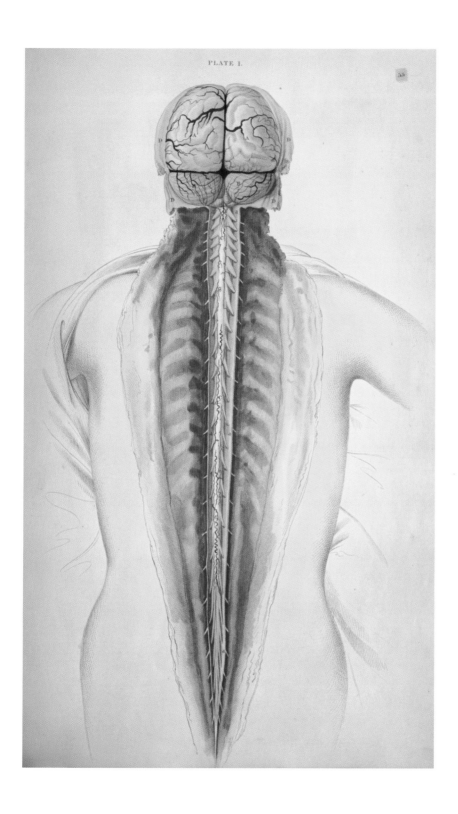

154–155. Paolo Mascagni (1755–1815) [anatomist]. Antonio Serantoni (1780–1837) [artist]. *Anatomia universale....* Florence, 1833. Overprinted and hand-colored copperplate engraving. National Library of Medicine.

Mascagni's great anatomical atlas was published only after his death. A lithographic 1826 edition names Corsican anatomist Francesco Antommarchi (Napoleon's personal physician, and Mascagni's sometime collaborator) as sole author. But scholars recognized the searingly bright colors and stylized grotesquerie of the figures as the distinctive work of Mascagni.

156. Wilhelm Braune (1831–1892) [anatomist]. C. Schmiedel (fl. mid-1800s) [artist]. *Topographisch-anatomischer atlas nach durchschnitten an gefrorenen cadavern....* Leipzig, 1872. Tab. IA. Chromolithograph. National Library of Medicine.

In the 1810s, Dutch anatomist Pieter de Riemer made specimens from frozen human bodies; 40 years later Russian anatomist Nicholas Pirogoff conceived of a similar method "by which the human body could be cut like wood into thin sections." Wilhelm Braune developed and popularized the technique.

130

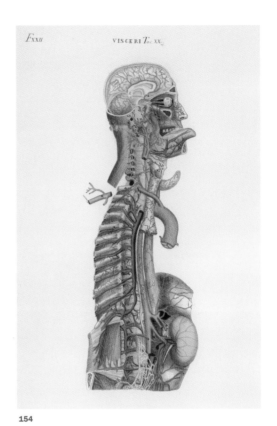

154

155

Tab. I A.

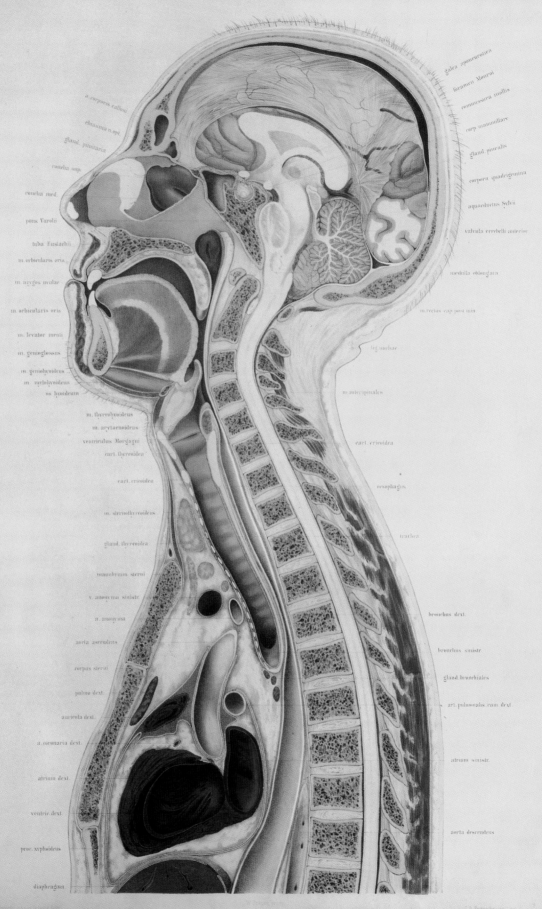

Veit & Comp.

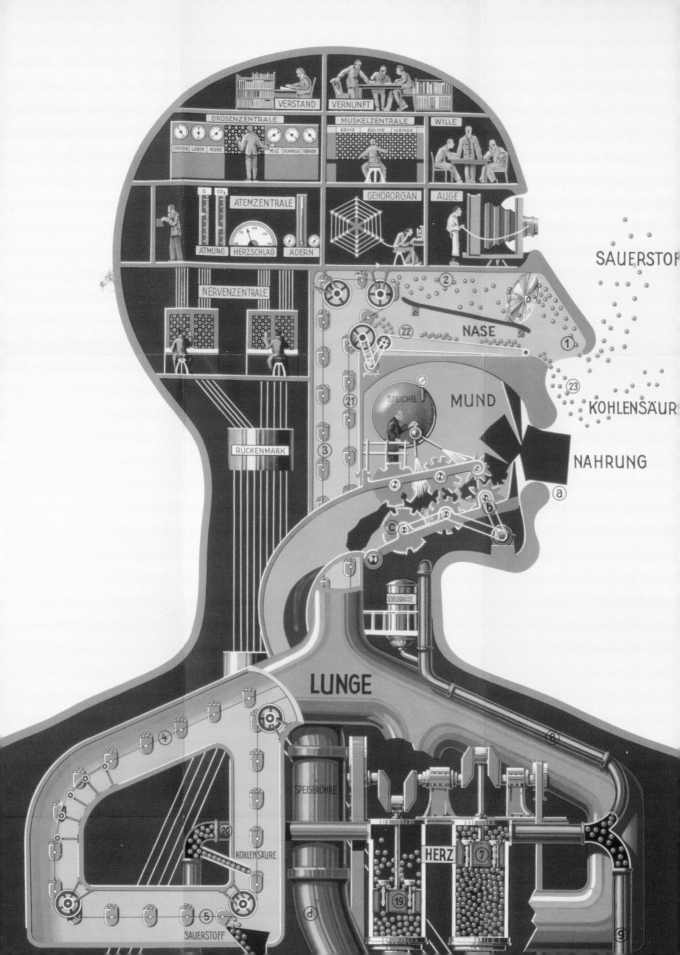

VISIONARY AND VISIBLE
DREAMING ANATOMY IN MODERNITY

By 1800, anatomy had been defined as a science—the investigation of the real—rather than an art. Anatomy could no longer tolerate humor, fancy, and ornament. Yet fantastic images of the anatomical body continued to proliferate. Cast out of medical illustration, imaginative anatomy found new homes: in academic art, where anatomy was an important part of the curriculum; in popular health, where the need to appeal to the public inspired the creation of vivid, playful, and eccentric images; and in political cartoons, film, and fiction—wherever anatomical images could be made to serve.

In our time, photography, radiography, digital imaging, and computer modeling have multiplied the possibilities for manipulation and play. Artists and scientists are again exploring and re-imagining the body, and investigating the boundaries between their respective disciplines. We continue to dream the anatomical body.

Dissection Scenes and Fancies: Anatomical Frontispieces and Title Pages

Title pages and frontispieces functioned as a visual synopsis of the science and art of anatomy—a place where artists could playfully represent the poetics of dissection. Such illustrations typically featured skeletons, cadavers, famous physicians, and mythical or allegorical figures, placed in anatomical theaters and arcadian landscapes, amidst dissecting tables, bones, classical architecture, floating symbols and text. The frontispiece was the last refuge of fantasy in scientific anatomy.

In the mid-1700s anatomists began to omit them, but they continued on in art anatomies and popular scientific books.

134

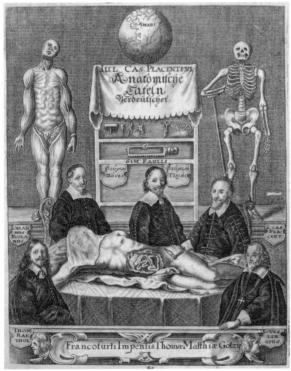

157

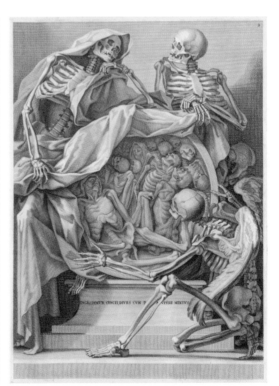

158

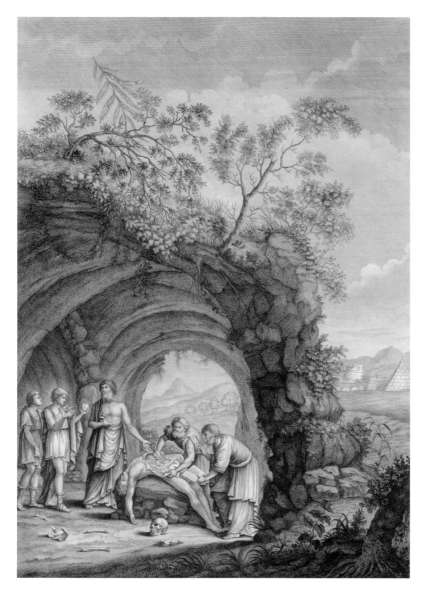

157. Giulio Casserio (ca. 1552–1616) [anatomist]. *Anatomische tafeln....* Frankfurt, 1656. Frontispiece. Copperplate engraving. National Library of Medicine.

Five notable anatomists pose around a cadaver. In the center of the picture, the image of the Earth, with the continent of "America" visible, signifies that the anatomized body is a "New World" and dissection a voyage of discovery.

158. Bernardino Genga (1620–1690?) [anatomist]. Charles Errard (1609?–1689) [artist]. *Anatomia per uso et intelligenza del disegno ricercata....* Rome, 1691. Frontispiece. Copperplate engraving. National Library of Medicine.

The association between death and anatomy continued in art anatomy even as it waned in medical texts. Genga, a Roman anatomist, specialized in studies of classical sculptures. Errard, court painter to Louis XIV, helped found the *Acadèmie Royale de Peinture* and was the first director of the *Acadèmie de France* in Rome.

159. Floriano Caldani (1772–1836) [anatomist]. Gajetano Bosa (1770?–1840) [artist]. *Tabulae anatomicae ligamentorum corporus humani....* Venice, 1803. Frontispiece. Copperplate engraving. National Library of Medicine.

Dreaming Art Anatomy: Fine Art and Anatomical Representation

As naturalistic styles of painting and sculpture developed, artists sought advanced knowledge of anatomy: Vesalius offered some illustrations specifically as an aid to artists. In the seventeenth and eighteenth centuries, formal art academies were founded, with anatomy as a core subject in the curriculum. Professors of anatomy performed dissections for their students, and published beautiful, imaginative, and monumental anatomical studies that were works of art in their own right. Typically, art anatomy used cadavers and skeletons as models for sculpture and painting. It concentrated on skeletal and muscular anatomy and omitted everything else.

136 **160.** Jean-Galbert Salvage (1770–1813) [anatomist; artist]. *Anatomie du gladiateur combattant, applicable aux beaux arts....* Paris, 1812. Planche 1re. Two-layer copperplate engraving, color. National Library of Medicine.

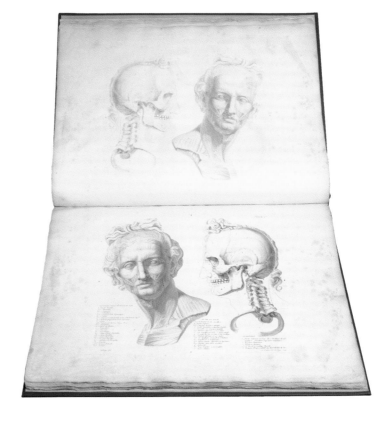

161. Jacques Gamelin (1739–1803) [artist]. *Nouveau recueil d'ostéologie et de myologie.* Toulouse, 1779. Etching. National Library of Medicine.

162. Francesco Bertinatti (fl. mid–1800s) [anatomist]. Paulo Morgari (fl. mid–1800s) [artist]. *Elementi di anatomia fisiologica applicata alle belle arti figurative.* Turin, 1837–1839. Tav. IXa. Lithograph. National Library of Medicine.

137

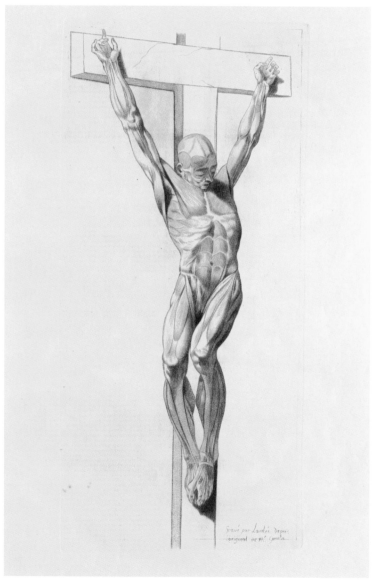

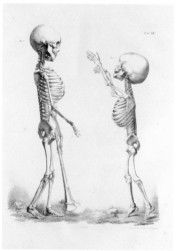

161

162

163. Jean-Galbert Salvage (1770–1813) [anatomist; artist]. *Anatomie du gladiateur combattant, applicable aux beaux arts….* Paris, 1812. Planche 6. Two-layer copperplate engraving, color. National Library of Medicine.

A military doctor of the Napoleonic era, Salvage based his drawings on dissections of soldiers "killed in duels, in their prime." For this study of the Borghese Gladiator, an ancient Greek statue, he arranged his cadavers in the same pose as the sculpture and meticulously worked out the skeletal and muscular anatomy. Anatomical studies of important classical sculptures constituted a genre within fine art.

164. Jacques Gamelin (1739–1803) [artist]. *Nouveau recueil d'ostéologie et de myologie….* Toulouse, 1779. "Orate ne intretis in tentalionem." ("Beware, lest ye be led into temptation".) Etching. National Library of Medicine.

Gamelin combined *memento mori* with anatomical study in beautifully finished etchings that have the formal qualities of engraving. An accompanying page presents the same scene in outline, with each bone marked with a letter linked to a caption.

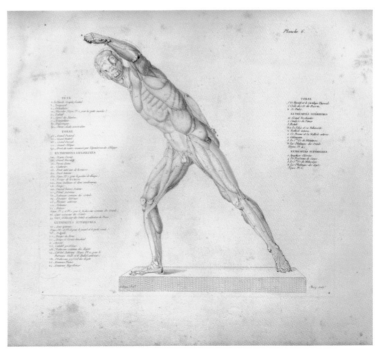

163

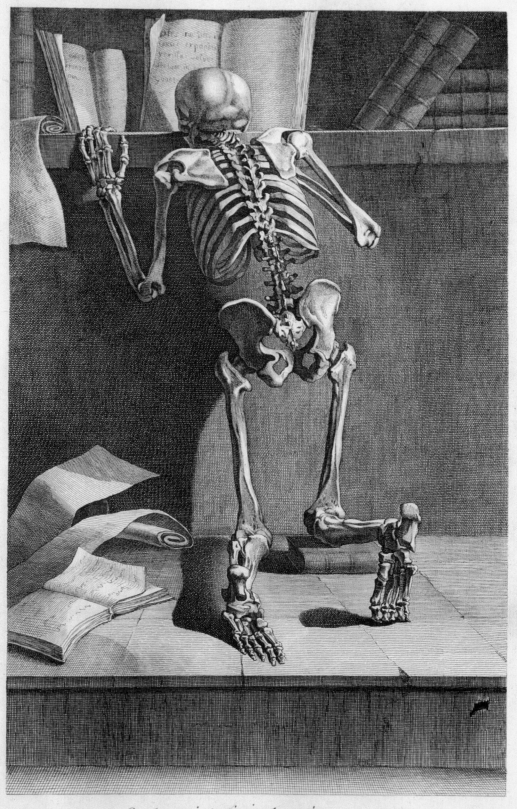

Orate ne intretis in tentationem

The People's Anatomy: Dreaming the Body in Popular Medicine

Although allegory, metaphor, and bizarre juxtapositions were no longer featured in serious scientific texts after 1800, popular writers on medical topics continued to use them. Books and lectures on health attracted large audiences but there was much competition. Phrenologists, dietary reformers, botanical healers, homeopaths, and orthodox health advocates all vied for the public eye and ear. Arresting visual images helped popular writers explain their ideas about the structure and workings of the body.

165. Dr. Franke [author]. *Anatomisch-physioloigischer atlas des menschen…* Berlin, 1891. (Repackaged version of J.T. White, *White's physiological mannikin.* New York, 1889.) Chromolithograph on cardboard. National Library of Medicine.

As lithographic color printing became cheaper, life-size two-dimensional anatomical manikins were increasingly sold for use in popular lectures, classes on hygiene, doctor's offices, and traveling medicine shows where patent medicines were sold.

166. Edwin Hartley Pratt (1849–1930) [author]. Frederick Williams [artist]. *The composite man as comprehended in fourteen anatomical impersonations.* 2nd ed. Chicago, 1901. Plate facing page 95. Lithograph. National Library of Medicine.

Pratt ardently recommended "orificial surgery"—operations on the mouth, nose, ears, rectum, cervix, urethra—for problems such as constipation, eczema, insanity, tuberculosis, or just for maintenance of health. His enthusiasm for surgery led to an emphasis on anatomy in his writings for the public.

165

140

THE SYMPATHETIC MAN

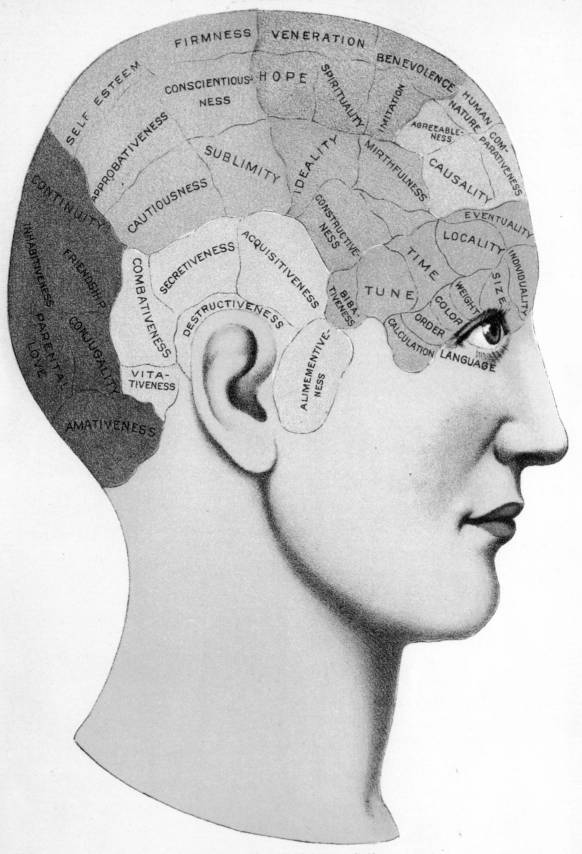

View showing divisions of the
brain according to Phrenology.

167. Edward Harris Ruddock (1822–1875) and George P. Wood (fl. 1880s) [authors]. *Vitalogy; or, Encyclopedia of health and home…*. Vol. 1. Chicago, 1907. Frontispiece. Chromolithograph. National Library of Medicine.

Ruddock, a homeopathic practitioner, wrote popular books on health and a manual of homeopathic veterinary medicine. *Vitalogy* stayed in print for decades and sold over 500,000 copies. It offered readers a smorgasbord of alternative medical treatments, including phrenology.

168. Richard Owen (1804–1892) [author]. *On the nature of limbs; a discourse delivered at an evening meeting of the Royal Institution of Great Britain, Feb. 9, 1849.* London, 1849. Titlepage illustration. Wood engraving. National Library of Medicine.

Owen, a leading anatomist, argued that all vertebrates are based on an ideal "Archetype" or "primal pattern." He criticized Darwin's theory of natural selection, arguing instead that the pattern of species variation was "ordained."

168

Dreaming the Industrial Body: Fritz Kahn's Modernist Physiology

In the early 20th century, Fritz Kahn produced a succession of books on the inner workings of the human body, using visual metaphors drawn from industrial society—assembly lines, internal combustion engines, refineries, dynamos, telephones, etc. The body in Kahn's work was "modern" and productive, a theme visually emphasized through his use of modernist art styles. Though his books sold well, his Jewishness and public advocacy of progressive reform made him a target for Nazi attacks. Rescued by American agent Varian Fry, along with other prominent Jewish scientists and intellectuals, he was brought to America in 1940.

169. Fritz Kahn (1888–1968) [author]. *Das leben des menschen.* Vol. 5. Stuttgart, 1931. Page 53. Relief halftone. National Library of Medicine.

The physiology of vision, with the rods and cones of the pupils as receptors of light, is compared to the technology of photographic reproduction in which an image is screened and broken down into dot patterns. The bust of Nefertiti went on display at the Egyptian Museum in Berlin in 1924 and quickly became a world-famous icon.

170. Fritz Kahn (1888–1968) [author]. *Das leben des menschen; eine volkstümliche anatomie, biologie, physiologie und entwicklungsgeschichte des menschen.* Vol. 2. Stuttgart, 1926. Tafel XIII. Two-color relief halftone. National Library of Medicine.

The nervous system here is represented as an electronical signaling system. The brain is the office where messages are sorted.

144

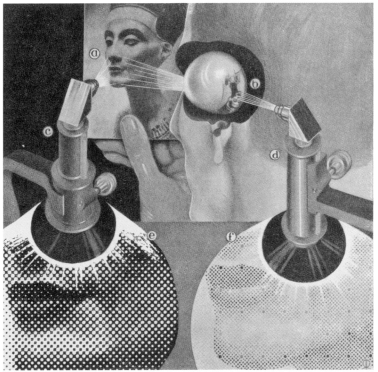

169

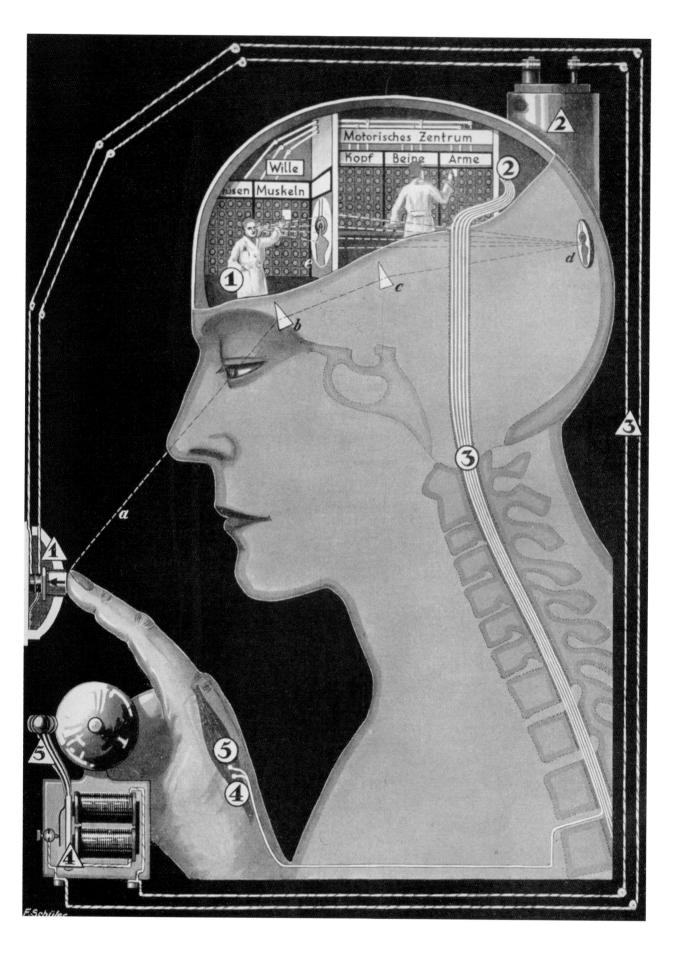

171. Fritz Kahn (1888–1968) [author; artist]. *Der mensch; bau und funktionen unseres körpers, allgemeinverständlich dargestellt.* Zurich, 1948. Page 297. Relief halftone. National Library of Medicine.

The body is shown as a board game, signifying that the distribution of ingested protein in the body is determined by chance and probability.

172. Fritz Kahn (1888–1968) [author; artist]. *Man in structure and function…* Vol. 1. New York, 1943. Page 267. Relief halftone. National Library of Medicine.

A body floats in water, with a U-boat in the distance, showing that the air capacity of the lungs and its effect on the body's buoyancy has a function similar to the ballast tanks of a submarine.

172

173. Fritz Kahn (1888–1968) [author; artist]. *Das Leben des Menschen…* Vol. 2. Stuttgart, 1926. Tafel XXXIII. Relief halftone. National Library of Medicine.

A view from the interior of a nostril.

148

174. Fritz Kahn (1888–1968) [author; artist]. *Man in structure and function…* Vol. 1.
New York, 1943. Page 266. Relief halftone. National Library of Medicine.

As agricultural laborers do the work of harvesting wheat, their bodies burn energy, a
process symbolically represented by an internal flame.

Reuniting the Divided Self:
Katherine Du Tiel and the Art
of Anatomical Identity

The process of anatomy involves a prying
apart of the self. The dissecting mind is
divorced from the dissected body. Our
identification with anatomical images
always creates a mirror effect: anatomical
representations are always both Self and
Other. Katherine Du Tiel makes photographs
of living bodies covered with projected
anatomical images—a playful exploration
of our continual attempts to synthesize the
two, or perhaps an ironic comment on the
impossibility of synthesis.

150

175. Katherine Du Tiel (b. 1961) [artist].
Inside/Outside: Brain Dummy. San
Francisco, 1994. Photograph: © Katherine
Du Tiel. National Library of Medicine.

176. Katherine Du Tiel (b. 1961) [artist].
Inside/Outside: Skull-Head. San Francisco,
1994. Photograph: © Katherine Du Tiel.
National Library of Medicine.

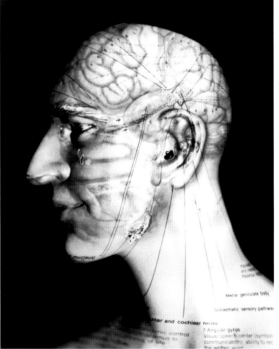

175

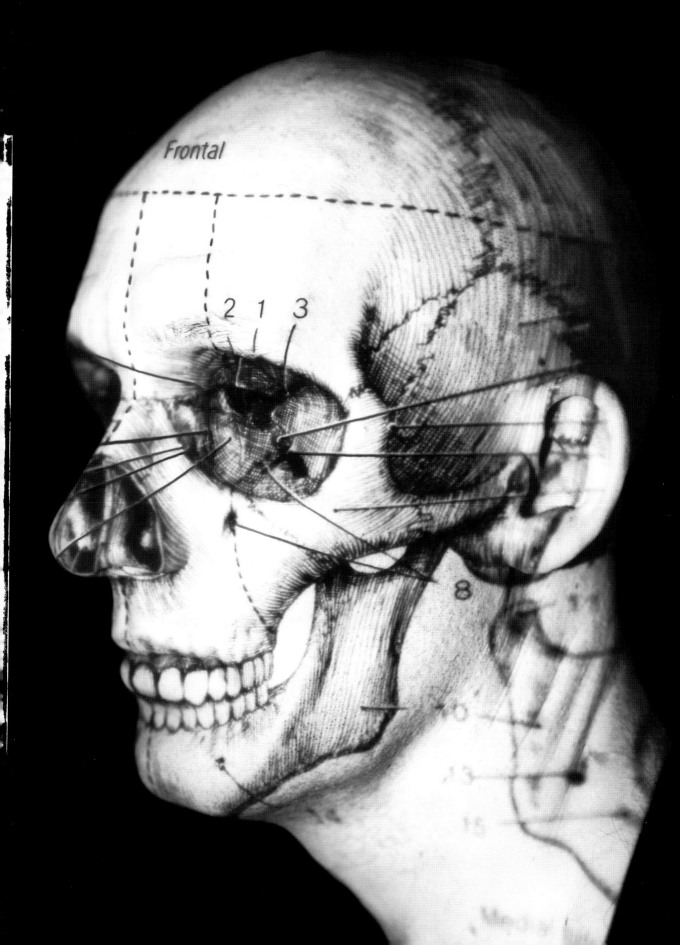

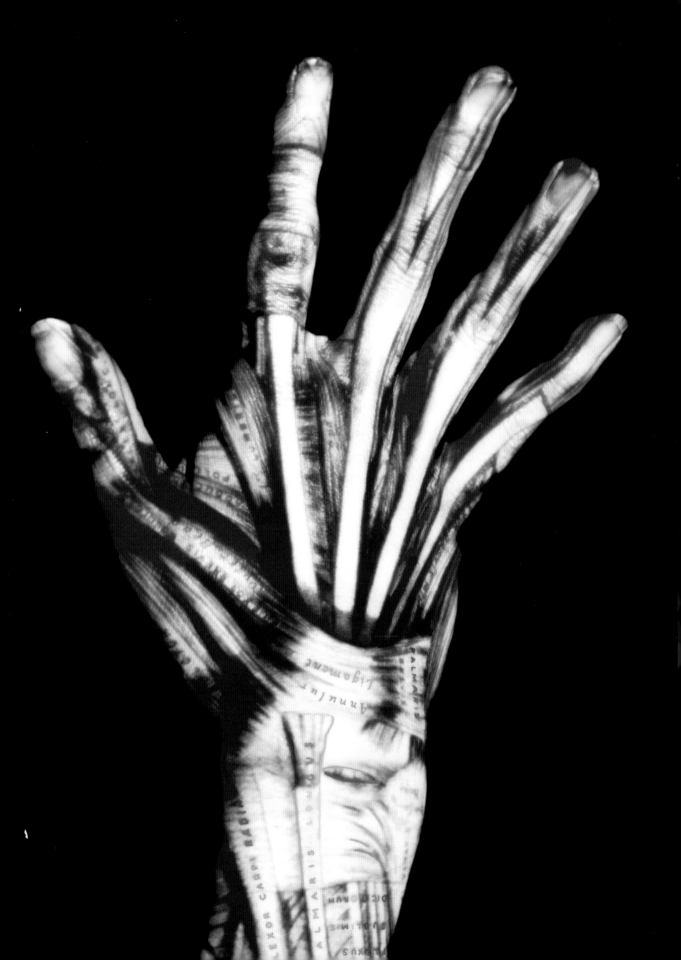

178

177. Katherine Du Tiel (b. 1961) [artist]. *Inside/Outside: Muscle/Hand.* San Francisco, 1994. Photograph: © Katherine Du Tiel. National Library of Medicine.

178. Katherine Du Tiel (b. 1961) [artist]. *Inside/Outside: Back.* San Francisco, 1994. Photograph: © Katherine Du Tiel. National Library of Medicine.

X-Rays and the Cultural Imagination

Wilhelm Roentgen's 1895 discovery of
the X-ray was greeted with rapturous
enthusiasm as one of the technological
wonders of the age. The ability to see
through the skin, into the interior of the
living body, saved lives and profoundly
stirred the cultural imagination. Roentgen
was awarded the first Nobel Prize in
physics and the X-ray rapidly became an
important tool for medical researchers and
clinicians. It also became a favorite subject
for cartoonists and artists—and quickly
found applications in shoe stores and other
unlikely places.

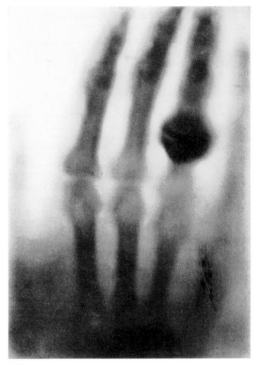

179

154 **179.** The hand of Mrs. Wilhelm Roentgen:
the first X-ray image, 1895. In Otto Glasser,
*Wilhelm Conrad Röntgen and the early
history of the Roentgen rays.* London, 1933.
Photograph. National Library of Medicine.

The announcement of Roentgen's
discovery, demonstrated by a widely
reproduced X-ray photograph of his wife's
hand, was hailed as great scientific
accomplishment that would revolutionize
every aspect of human existence.

180. John Sloan (1871–1951) [artist].
X-Rays. N.p., 1926. Etching. National Library
of Medicine.

Like other exponents of the "Ashcan
School," Sloan sought inspiration from
everyday scenes of modern life, such as the
taking of X-rays, rather than from landscape,
nudes and the other traditional subjects of
academic art.

180

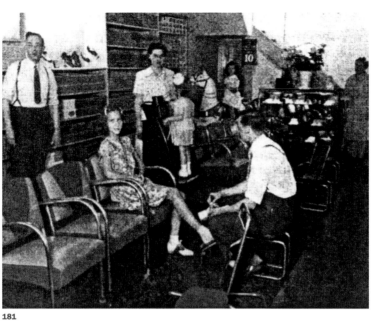

181

182

181. "Deegan Demonstrates How North Country Keeps Pace." In *Shoe and Leather Journal* 26 (1946). Graphic reproduction of a photograph. National Library of Canada.

As the X-ray took hold of the popular imagination, X-ray technology was applied to a variety of medical and non-medical uses. In the 1930s, '40s, and '50s shoe stores often had fluoroscopes to help customers get a good fit.

182. *X-ray of woman's foot, showing fitted shoe.* Photograph. National Museum of Health and Medicine, Armed Forces Institute of Pathology.

The Visible Human Project

Anatomists first began to take cross sections from frozen cadavers in the early 1800s. They found that slices could translate the three-dimensional complexity of organic structures into flat, easy-to-read specimens, which then could be preserved or drawn by an artist.

In 1989 the National Library of Medicine embarked on a plan to use frozen cross sections to make a comprehensive digitized "library" of the human body: the Visible Human Project. Two bodies acquired through donations met bioethical standards of informed consent: a 39-year-old convict executed in Texas by lethal injection; and a 59-year-old Maryland housewife who died of cardiovascular disease. Scientists scanned the cadavers, using CT (computerized tomography) and MRI (magnetic resonance imaging). The corpses, deep-frozen in blue gelatin, were then milled to remove thin cross sections of tissue, from head to toe.

As each layer was exposed, the surface was digitally photographed, creating data that could be reassembled, navigated and manipulated with computer software.

156

183–186. *Visible Human Project Images*
Photographs. National Library of Medicine.

Dream Anatomies: The Art of the Visible Human

Anatomical representation and imaging offer us a trace or facsimile of the inner self: a mirror image that is an incitement to dream. The monumental pieces presented here—works by Alexander Tsiaras, Carolyn Henne and two Visible Human Plexi-Books originally commissioned by the San Francisco Exploratorium—use data from the National Library of Medicine's Visible Human dataset. By virtue of their scale, they model a direct one-to-one correspondence between representation and reality: the anatomical image looms as large as the living, breathing self.

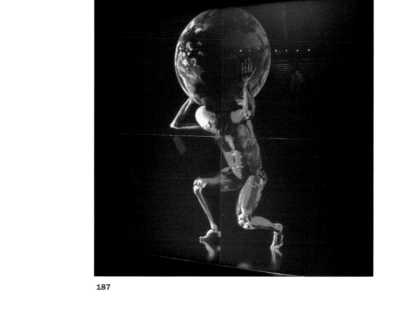

187

158 **187.** *The Visible Human as Atlas Holding the World.* Alexander Tsiaras (b. 1963) [United States]. Animated hologram, 2002. National Library of Medicine.

Seventeenth-century readers were encouraged to think of the anatomical body in geographical terms, as "a little world," a microcosm. "Whatsoever is in the universal world is also in man," and made visible through anatomy, argued Nicholas Culpepper in 1654. This piece, based on a celebrated ancient statue, the Farnese Atlas (ca. 200 A.D., currently in the National Archeological Museum, Naples), updates the metaphor.

188. *The Visible Human Plexi-Book: Male.* Hinged transparencies in Plexiglas, 2000. National Library of Medicine.

Originally created for the San Francisco Exploratorium's *Revealing Bodies* exhibition, these two Visible Human Plexi-books, representing the male and female Visible Human, are now the largest "books" in the National Library of Medicine.

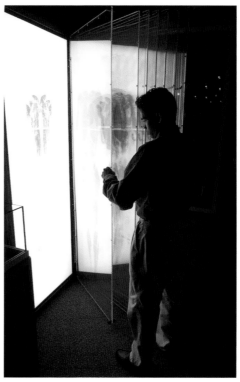

188

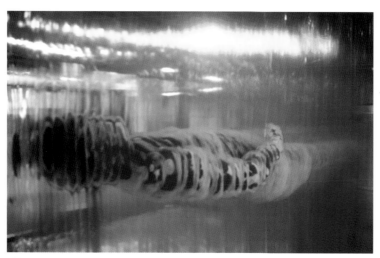

189

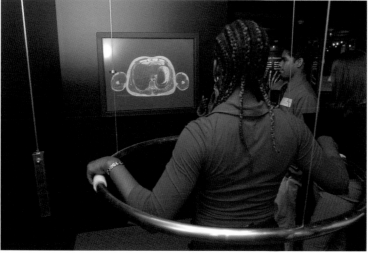

190

189. *Suspended Self Portrait.* Carolyn Henne (b. 1960) [United States]. Sculpture installation, 2001. Courtesy of the artist [now in the National Museum of Health and Medicine]. Photo by Travis Fullerton.

This piece consists of 89 vinyl sheets painted with cross-section images derived from the Visible Human dataset. To determine the images, Henne made a mold of herself and sliced it. Then she painted a corresponding Visible Human cross section on each sheet. From a distance, the body seems to float in three dimensions. Closer up, visitors can touch the sheets to make the organs assemble and dissolve, or subtly move as if floating or breathing.

190. *Body Scanner.* Jussi Ängeslevä (b. 1977) [Finland]. Interactive installation, 2001. Collection of the designer.

Ängeslevä's installation allows a person to track segments of the Visible Human dataset against segments of his or her own body. Despite the discrepancy between displayed image and user—the lack of heartbeat and other internal movements, etc.—visitors often assume they are seeing themselves. The experiential "realness" of *Body Scanner* shows how easily anatomical imagery gets translated into body image.

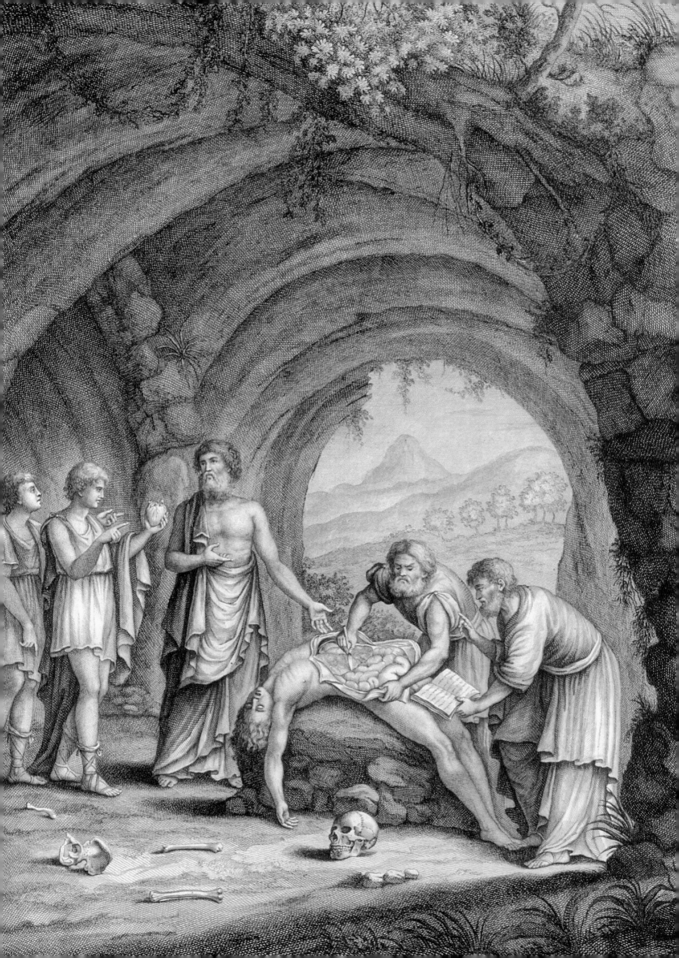

HISTORY OF ANATOMY TIMELINE

275 BCE
Herophilus teaches anatomy, Alexandria, Egypt; performs dissections of human bodies.

ca. 150 AD
Galen dissects apes, monkeys, cows, dogs; writes treatises on human anatomy.

ca. 600–1100
Knowledge of Greek anatomical treatises lost to Western Europeans, but retained in Byzantium and the Islamic world. Islamic scholars translate Greek anatomical treatises into Arabic, Syriac and Persian.

1100s–1500s
Galen's anatomical treatises translated from Arabic into Latin, later from the Greek originals.

1235
First European medical school founded at Salerno, Italy; human bodies are publicly dissected.

1316
Mondino de'Luzzi stages public dissections, Bologna, Italy; writes *Anatomia,* based on the work of Galen.

1450s
Moveable type invented; Gutenberg Bible printed (1455). Copperplate engraving invented.

1490
Anatomical theater opens in Padua, Italy.

1491
First illustrated printed medical book published in Venice, Johannes de Ketham, *Fasciculus medicinae.*

ca. 1500–1540
Earliest printed illustrated anatomies.

1510
Leonardo da Vinci dissects human beings, makes anatomical drawings.

1543
First profusely illustrated printed anatomy, Vesalius's *De humani corporis fabrica.*

1630s
Print etching invented.

1670s–1690s
Schwammerdam, Ruysch and others start making anatomical specimens and museums. Bidloo starts movement toward greater anatomical realism. First art academies founded, with anatomy as a key part of the curriculum.

1740s
Mezzotint color printing method perfected.

1780s
Modern technique of wood engraving developed by Thomas Bewick, England.

1798
Lithography invented by Alois Senefelder, Germany.

1818
Experiments with the frozen cross section technique by Pieter De Riemer, Netherlands.

1837
First practical photographic method invented by Louis Jacques Mande Daguerre, France.

1880s
Relief halftone (photoetching) and photolithography invented.

1895
X-ray imaging demonstrated by Wilhelm Roentgen.

1989
Visible Human Project commences.

191. Detail, Floriano Caldani (1772–1836) [anatomist]. Gajetano Bosa (1770?–1840) [artist]. *Tabulae anatomicae ligamentorum corporus humani....* Venice, 1803. Frontispiece. Copperplate engraving. National Library of Medicine.

162

Woodcut

To make a woodcut, an engraver starts by drawing an image, usually a tracing of a pencil drawing, onto the side grain of a wood plank. Areas not printed are cut away well below the surface with a knife or gouge, leaving the flat surface to be inked. Woodcuts can be put into type blocks along with moveable type, so that the image and type can be printed together in one run through the press.

Copperplate Engraving

In copperplate engraving, an engraver copies a drawing onto the surface of a copper plate. Areas that will be black when printed are cut away below the surface with a sharp tool. The plate is inked and then wiped clean, leaving ink in the incised lines, a method that is called *intaglio*. Copperplate engravings allow for finer lines and more detail than woodcuts, but the printing of the image requires more pressure than type or woodcuts (leaving a characteristic line of indentation around the image). Because of this difference in pressure, if moveable type on the page is desired, then the page has to be run through the press twice, once for the image, once for the type.

Hand Coloring

Before the invention of multiple-layer color printing, black ink anatomical illustrations were sometimes colored freehand, using tempera or watercolor, by freehand, or in some cases stencil.

WOODCUT *COPPERPLATE ENGRAVING* *HAND COLORING* 163

Mezzotint

Unlike other engraving techniques, mezzotint proceeds from dark to light. A metal plate is totally abraded with a tool called a rocker. If inked and printed at this point, it produces an even, rich black. The design consists of areas of tone rather than lines, and is produced by smoothing areas of the plate with a scraper or a burnishing tool. The more scraping and burnishing, the lighter the area. The resultant illustrations have effects of light and shadow. By printing multiple color layers, different shades can be combined to produce rich hues that look much like oil painting.

Lithography

In lithography, a design is drawn or painted on a polished, or grained, flat surface of a stone with a greasy crayon or ink. The image is chemically fixed on the stone with a weak solution of acid and gum arabic. The stone is flooded with water, which is absorbed everywhere except where repelled by the greasy ink. Oil-based printer's ink is then rolled on the stone, which is repelled in turn by the water-soaked areas and accepted only by the drawn design. A piece of paper is laid on the stone and run through the press with light pressure. The design may be divided among several stones, properly registered, to produce a lithograph in more than one color, through multiple printings on the same page.

MEZZOTINT

LITHOGRAPHY

Etching

In etching, a plate is covered with a thin, acid-impervious coating. Lines are drawn through the coating with a stylus, baring the metal of the plate. Acid is then applied which eats into the exposed areas. The longer the plate is exposed to the acid, the deeper the bite and stronger the line. The appearance of etchings is usually free and spontaneous but sometimes can mimic the formality of engraving. The plate is inked and then wiped clean, so that the etched-out areas print black.

Wood Engraving

In wood engraving, an engraver draws an image on polished blocks of dense end-grain wood (usually boxwood). Tools similar to metal engraving are used to produce non-printing lines. The uncut surface takes the ink and prints onto paper. The block can be inserted into a frame along with moveable type, and the entire page can be printed in one run through the press. The familiar nineteenth-century newspaper engraving uses this process, which allows for more detail than the older woodcut technique.

Relief Halftone

Relief halftone is an industrial form of photo-etching. First the artwork is photographed through a dot screen. The negative is exposed onto a zinc plate covered with light-sensitive gelatin. The picture is now converted into a dot pattern. The gelatin on the zinc plate is sensitized by the light through the negative in the shape of the line drawing, and the gelatin which has not been sensitized is washed away. The sensitized area is then covered with a waxy substance resistant to acid; the rest of the plate is etched, so that the dot pattern appears in relief. The image then can be inked and printed onto paper.

ETCHING *WOOD ENGRAVING* *RELIEF HALFTONE* 167

192. Fritz Kahn (1888–1968) [author]. *Das Leben des Menschen; eine volkstümliche Anatomie, Biologie, Physiologie und Entwicklungsgeschichte des Menschen.* Vol. 3. Stuttgart, 1926. Tafel XV. Relief halftone. National Library of Medicine.

EXHIBITION CHECKLIST

A complete list of the books, prints, art installations, multimedia interactives and graphic reproductions on display during the *Dream Anatomy* exhibition (October 9, 2002 to July 31, 2003) at the National Library of Medicine. All dimensions refer to the height and width respectively of the print or the height of the spine of the book.

ANATOMICAL DREAM TIME
THE EARLY MODERN ERA

Pre-Modern Anatomies

Rock painting, Kakadu National Park, Northern Territory, Australia. ca. 6000 B.C.E. Graphic reproduction of a photograph. © Archivo Iconografico, S.A./Corbis.

Mansūr ibn Ilyās (fl. ca. 1390) [author] *Tashrih-i badan-i insan.* Iran, 1488. Graphic reproduction of MS P19, folio 18a. Manuscript. National Library of Medicine.

Anatomical Primitives

Johann Remmelin (1583–1632) [anatomist; artist]. *Catoptrum microcosmicum, visio secunda....* Augsburg? 1613. Copperplate engraving. 20 5/8 by 14 1/4 inches. National Library of Medicine.

Johannes de Ketham (fl. late 15th century) [author]. *Fasciculus medicinae.* Venice, 1500. Woodcut. 12 1/4 inches. National Library of Medicine.

Jacopo Berengario da Carpi (ca. 1460–ca. 1530) [anatomist]. *Isagogae breves per lucidae ac uberrimae in anatomiam human corporis....* Bologna, 1523. Book open to leaf 72. Woodcut. 8 1/4 inches. National Library of Medicine.

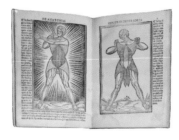

Jacopo Berengario da Carpi (ca. 1460–ca. 1530) [anatomist]. *Anatomia Carpi. Isagoge breves perlucide ac uberime, in anatomiam humani corporis....* Venice, 1535. Book open to leaf 7. Woodcut. 8 inches. National Library of Medicine.

Johannes Eichmann (also known as Dryander) (1500–1560) [anatomist]. *Anatomiae, hoc est, corporis humani dissectionis....* Marburg, 1537. Graphic reproduction of page facing colophon. Woodcut. National Library of Medicine.

Toviyah Kats (ca. 1652–1729) [author]. *Ma'a'seh toviyah.* Venice, 1708. Graphic reproduction of Folio 106 Recto. Woodcut. National Library of Medicine.

Cadavers at Play: The Anatomical Visions of Charles Estienne

Charles Estienne (1504–ca. 1564) [author]. Étienne de la Rivière (d. 1569) [anatomist]. *La dissection des parties du corps humain....* Paris, 1546. Book open to page 242. Woodcut. 14 1/4 inches. National Library of Medicine.

Charles Estienne (ca. 1504–1564) [author]. Étienne de la Rivière (d. 1569) [anatomist]. *De dissectione partium corporis humani....* Paris, 1545. Graphic reproduction of page 275. Woodcut. National Library of Medicine.

Charles Estienne (ca. 1504–1564) [author]. Étienne de la Rivière (d. 1569) [anatomist]. *De dissectione partium corporis humani....* Paris, 1545. Graphic reproduction of page 59. Woodcut. National Library of Medicine.

Anatomical Arts and Sciences

Andreas Vesalius (1514–1564) [anatomist]. Stephen van Calcar and the Workshop of Titian [artists]. *De humani corporis fabrica....* Basel, 1543. Book open to page 187. Woodcut. 16 3/4 inches. National Library of Medicine.

Andreas Vesalius (1514–1564) [anatomist]. Stephen van Calcar and the Workshop of Titian [artists]. *De humani corporis fabrica....* Venice, 1568. Book open to page 125. Woodcut. 12 3/4 inches. National Library of Medicine.

Andreas Vesalius (1514–1564) [anatomist]. Stephen van Calcar and the Workshop of Titian [artists]. *De humani corporis fabrica....* Basel, 1543. Graphic reproduction of portrait of Vesalius. Woodcut. National Library of Medicine.

Andreas Vesalius (1514–1564) [anatomist]. Stephen van Calcar and the Workshop of Titian [artists]. *De humani corporis fabrica....* Basel, 1543. Graphic reproduction of page 192. Woodcut. National Library of Medicine.

Andreas Vesalius (1514–1564) [anatomist]. Stephen van Calcar and the Workshop of Titian [artists]. *De humani corporis fabrica....* Basel, 1543. Graphic reproduction of frontispiece. Woodcut. National Library of Medicine.

Andreas Vesalius (1514–1564) [anatomist]. Stephen van Calcar and the Workshop of Titian [artists]. *De humani corporis fabrica....* Basel, 1543. Graphic reproduction of page 178. Woodcut. National Library of Medicine.

Turning the Pages: Vesalius. Multimedia installation, 2002. Created by the National Library of Medicine

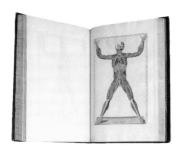

Vesalius's Progeny: Valverde and Eustachi

Bartolomeo Eustachi (d. 1574) [anatomist]. Giulio de'Musi (fl. 1535–1553) [artist]. *Romanae archetypae tabulae anatomicae novis....* Rome, 1783. Book open to Tab XXIV. Colored copperplate engraving. 15 3/4 inches. National Library of Medicine.

Bartolomeo Eustachi (d. 1574) [anatomist]. Giulio de' Musi (fl. 1535–1553) [artist]. *Romanae archetypae tabulae anatomicae novis....* Rome, 1783. Graphic reproduction of Tab XXX. Colored copperplate engraving. National Library of Medicine.

Bartolomeo Eustachi (d. 1574) [anatomist]. Giulio de' Musi (fl. 1535–1553) [artist]. *Romanae archetypae tabulae anatomicae novis....* Rome, 1783. Graphic reproduction of Tab XXXIX. Colored copperplate engraving. National Library of Medicine.

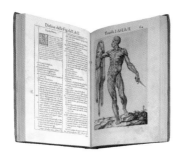

Juan Valverde de Amusco (ca. 1525–ca. 1588) [anatomist]. Gaspar Becerra (1520?–1568?) [artist]. *Anatomia del corpo humano....* Rome, 1559. Book open to page 64. Copperplate engraving. 11 inches. National Library of Medicine.

Juan Valverde de Amusco (ca. 1525–ca. 1588) [anatomist]. Gaspar Becerra (1520?–1568?) [artist]. *Anotomia de corpo humano....* Venice, 1606. Book open to page 108. Copperplate engraving. 12 1/4 inches. National Library of Medicine.

Juan Valverde de Amusco (1525–ca. 1588) [anatomist]. Gaspar Becerra (1520?–1568?) [artist]. *Anatomia del corpo humano....* Rome, 1559. Graphic reproduction of page 95. Copperplate engraving. National Library of Medicine.

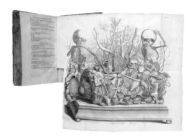

A Peek in the Cabinet: Ruysch's Theater of the Body

Frederik Ruysch (1638–1731) [anatomist]. *Alle de ontleed-genees-en heelkindige werken....* Vol. 3. Amsterdam, 1744. Book open to page 32; foldout. Etching with copperplate engraving. 16 inches. National Library of Medicine.

Frederik Ruysch (1638–1731) [anatomist]. *Alle de ontleed-genees-en heelkindige werken....* Vol. 3. Amsterdam, 1744. Graphic reproduction of frontispiece and title page. Etching with copperplate engraving. National Library of Medicine.

Frederik Ruysch (1638–1731) [anatomist] *Alle de ontleed-genees-en heelkindige werken....* Vol. 3. Amsterdam, 1744. Graphic reproduction of portrait of Ruysch. Etching with copperplate engraving. National Library of Medicine.

Frederik Ruysch (1638–1731) [anatomist]. *Alle de ontleed-genees-en heelkindige werken....* Vol. 3. Amsterdam, 1744. Graphic reproduction of page 568. Etching with copperplate engraving. National Library of Medicine.

Frederik Ruysch (1638–1731) [anatomist]. *Alle de ontleed-genees-en heelkindige werken....* Vol. 3. Amsterdam, 1744. Graphic reproduction of Neerd. Taf. 85. Etching with copperplate engraving. National Library of Medicine.

Frederik Ruysch (1638–1731)
[anatomist]. Rosamond Purcell (b. 1942)
[photographer]. Jar containing hand
grasping the rim of an eyesocket. Leiden,
early 1700s. Anatomical specimen.
Boerhaave Museum, Leiden. 1991.
Photograph. 19 x 13 $^{1/4}$ inches. National
Library of Medicine.

Unknown anatomist. Rosamond Purcell (b.
1942) [photographer]. Dissected, cleared
and stained baby in a jar. Amsterdam,
early 20th century. Anatomical specimen.
Vrolik Museum, Amsterdam. 1995. Graphic
reproduction of a photograph. National
Library of Medicine.

Unknown anatomist. Rosamond Purcell
(b. 1942) [photographer]. Dissected
hand with stretched tendons, mounted
on a board. Dried anatomical specimen.
University of Valladolid, Spain, 18th or 19th
century. 1995. Graphic reproduction of a
photograph. National Library of Medicine.

Show-Off Cadavers: The Anatomy of Self Display

Giulio Casserio (ca.1552–1616)
[anatomist]. Odoardo Fialetti (1573–
1638) [artist]. In Adriaan van Spiegel
(1578–1625), De formato foetu.... Padua,
1627. Graphic reproduction of Tab. IIII.
Copperplate engraving. National Library
of Medicine.

Giulio Casserio (ca. 1552–1616)
[anatomist]. Odoardo Fialetti (1573–1638)
[artist]. Tabulae anatomicae.... Venice,
1627. Graphic reproduction of Tab. XV.
Copperplate engraving. National Library
of Medicine.

Giulio Casserio (ca. 1552–1616)
[anatomist]. Odoardo Fialetti (1573–1638)
[artist]. Tabulae anatomicae.... Venice,
1627. Graphic reproduction of Tab. XVI.
Copperplate engraving. National Library
of Medicine.

Giulio Casserio (ca. 1552–1616)
[anatomist]. Odoardo Fialetti (1573–1638)
[artist]. Tabulae anatomicae.... Venice,
1627. Graphic reproduction of Tab. VI.
Copperplate engraving. National Library of
Medicine.

Giulio Casserio (ca. 1552–1616)
[anatomist]. Josias Murer (1564–1630?)
[artist]. De vocis auditusque organis historia
anatomica singulari fide methodo. Ferrara,
1601. Graphic reproduction of Tab. XIII.
Copperplate engraving. National Library
of Medicine.

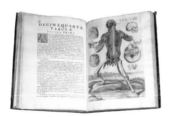

Pietro Berrettini da Cortona (1596–1669)
[artist]. Tabulae anatomicae.... Rome,
1741. Book open to page 38. Copperplate
engraving. 17 $^{1/2}$ inches. National Library
of Medicine.

Pietro Berrettini da Cortona (1596–1669)
[artist]. Unbound plate from Tabulae
anatomicae.... Rome, 1741. Tab. XVI.
Copperplate engraving. 15 $^{1/4}$ x 10 $^{5/8}$
inches. National Library of Medicine.

Pietro Berrettini da Cortona (1596–1669)
[artist]. Unbound plate from Tabulae
anatomicae.... Rome, 1741. Tab. VII.
Copperplate engraving. 15 $^{1/4}$ x 10 $^{5/8}$
inches. National Library of Medicine.

Pietro Berrettini da Cortona (1596–1669)
[artist]. Tabulae anatomicae.... Rome,
1741. Graphic reproduction of Tab. X.
Copperplate engraving. National Library
of Medicine.

Pietro Berrettini da Cortona (1596–1669)
[artist]. Tabulae anatomicae.... Rome,
1741. Graphic reproduction of Tab. XX.
Copperplate engraving. National Library
of Medicine.

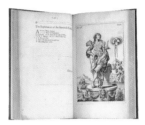

John Browne (1642–ca. 1702) [anatomist].
A compleat treatise of the muscles, as they
appear in the humane body, and arise in
dissection.... London, 1681. Book open
to page 98. Copperplate engraving. 13 $^{1/2}$
inches. National Library of Medicine.

John Browne (1642–ca. 1702) [anatomist].
A compleat treatise of the muscles, as
they appear in the humane body, and arise
in dissection.... London, 1681. Graphic
reproduction of titlepage. Copperplate
engraving. National Library of Medicine.

John Browne (1642–ca. 1702) [anatomist].
Myographia nova.... Leiden, 1687. Graphic
reproduction of frontispiece. Copperplate
engraving. National Library of Medicine.

John Browne (1642–ca. 1702) [anatomist].
Myographia nova.... Leiden, 1687. Graphic
reproduction of Tab. XIII. Copperplate
engraving. National Library of Medicine.

John Browne (1642–ca. 1702) [anatomist]
A compleat treatise of the muscles, as
they appear in the humane body, and arise
in dissection.... London, 1681. Graphic
reproduction of Tab. XIII. Copperplate
engraving. National Library of Medicine.

John Browne (1642–ca. 1702) [anatomist]
A compleat treatise of the muscles, as
they appear in the humane body, and arise
in dissection.... London, 1681. Graphic
reproduction of Tab. XXVII. Copperplate
engraving. National Library of Medicine.

172

Govard Bidloo (1649–1713) [anatomist].
Gérard de Lairesse (1640–1711) [artist].
Ontleding des menschelyken lichaams....
Amsterdam, 1690. Graphic reproduction of
T. 14. Copperplate engraving with etching.
National Library of Medicine.

Govard Bidloo (1649–1713) [anatomist].
Gérard de Lairesse (1640–1711) [artist].
Ontleding des menschelyken lichaams....
Amsterdam, 1690. Graphic reproduction of
T. 88. Copperplate engraving with etching.
National Library of Medicine.

William Hunter (1718–1783) [anatomist].
Jan van Riemsdyk (fl. 1750–1788) [artist].
The anatomy of the human gravid uterus.
Birmingham, 1774. Graphic reproduction
of Tab. VI. Copperplate engraving. National
Library of Medicine.

Albrecht von Haller (1708–1777)
[anatomist]. C. J. Rollinus [artist]. *Icones
anatomicae...* Vol. 2. Göttingen, 1756.
Graphic reproduction of Fascicle II, Lectori
S, Figurae I and II. Copperplate engraving.
National Library of Medicine.

Albrecht von Haller (1708–1777)
[anatomist]. C. J. Rollinus [artist]. *Icones
anatomicae...* Vol. 2. Göttingen, 1756.
Graphic reproduction of Fascicle III, Tab. V.
Copperplate engraving. National Library
of Medicine.

Casting the Artist Aside: The Anatomy of John Bell

John Bell (1763–1820) [anatomist; artist]
*Engravings of the bones, muscles, and joints,
illustrating the first volume of the anatomy
of the human body.* 2d ed. London, 1804.
Book open to page 133. Etching. 10 1/4
inches. National Library of Medicine.

John Bell (1763–1820) [anatomist; artist]
*Engravings of the bones, muscles, and joints,
illustrating the first volume of The anatomy
of the human body.* 2d ed. London, 1804.
Graphic reproduction of Plate VII. Etching.
National Library of Medicine.

Another Reality: The Colorized Human Project

Paolo Mascagni (1755–1815) [anatomist].
Antonio Serantoni (1780–1837) [artist].
Anatomia universale.... Florence, 1833.
Book open to Strato Primo Tavola
Paricolare I. Overprinted and hand-colored
copperplate engraving. 18 inches. National
Library of Medicine.

Paolo Mascagni (1755–1815) [anatomist].
Antonio Serantoni (1780–1837) [artist].
Unbound plate from *Anatomia universal....*
Pisa, 1823. Viscera Tabula VI. Overprinted
and hand-colored copperplate engraving.
28 1/2 x 39 1/4 inches. National Library of
Medicine.

Paolo Mascagni (1755–1815) [anatomist]
Antonio Serantoni (1780–1837) [artist]
Anatomia universale.... Florence, 1833.
Graphic reproduction of Visceri Tav. XX.
Overprinted and hand-colored copperplate
engraving. National Library of Medicine.

Paolo Mascagni (1755–1815) [anatomist]
Antonio Serantoni (1780–1837) [artist]
Anatomia universale.... Florence, 1833.
Graphic reproduction of Strato Terzo Tav. X.
Overprinted and hand-colored copperplate
engraving. National Library of Medicine.

John Lizars (1787?–1860) [anatomist].
W. H. Lizars (1788–1859) [artist; engraver].
Unbound plate from *A system of anatomical
plates of the human body....* Edinburgh, ca.
1825. Plate I. Hand-colored copperplate
etching. 18 1/4 x 11 1/4 inches. National
Library of Medicine.

John Lizars (1787?–1860) [anatomist].
W. H. Lizars (1788–1859) [artist; engraver].
*A system of anatomical plates of the human
body....* Edinburgh, ca. 1804. Graphic
reproduction of Plate LXXXIV. Hand-colored
etching. National Library of Medicine.

John Lizars (1787?–1860) [anatomist].
W. H. Lizars (1788–1859) [artist; engraver].
*A system of anatomical plates of the human
body....* Edinburgh, ca. 1825. Graphic
reproduction of Plate IX. Hand-colored
etching. National Library of Medicine.

John Lizars (1787?–1860) [anatomist].
W. H. Lizars (1788–1859) [artist; engraver].
*A system of anatomical plates of the human
body....* Edinburgh, ca. 1825. Graphic
reproduction of Plate I. Hand-colored
etching. National Library of Medicine.

Wilhelm Braune (1831–1892) [anatomist].
C. Schmiedel (fl. mid-1800s) [artist].
*Topographisch-anatomischer atlas nach
durchschnitten an gefrorenen cadavern....*
Leipzig, 1872. Graphic reproduction of Tab.
III. Chromolithograph. National Library
of Medicine.

Wilhelm Braune (1831–1892) [anatomist].
C. Schmiedel (fl. mid-1800s) [artist].
*Topographisch-anatomischer atlas nach
durchschnitten an gefrorenen cadavern....*
Leipzig, 1872. Graphic reproduction of Tab.
IA. Chromolithograph. National Library of
Medicine.

Jean Baptiste Sarlandière (1787–1838)
[author]. *Systematized anatomy; or, Human
organography.* New York, 1837. Book open
to Plate XV. Chromolithograph. 14 inches.
National Library of Medicine.

173

George Viner Ellis (1812–1900) [anatomist]. George Henry Ford (1809–1876) [artist]. *Illustrations of dissections in a series of original coloured plates, the size of life, representing the dissection of the human body....* London, 1867. Graphic reproduction of Plate XXV. Chromolithograph. National Library of Medicine.

Francis Sibson (1814–1876) [anatomist]. William Fairland (fl. mid-1800s) [artist]. *Medical anatomy....* London, 1869. Graphic reproduction of Plate XXI. Chromolithograph. National Library of Medicine.

Francis Sibson (1814–1876) [anatomist]. William Fairland (fl. mid-1800s) [artist]. *Medical anatomy....* London, 1869. Graphic reproduction of Pl. IX. Chromolithograph. National Library of Medicine.

174

VISIONARY AND VISIBLE
DREAMING ANATOMY IN MODERNITY

Dissection Scenes and Fancies: Anatomical Frontispieces and Title Pages

Giulio Casserio (ca. 1552–1616) [anatomist]. *Anatomische tafeln....* Frankfurt, 1656. Graphic reproduction of frontispiece. Copperplate engraving. National Library of Medicine.

Bernardino Genga (1636?–1734?) [anatomist]. Charles Errard (1609?–1689) [artist]. *Anatomia per uso et intelligenza del disegno ricercata....* Rome, 1691. Graphic reproduction of frontispiece. Copperplate engraving. National Library of Medicine.

Floriano Caldani (1772–1836) [anatomist]. Cajetano Bosa [artist]. *Tabulae anatomical ligamentorum corporus humani....* Venice, 1803. Graphic reproduction of frontispiece. Copperplate engraving. National Library of Medicine.

Francesco Bertinatti (fl. mid-1800s) [anatomist]. Paolo Morgari (fl. mid. 1800s) [artist]. *Elementi di anatomia fisiologica applicata alle belle arti figurative.* Turin, 1837–1839. Graphic reproduction of frontispiece. Lithograph. National Library of Medicine.

Dreaming Art Anatomy: Fine Art and Anatomical Representation

Jacques Gamelin (1739–1803) [artist]. *Nouveau recueil d'ostéologie et de myologie....* Toulouse, 1779. Book open to plate titled *Orate ne intretis in tentalionem.* Etching. 22 3/4 inches. National Library of Medicine.

Jacques Gamelin (1739–1803) [artist]. *Nouveau recueil d'ostéologie et de myologie....* Toulouse, 1779. Graphic reproduction of portrait of Gamelin. Etching. 22 3/4 inches. National Library of Medicine.

Jacques Gamelin (1739–1803) [artist]. *Nouveau recueil d'ostéologie et de myologie.* Toulouse, 1779. Graphic reproduction of Pl. 28. Etching. National Library of Medicine.

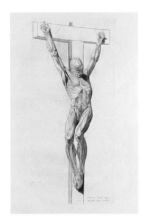

Jacques Gamelin (1739–1803) [artist]. *Nouveau recueil d'ostéologie et de myologie.* Toulouse, 1779. Graphic reproduction of crucifixion study. Etching. National Library of Medicine.

Francesco Bertinatti (fl. mid-1800s) [anatomist]. Paolo Margari [artist]. *Elementi di anatomia fisiologica applicata alle belle arti figurative.* Turin, 1837–1839. Graphic reproduction of Tav. VIIa. Lithograph. National Library of Medicine.

Francesco Bertinatti (fl. mid-1800s) [anatomist]. Paolo Margari [artist]. *Elementi di anatomia fisiologica applicata alle belle arti figurative.* Turin, 1837–1839. Graphic reproduction of Tav. IXa. Lithograph. National Library of Medicine.

Jean-Galbert Salvage (1770–1813) [anatomist; artist]. *Anatomie du gladiateur combattant, applicable aux beaux arts....* Paris, 1812. Book open to Planche 1re. Two-layer copperplate engraving, color. 23 1/2 inches. National Library of Medicine.

The People's Anatomy: Dreaming the Body in Popular Medicine

Frederick Hollick (1818–ca. 1875) [author]. *The origin of life: a popular treatise on the philosophy and physiology of reproduction, in plants and animals, including the details of human generation....* New York–St. Louis, 1845. Graphic reproduction of portrait of Hollick. Lithograph, from daguerrotype. National Library of Medicine.

Edwin Hartley Pratt (1849–1930) [author]. Frederick Williams [artist]. *The composite man as comprehended in fourteen anatomical impersonations.* 2d ed. Chicago, 1901. Graphic reproduction of plate facing page 95. Lithograph. National Library of Medicine.

Henry Hall Sherwood (1769–1847?) [author]. *The motive power of the human system, with the symptoms and treatment of chronic diseases....* New York, 1841. Book open to page 13. Wood engraving. 8 1/2 inches. National Library of Medicine.

Mary S. Gove (1810–1884) [author]. *Lectures to ladies on anatomy and physiology.* Boston, 1842. Book open to frontispiece. Wood engraving. 7 1/2 inches. National Library of Medicine.

Edward Harris Ruddock (1822–1875) and George P. Wood (fl. 1880s) [authors]. *Vitalogy; or, Encyclopedia of health and home....* Vol. 1. Chicago, 1907. Book open to frontispiece: View showing divisions of the brain according to Phrenology. 9 3/4 inches. Chromolithograph. National Library of Medicine.

Dr. Franke [author]. *Anatomisch-physiologischer atlas des menschen....* Berlin, 1891. (Repackaged version of J.T. White, *White's physiological mannikin.* New York, 1889.) Chromolithograph on cardboard. 34 1/2 by 23 1/4 inches. National Library of Medicine.

Dreaming the Industrial Body: Fritz Kahn's Modernist Physiology

Fritz Kahn (1888–1968) [artist]. *Der mensch als industriepalast.* Stuttgart, 1926. Chromolithograph. 37 1/2 x 19 inches. National Library of Medicine.

Fritz Kahn (1888–1968) [author; artist]. Man in structure and function.... Vol. 1. New York, 1943. Book open to page 82. Relief halftone. 9 1/2 inches. National Library of Medicine.

Fritz Kahn (1888–1968) [author; artist]. *Der mensch; bau und funktionen unseres körpers, allgemeinverständlich dargestellt.* Zurich, 1948. Book open to page 297. Relief halftone. 10 inches. National Library of Medicine.

Fritz Kahn (1888–1968) [author; artist]. *Das leben des menschen; eine volkstümliche anatomie, biologie, physiologie und entwicklungsgeschichte des menschen.* Vol. 2. Stuttgart, 1926. Book open to Tafel XIII. Two-color relief halftone. 10 1/4 inches. National Library of Medicine.

Fritz Kahn (1888–1968) [author; artist]. *Der mensch gesund und krank, menschenkunde 1940....* Vol. 2. Zürich-Leipzig, 1939. Book open to page 471. Relief halftone. 10 inches. National Library of Medicine.

Fritz Kahn (1888–1968) [author]. *Das Leben des Menschen....* Vol. 2. Stuttgart, 1926. Graphic reproduction of Tafel XXXIII. Photo offset. National Library of Medicine.

Fritz Kahn (1888–1968) [author, artist]. *Das leben des menschen.* Vol. 5. Stuttgart, 1931. Graphic reproduction of page 53. Relief halftone. National Library of Medicine.

Fritz Kahn (1888–1968) [author, artist]. *Man in structure and function....* Vol. 1. New York, 1943. Graphic reproduction of page 266. Relief halftone. National Library of Medicine.

Fritz Kahn (1888–1968) [author, artist]. *Man in structure and function....* Vol. 1. New York, 1943. Graphic reproduction of page 267. Relief halftone. National Library of Medicine.

Reuniting the Divided Self: Katherine Du Tiel's Art of Anatomical Identity

Katherine Du Tiel (b. 1961) [artist]. *Inside/Outside: Muscle/hand.* San Francisco, 1994. Photograph: © Katherine Du Tiel. 40 x 30 inches. National Library of Medicine.

Katherine Du Tiel (b. 1961) [artist]. *Inside/Outside: Lymphatic System.* San Francisco, 1994. Photograph: © Katherine Du Tiel. 40 x 30 inches. National Library of Medicine.

Katherine Du Tiel (b. 1961) [artist] *Inside/Outside: Cardiovascular system.* San Francisco, 1994. Graphic reproduction of a photograph: © Katherine Du Tiel. National Library of Medicine.

Katherine Du Tiel (b. 1961) [artist] *Inside/Outside: Back.* San Francisco, 1994. Graphic reproduction of a photograph: © Katherine Du Tiel. National Library of Medicine.

The Visible Human Project

Visible Human Project Images. Graphic Reproduction of photographs. National Library of Medicine.

Dream Anatomies: The Art of the Visible Human

Suspended Self Portrait. Carolyn Henne (b. 1960) [United States]. Sculpture installation, 2001. Courtesy of the artist.

Body Scanner. Jussi Ängeslevä (b. 1977) [Finland]. Interactive installation, 2001. Collection of the designer.

The Visible Human as Atlas Holding the World. Alexander Tsiaras (b. 1963) [United States]. Animated hologram, 2002. National Library of Medicine.

The Visible Human Plexi-Book: Male. Created by the Exploratorium. San Francisco. Hinged Transparencies in Plexiglas, 2000. National Library of Medicine.

The Visible Human Plexi-Book: Female. Created by the Exploratorium. San Francisco. Hinged Transparencies in Plexiglas, 2000. National Library of Medicine.

Anatquest. Multimedia installation, 2002. Created by the National Library of Medicine

175

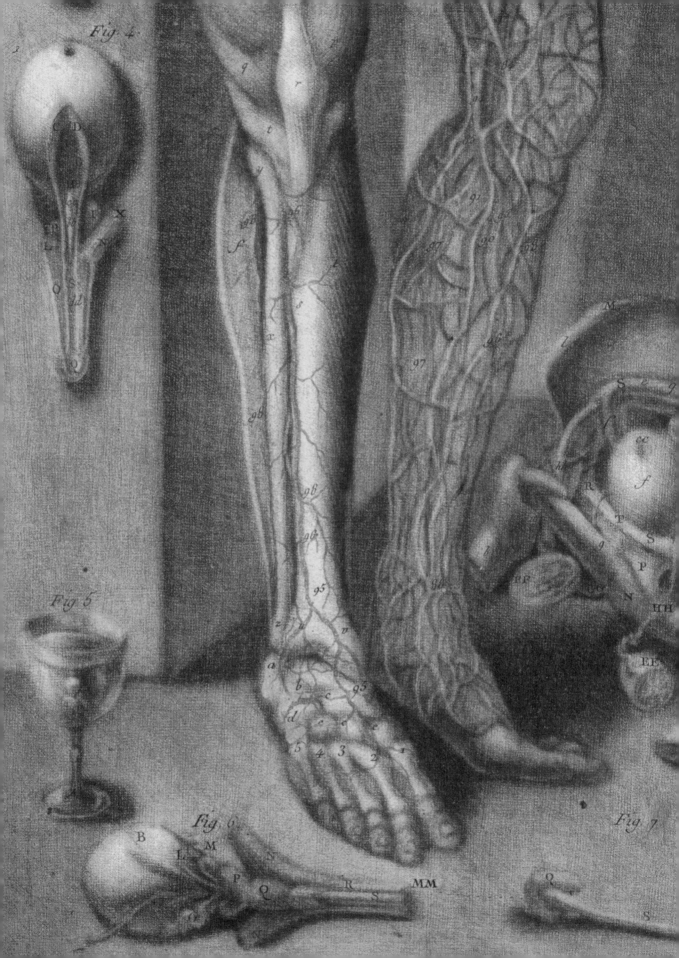

Fig. 4

Fig. 5

Fig. 6

Fig. 7

FURTHER READING

Svetlana Alpers, *The art of describing: Dutch art in the seventeenth century* (Chicago: University of Chicago Press, 1983).

Andrea Carlino, *Books of the body: Anatomical ritual and Renaissance learning*; trans. John Tedeschi and Anne C. Tedeschi (Chicago: University of Chicago Press, 1999).

Mimi Cazort, Monique Kornell, K.B. Roberts, and National Gallery of Canada, *The ingenious machine of nature: Four centuries of art and anatomy* (Ottawa: National Gallery of Canada, 1996).

Ludwig Choulant, trans. and ed. Mortimer Frank, with Fielding H. Garrison and Edward C. Streeter, *History and bibliography of anatomic illustration in its relation to anatomic science and the graphic arts* (Chicago: University of Chicago Press, 1920).

Andrew Cunningham, *The anatomical renaissance: The resurrection of the anatomical projects of the ancients* (Aldershot, England: Scolar Press, 1997).

Lorraine Daston, "Objectivity and the escape from perspective," In Mario Biagioli, ed., *The science studies reader* (New York: Routledge, 1999).
____ & Peter Galison, "The image of objectivity," *Representations* 40 (1992): 81–128.

Martin Kemp, *Visualizations: The nature book of art and science* (Berkeley: University of California Press, 2000).
____ & Marina Wallace, *Spectacular bodies: The art and science of the human body from Leonardo to now* (Los Angeles: University of California Press, 2000).

Alexander Nemerov, *The body of Raphaelle Peale: Still life and selfhood, 1812–1824* (Berkeley: University of California Press, 2001).

C.D. O'Malley, *Andreas Vesalius of Brussels, 1514–1564* (Berkeley: University of California Press, 1964).

Deanna Petherbridge, L.J. Jordanova, Royal College of Art, Mead Gallery, City Art Gallery (Leeds), *The quick and the dead: Artists and anatomy* (Berkeley: University of California Press, 1998).

Ruth Richardson, *Death, dissection, and the destitute* (2d ed.; Chicago: University of Chicago Press, 2000).

K.B. Roberts and J.D.W. Tomlinson, *The fabric of the body: European traditions of anatomical illustrations* (New York: Oxford University Press, 1992).

Michael Sappol, *A traffic of dead bodies: Anatomy and embodied social identity in nineteenth-century America* (Princeton: Princeton University Press, 2002).

Jonathan Sawday, *The body emblazoned: Dissection and the human body in Renaissance culture* (London and New York: Routledge, 1995).

Steven Shapin, *The scientific revolution* (Chicago: University of Chicago Press, 1996)

Barbara Maria Stafford, *Body criticism: Imaging the unseen in Enlightenment art and medicine* (Cambridge, Mass.: MIT Press, 1991).
____, *Artful science: Enlightenment, entertainment, and the eclipse of visual education* (Cambridge, Mass.: MIT Press, 1994).

Bette Talvacchia, *Taking positions: On the erotic in Renaissance culture* (Princeton: Princeton University Press, 2001).

Gretchen Worden, *The Mütter Museum of the College of Physicians of Philadelphia* (New York: Blast Books, 2002).

193. Detail, Jacques Fabien Gautier d'Agoty (1717–1785) [artist; printer]. *Anatomie des parties de la génération de l'homme et de la femme.* Paris, 1773. Pl. I and II. Color mezzotint. National Library of Medicine.

MARINELLI

THE ANATOMICAL PUZZLE

Reproduction of a drawing made by Dr. H. Welcker.

Proffessor of Anatomy, HALLE, Germany. Taken from Actual Photograph.

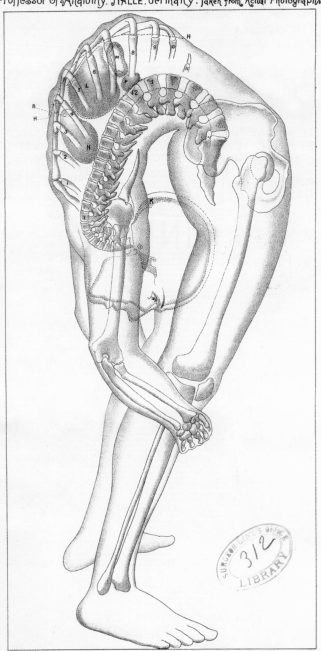

THIS HUMAN MARVEL HAS APPEARED BEFORE
ALL THE LEADING CONTINENTAL PHYSICIANS
NOTABLY

GEH. OBERMEDICINAIRATH PROFESSOR DR. BARDELEBEN, GEHEIMRAETHE AND
PROFESSORS DR. VIRCHOW, WELCKER, HENOCH, GURLT, WESTPHAL EULENBURG
KÖRTE, JULUIS MEYER, BUSCH, TAME ISRAEL, WARLOMONT PHIRY KUFFERATH, ET CETRA, ETC.